GAINSBOROUGH

GAINSBOROUGH

Nicola Kalinsky

Phaidon Press Limited
Regent's Wharf, All Saints Street, London N1 9PA

First published 1995
Reprinted 1995, 1998
© Phaidon Press Limited 1995

A CIP catalogue record for this book is available from the
British Library

ISBN 0 7148 3178 6

Printed in Singapore

Cover illustrations:
Front: *Mr and Mrs Andrews*, c1748–9 (Plate 5)
Back: *Mary, Countess Howe*, c1763–4 (Plate 14)

The publishers would like to thank all those museum authorities and
private owners who have kindly allowed works in their possession to be
reproduced. Particular acknowledgement is made for the following:
Plate 11: by permission of Ipswich Borough Council Museums and
Galleries; Plates 26, 41 and 47: reproductions © 1994 Her Majesty the
Queen; Plate 44: BAL/ National Gallery of Art, Washington DC.

Note: All dimensions of works are given height before width.

Gainsborough

'We love a genius for what he leaves and we mourn him for what he takes away.' These were the words of Thomas Gainsborough on the death of his friend, the musician, Carl Friedrich Abel, and they make a fitting introduction to Gainsborough himself, conveying as they do his generosity of heart with his own characteristic grace and directness. It is, of course, not at all necessary to like our geniuses, nor to demand that they have good natures; many of the greatest figures of the past (or present) seem at best remote, at worst, quite disagreeable. This is not so with Thomas Gainsborough (Fig. 1). In addition to admiring and appreciating his art, we have the pleasure of his person, albeit at second hand, through his letters and the stories and anecdotes left by those who knew him. Gainsborough's simple elegy to a friend could be his own epitaph, for the more we learn of him, the more impossible it is not to mourn and love this most likeable of men.

The hundred or so of his letters that survive reveal glimpses of Gainsborough the professional artist, Gainsborough the family man and Gainsborough the friend. These last form the majority and show Gainsborough at his most vivid, using words and phrases much as he did paint, with natural ease, vivid imagery and swift immediacy. 'For a letter to an intimate friend,' one recipient claimed, 'he had few equals, and no superior. It was like his conversation, gay, lively – fluttering round subjects which he just touched, and away to another.' In his correspondence, Gainsborough describes himself as a 'Cock Sparrow', 'a wild goose at best' and 'the most inconsistent, changeable being, so full of fitts and starts', but there was a more serious side to this man, with his self-deprecating good humour. Gainsborough could write to his sister with clear-eyed analysis of his none too perfect family life, and he forwarded regular funds complete with sensible instructions to his dreamer of an older brother. To patrons, Gainsborough neither grovelled nor was surly. Wherever possible, he laughed them out of any propensity to superiority or impatience by his honesty and charming excuses: 'If I disappoint you...I'll give you leave to boil me down for Painters Drying oil, and shiver my Bones into Pencil Sticks.'

Gainsborough was certainly not a good man in any narrowly pious sense. Although, once he had taken 'a liking to it', he went to Chapel on Sundays, he told his sister, 'a rank Methodist', that 'It does not signify what, if you are but free from hypocrisy, and don't set your heart upon worldly honors and wealth.' Gainsborough frequently misbehaved on jaunts with his friends, playfully chastising the painter Giovanni Battista Cipriani (1727–85) for unsettling him by 'the continual run of Pleasure which my Friend Giardini and the rest of you engaged me in'. He paid far less attention to cultivating 'that worldly knowledge, to enable him to make his own way into the notice of the Great World' than other painters of his stature. This was an observation made by Gainsborough's Ipswich friend and biographer, Philip Thicknesse (see Plate 12). When crossed, he went his own way,

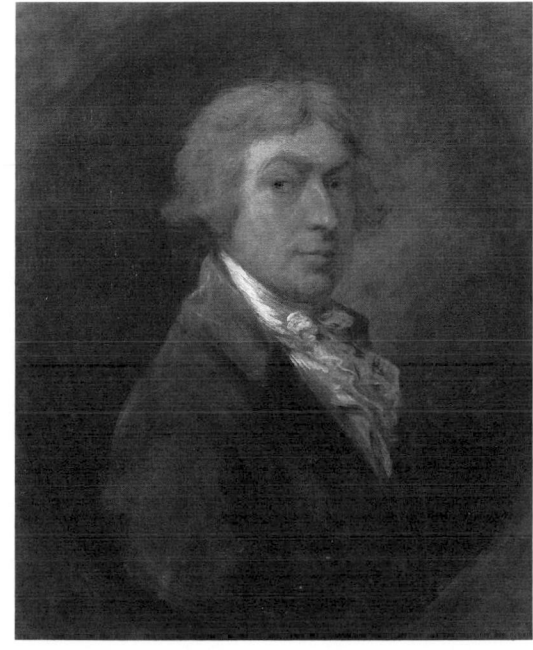

Fig. 1
Self-portrait
1787. Oil on canvas,
74.9 x 61 cm. Royal
Academy of Arts, London

but more out of impulsive irritation than 'the least tendency to the sour Critic'. His friends were mainly fellow artists, actors (including David Garrick and John Henderson), and, most significantly, musicians. His daughter Margaret told the diarist Joseph Farington how her father was 'led much into company with Musicians, with whom he often exceeded the bounds of temperance...being occasionally unable to work for a week afterwards'. A list of Gainsborough's boon companions reads like a roll-call of musicians in late eighteenth-century England: the Italian violinist, Felice de Giardini; the German organist, Johann Christian Bach (Fig. 2); the Linley family of Bath (Fig. 3 and Plate 24); William Jackson, composer and organist at Exeter Cathedral and, of course, Abel, the virtuoso on the viola da gamba (Plate 28). His love of music was exceptional. 'Gainsborough's profession was painting and music was his amusement,' said Jackson, 'yet, there were times when music seemed to be his employment, and painting his diversion.' Possessed of 'ear, taste, and genius', friends recalled him accompanying 'a slow movement of the harpsichord, both on the fiddle and the flute, with taste and

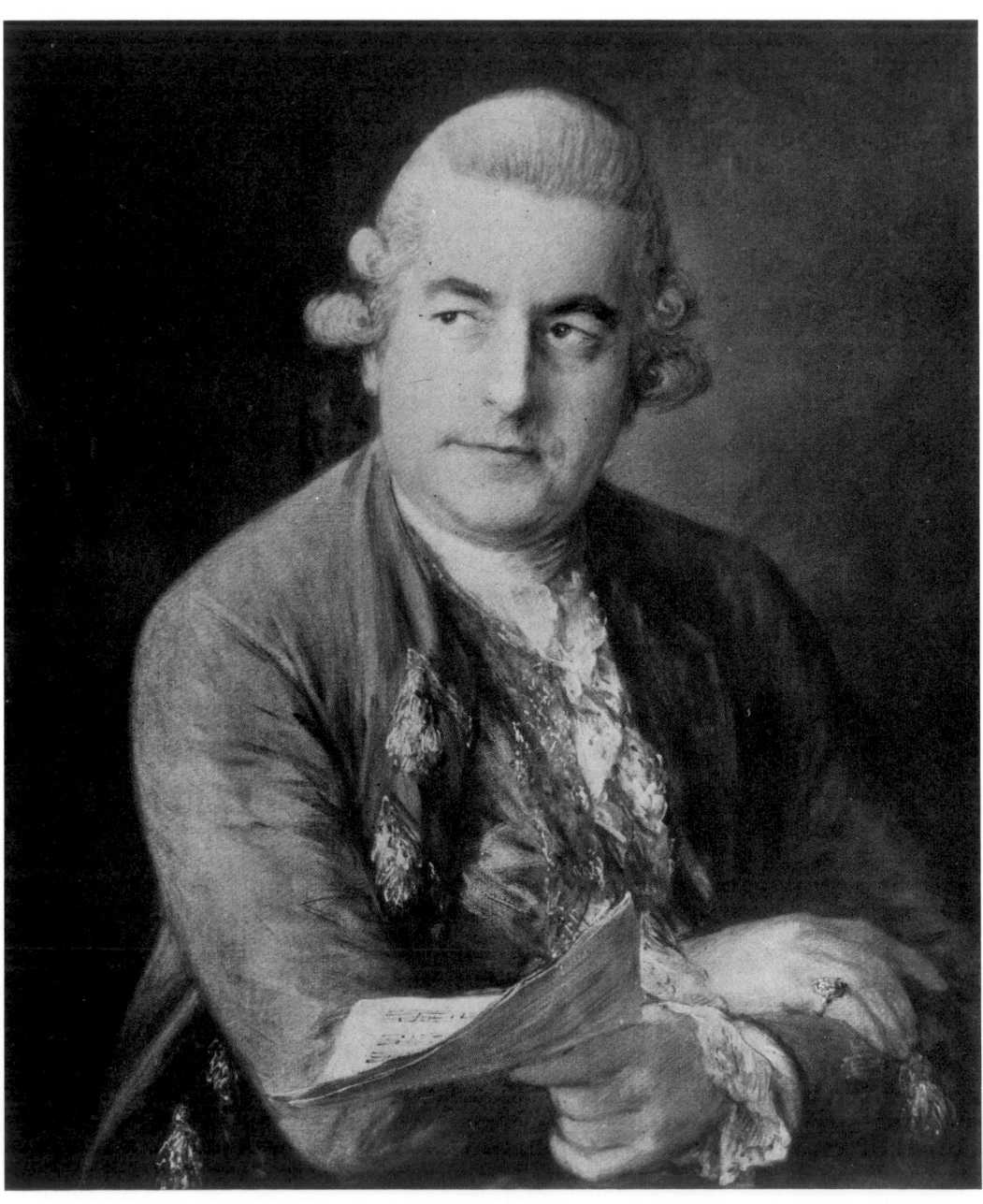

Fig. 2
Johann Christian Bach
1776. Oil on canvas,
74.3 x 61.6 cm. National
Portrait Gallery, London

6

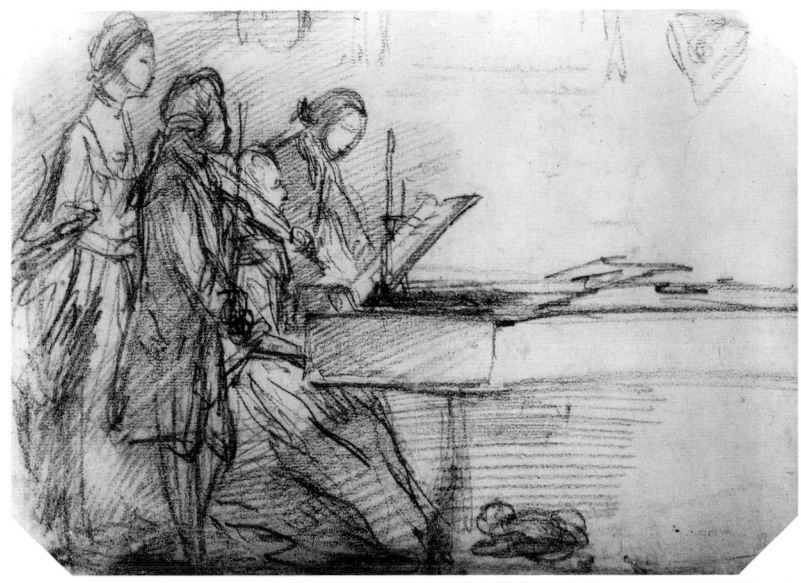

Fig. 3
The Music Party
(possibly the Linley
family)
Early 1770s. Red chalk
and stump on paper,
24.1 x 32.4 cm. British
Museum, London

feeling'. Gainsborough was also passionate about musical instruments, finding much solace in his possession of five violas da gamba.

Henry Bate, the newspaper editor and Gainsborough's staunch defender in the contemporary Press, went so far as to say that Gainsborough 'thought he was not intended by nature for a painter, but a musician'. Against this, we only have the evidence of his performance as an artist and Gainsborough is arguably England's greatest portrait painter of the eighteenth century and her most original landscapist. Philip Thicknesse was in no doubt that 'Mr Gainsborough…was born a Painter, for he told me, that during his *Boy-hood*, though he had no Idea of becoming a Painter then, yet there was not a Picturesque clump of Trees, nor even a single Tree of beauty, no, nor hedgerow, stone, or post…that he had not so perfectly in his *mind's eye*, that had he known he *could use* a pencil, he could have perfectly delineated.'

Few facts are known of Gainsborough's earliest years in Sudbury, Suffolk, although various stories about his prodigious skills as a child circulated after his death. He had, they claimed, painted a pear thief in a neighbour's orchard so realistically that the man was identified and apprehended, and he forged sick notes to avoid school and go sketching in the countryside. Such tales cannot be verified, but, by the age of 13, Gainsborough must have demonstrated enough talent for his parents to risk sending him to London to be apprenticed in the art trades. Gainsborough came from a large family, and his father, a cloth manufacturer and then postmaster at Sudbury, was not wealthy so the decision cannot have been taken lightly. Gainsborough's niece believed that he stayed in the house of a family friend in London who was a silversmith, and his earliest biographers said that he began by learning to make small models of animals. While the exact arrangements of his training remain unclear, Gainsborough's direct involvement with the St Martin's Lane set, dominated by the artists William Hogarth (1697–1764), Francis Hayman (1708–76) and Hubert Gravelot (1699–1773), is, as we shall see, not in doubt.

London in 1740, the year Gainsborough arrived from provincial Suffolk, was as exciting a city as any young artist could have wished for. Hogarth, painter, engraver and tireless promoter of the English artist, had established an academy at St Martin's Lane, Covent Garden, which had become a forum for the exchange of current ideas – aesthetic and practical – with discussions convivially continued in

the next-door coffee house. Other key figures who taught at St Martin's Lane included Hayman and the French designer, Gravelot. This loose confederacy of colleagues, who spanned the Fine and Decorative Arts, disseminated and popularized the lively and informal style now known as 'Rococo'. The very notion of a body of London-based artists working in the current European style would have been unthinkable 50 years earlier and Gainsborough was fortunate to find himself in a milieu that suited his own temperament and talents. He almost certainly spent time working with Gravelot, he would undoubtedly have attended St Martin's Lane, and he was definitely associated with Hayman. In Gravelot, Gainsborough had a direct link to the heart of the French Rococo, with its curves and serpentine lines, and depictions of elegant contemporary figures in informal settings (see Plate 1). In the work of Hogarth and Hayman, he saw examples of England's specific contribution to the Rococo: the development of the conversation piece. These were small-scale portraits of sitters engaged in everyday leisurely activity, such as taking tea or sitting in a garden with family and friends (see Fig. 20). Hogarth's brilliant and sensuous handling of paint was an important example to Gainsborough as was Hogarth's conviction that contemporary subject-matter and a naturalistic style were more appropriate for the modern age than the traditional grand manner of the Old Masters.

Unfortunately, this emergent artistic community faced a major obstacle: the lack of a sympathetic market to buy what they wished to produce. England's record of encouraging artists was poor; in effect, patronage was confined to a small number of aristocrats who restricted their activity to collecting foreign works. Demand for new paintings by English artists was limited to commissions for portraits, copies and delineations of specific views. Although the older generation of painters, led by Hogarth, strove to overcome this problem, it persisted, shaping the progress and choices of Gainsborough's own career. Hogarth had initiated several schemes which aimed to attract new patrons with displays of contemporary paintings. As there were, at that time, no public exhibitions or art galleries, he was literally trying to create a shop-window for English artists. Vauxhall Gardens was the site of one such enterprise. This was a fashionable private park, on the south bank of the Thames, where, in the season (May to September), one could listen to music, dine and promenade outdoors. Hogarth knew the owner well, and at his suggestion the 50 or so supper-boxes were decorated with paintings. The subjects were appropriate to the social ambience of the gardens: children's games and scenes from popular plays and novels. Hayman was responsible for most of the designs which date from c1741–2, but, given the sheer amount of canvas involved (each picture was more than three square metres), young assistants would have done much of the painting and Gainsborough may well have been among them. Contemporary English painting found a rather more respectable venue in Thomas Coram's Foundling Hospital, a charitable institution for abandoned children, established by an old sea-captain in 1739. Hogarth, who was a governor of the Foundling Hospital, initiated a plan whereby the prominent artists of the day would each submit an example of their work, gratis, to the hospital which was open to public view on application. The big names (including Hogarth) painted biblical scenes of lost children and eight landscape painters gave roundels showing other London hospitals. Gainsborough, only 21 years old, was invited to contribute, and in 1748 donated his painting of *The Charterhouse* (Fig. 4).

Gainsborough, by this date, was already an independent artist,

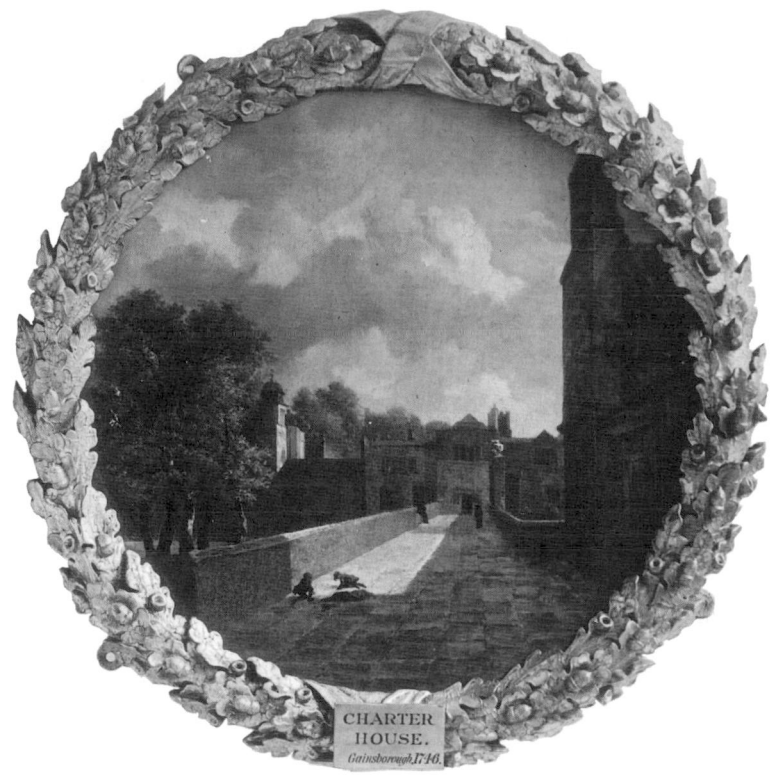

Fig. 4
The Charterhouse
1748. Oil on canvas,
diameter 56 cm. Thomas
Coram Foundation for
Children, London

having set up his own studio in Holborn, London, in about 1745. As well as painting small portraits, he sold landscapes to the dealers for a few shillings each, repaired and added figures to Dutch paintings for the salerooms and produced drawings for the print trade. He had married in 1746. The origins of Margaret Burr, his new wife, (Plates 1 and 32) are rather mysterious – she was the illegitimate daughter of an aristocrat, probably the Duke of Beaufort, and had an income of £200. The same year that Gainsborough's work went on public view at the Foundling Hospital, he returned to Sudbury with Margaret and he was to remain in Suffolk for over ten years. Thicknesse, who became Gainsborough's friend in the early 1750s, claimed that Gainsborough had left London because he lacked confidence and ambition, but the move, initially at least, was probably prompted by his father's death.

Gainsborough was later to write: 'damme Exeter is no more a place for a Jackson than Sudbury in Suffolk is for a G.' Sudbury was (and is) only a small town, its woollen cloth trade was in decline and the possibilities of provincial patronage were limited. In 1752 Gainsborough, who was now the father of two girls, Mary and Margaret, moved a few miles east to the more prosperous and populous town of Ipswich. But the average customer, mainly from the middling ranks of the professional classes and clergy, with a smattering of local gentry, (see Plates 5 and 7) was only interested in face-painting and was not prepared to pay very much. Gainsborough's price for a head was five guineas; in London, the newly established Joshua Reynolds (1723–92) was charging at least 12 guineas. Gainsborough's landscapes were of interest only to himself and one or two discerning customers; the majority were still on his hands when he sold up in 1759. During the 1750s Gainsborough had difficulties paying his rent; he took out several loans secured against his wife's annuity, and the surviving letters imply that he was grateful for work whenever it presented itself and wherever it might be. He travelled around the area to towns such as Colchester, and by the late 1750s was going as far as Bicester in Oxfordshire for his commissions.

Fig. 5
The Hon Mrs Graham
1777. Oil on canvas,
237 x 154 cm. National
Gallery of Scotland,
Edinburgh

In 1759, Gainsborough moved to Bath, and this was the turning point of his career. Bath, 'the great resort of the fashionable world', was the spa town where society went, not so much for their health, as for the constant round of socializing at concerts, receptions and dances (see Plate 23). Commissioning a portrait was a natural adjunct to taking the waters, and Gainsborough had no serious rivals for business. He was able to raise his prices, first to eight guineas a head and, eventually, to 30 guineas a head (but this was consistently less than Reynolds in London). Overwork probably contributed to his serious illness in 1763 and it is around this time that remarks began to appear in his letters about 'the curs'd Face Business'. More positively, this new location gave Gainsborough the opportunity to see Old Master paintings in the country seats around Bath when he went to paint their owners, several of whom became his friends. He is known to have spent time at Corsham, Wilton, Shobdon and Stourhead and many of his now more sophisticated sitters, such as Dr Charleton, who looked after him during his illness, had collections of paintings.

In 1761 Gainsborough sent his first paintings up to London for public exhibition at the Society of Artists. The idea of holding annual shows of contemporary painting had arisen directly out of the Foundling Hospital experience. These exhibitions attracted large audiences, 13,000 in 1761, for example, and their success encouraged some artists to explore the idea of a more formal organization. This emerged at the end of 1768 as the Royal Academy with Reynolds as its first president. Reynolds had a very different approach from Hogarth to the promotion of English art and artists. Although by profession a portrait painter, Reynolds strongly believed that some kinds of subject-matter (ie historical or literary) were inherently superior to others, and that art should idealize whatever it depicted, as he felt the best Old Masters had done. Nevertheless, many of the St Martin's Lane set joined the new academy – an institution that Hogarth, who had died in 1764, would not have supported. Gainsborough was invited to become a founder member, the only provincial portrait painter to be so honoured. Not that his relationship with this institution was ever close or harmonious. To Gainsborough, always the individualist and never a committee man, the bureaucracy of the Royal Academy was an anathema. He had his first major quarrel with the hanging committee of the annual exhibition in 1773, and did not send his work again until 1777.

In 1774, apparently without much prior planning (he had arranged for a harpsichord to be shipped from London earlier in the year), Gainsborough left Bath and took the lease of a wing of Schomberg House in Pall Mall, London, where he was to live and work until his death. It is possible that his famous quarrel with his friend Thicknesse over a portrait promised to Mrs Thicknesse, but never finished (see Plate 12), was the immediate catalyst of this relocation. But Gainsborough, despite his frequently expressed wish to 'walk off to some sweet Village', was an ambitious man and highly conscious of his professional standing. London was the only stage on which he could really proclaim his maturity as an artist.

Gainsborough wrote to his sister in 1775: 'My present situation with regard to encouragement is all that heart can wish', and in 1777 he returned triumphantly to the Royal Academy exhibition with a group of magnificent paintings (Plates 25, 26, 27 and Fig. 5). A certain rivalry between Reynolds and Gainsborough now became a much relished feature of the annual show. That same year, Gainsborough first painted a member of the Royal Family (Plate 26). Like Reynolds, Gainsborough was wealthy enough to be able to live in a gentlemanly

fashion, with a coach and servants. Although Gainsborough probably saw no more intrinsic worth in such things than their showing him to be as good as the next man (he smiled at his family's sense of the 'honour' due to 'Ladies that *keep a Coach*'), it pained him that he was never knighted – Reynolds had been made Sir Joshua in 1769. In 1784, on the death of the artist Allan Ramsay (1713–84), the official post of Principal Painter to the King went to Reynolds, who, in contrast to Gainsborough, had never received a single portrait commission from the Royal Family. For all his reputation, Gainsborough remained a little on the sidelines of the Royal Academy, the official Parnassus of the London art world. His relations with Reynolds were not particularly cordial and the Royal Academy establishment felt that Gainsborough paid scant respect to their business, whether 'official or convivial'. In 1784 he withdrew his paintings from the exhibition, again angry at the proposed insensitivity of the hang (see Plate 41), and never showed there again. But Gainsborough was never in retreat. His own exhibitions at Schomberg House attracted hundreds of visitors and the Royal Family continued to take an interest in him. If anything, in these last years, Gainsborough became more artistically ambitious and boldly experimental. On his deathbed in 1788, he told his old rival, Reynolds, that 'his regret at losing life, was principally the regret of leaving his art.'

Gainsborough's character as an artist was largely defined by the continual tension which existed between his successful career as a portrait painter and his desire to paint landscapes; the one was his necessary livelihood, the other his 'infinite delight'. Like so many other painters of this period, Gainsborough resented the limitations imposed by English patronage. As he said to Jackson, 'a Man may do great things and starve in a Garret if he does not conquer his Passions and conform to the *Common Eye* in chusing that branch which *they* will encourage & pay for.' Gainsborough was also, and here he differed radically from Reynolds, temperamentally unsuited to many aspects of the portrait business. To be an artist at this period was to occupy a dubious social position, rather like a governess in Victorian England, and the day-to-day practicalities of face-painting exposed all the contradictions inherent in this. The relationship between sitter and painter was rarely an equal one, the client would almost always be a proper gentleman or lady. Gainsborough had his own views on the former: 'damn Gentlemen, there is not such a set of Enemies to a real artist in the world as they are...*They* think...that they reward your merit by their Company & notice; but I, who blow away all the chaff & by G- in their eyes too if they dont stand clear, know that they have but one part worth looking at, and that is their Purse.' His contemporary and fellow artist, Francis Bourgeois (1756–1811), recalled an incident which is symptomatic of both the casual arrogance of the ruling class and Gainsborough's reaction to such behaviour. When the politician, Pitt, came to be painted, he sat straight down and began, without a word, to read a book: 'Gainsborough struck with the hauteur and disrespectful manner of Mr. Pitt, treated him in this way. He took up his pallet and seeming to be trifling among his Colours, began carelessly to hum toll, loll de roll, on hearing which Mr. Pitt recollected himself *shut his book*, and sat in a proper manner.' Gainsborough, although 'very familiar and loose in his conversation to his intimate acquaintance...*knew his own value*; was reserved; and maintained an importance with his sitters.' He also had a strong sense of his being an artist entailing a due consideration, on the part of others, towards his methods and manners. One patron, who was obviously having to wait for his portrait, was told that 'Painting &

Punctuality mix like Oil & Vinegar, & that Genius and regularity are utter Enemies.' Comments and phrases in his letters vividly convey his impatience with 'plaguesome sitters': 'If the People with their damn'd Faces could but let me alone a little', he wrote. Gainsborough naturally turned to the idyllic imagery of his landscapes to express the extent of his frustration. Writing to Jackson, after saying how sick he was of portraits, he went on 'But...we must jogg on and be content with the jingling of Bells, only d-mn it I hate a dust, the Kicking up of a dust, and being confined *in Harness* to follow the track, whilst others ride in the waggon under cover, stretching their Legs in the straw at Ease, and gazing at Green Trees & Blue skies without half my *Taste*, that's damn'd hard.' Gainsborough's word-picture mirrors his sketches of idling rustic youths (Fig. 6) and sleepy, horse-drawn carts (Plate 15).

But Gainsborough was a practical man, with a wife and family to support, and he realized that he must 'pick pockets in the portrait way'. If he did not work for three or four weeks at a time, he could equally 'apply with great diligence' for a month. For all his dilatoriness and refusal to toady, Gainsborough was recognized as the rival to Reynolds and held as the superior of the two in his ability to capture a likeness. There is also evidence in his letters (see Plate 10) and in comments made by his contemporaries, that Gainsborough gave considerable thought to the problems of trying to communicate character in paint, even if he did not express himself in the philosophical language of Reynolds. He told one friend that 'he was

Fig. 6
Boy Reclining in
a Cart
Late 1760s. Pen and
brown ink with grey and
brown wash,
17.6 x 22.1 cm.
British Museum, London

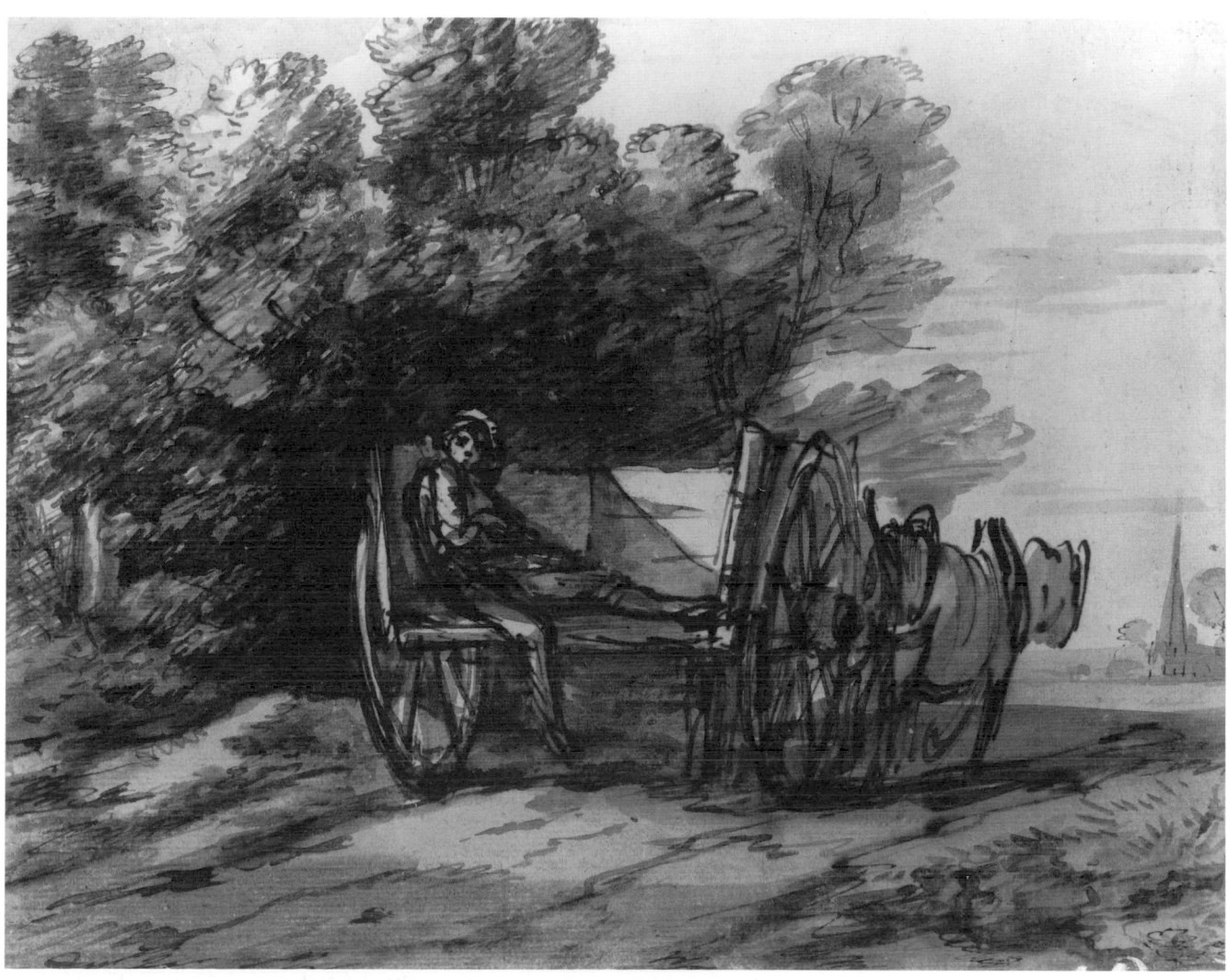

sure the perplexities of rendering something like a human resemblance, from human blocks, was a trial of patience'. The most analytical and revealing faces are, not surprisingly, Gainsborough's self-portraits and those of intimate family and friends. His best society portraits are of sitters with whom he had some spark of sympathy – this was often coincident with them being female, especially if young and lovely. His servant was instructed to repel the time-wasting gentlemen who came to call, but, 'if a *Lady* a handsome Lady comes tis as much as his Life is worth…[to] send them away.' Gainsborough became the favourite painter of the *demi-mondaines*, the fascinating ladies who were the mistresses of great aristocrats, Giovanna Baccelli (Plate 36), for example, or Mrs Robinson (Fig. 7), the discarded lover and blackmailer of the Prince of Wales.

Gainsborough took a professional pride in his business and his pictures were well-made objects which have generally survived in a good state of preservation. His apprenticeship in London, to whoever it was, clearly served him well in the craft of painting. Comments in his letters attest to his care in selecting materials; he chose his pigments with a view to both beauty and permanence, unlike Reynolds, who

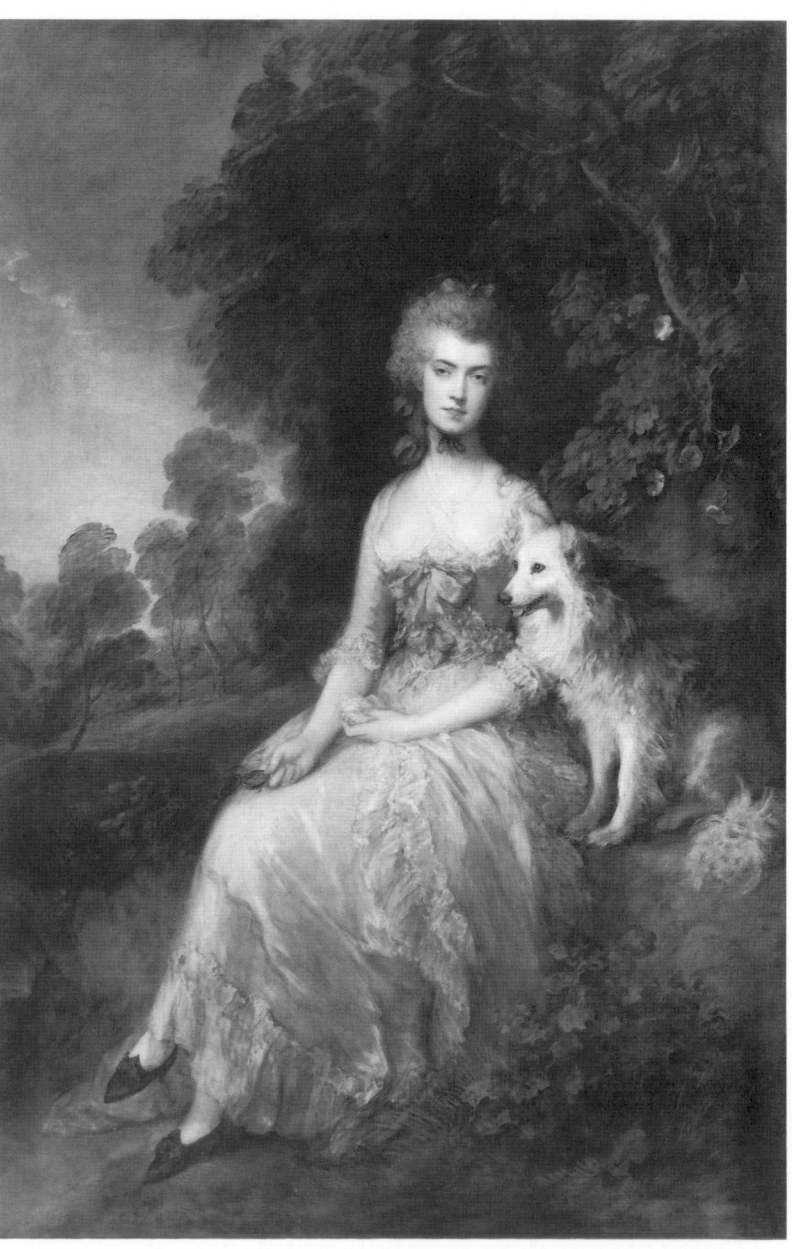

Fig. 7
Perdita
(Mrs Robinson)
1781–2. Oil on canvas,
234 x 153 cm. Wallace
Collection, London

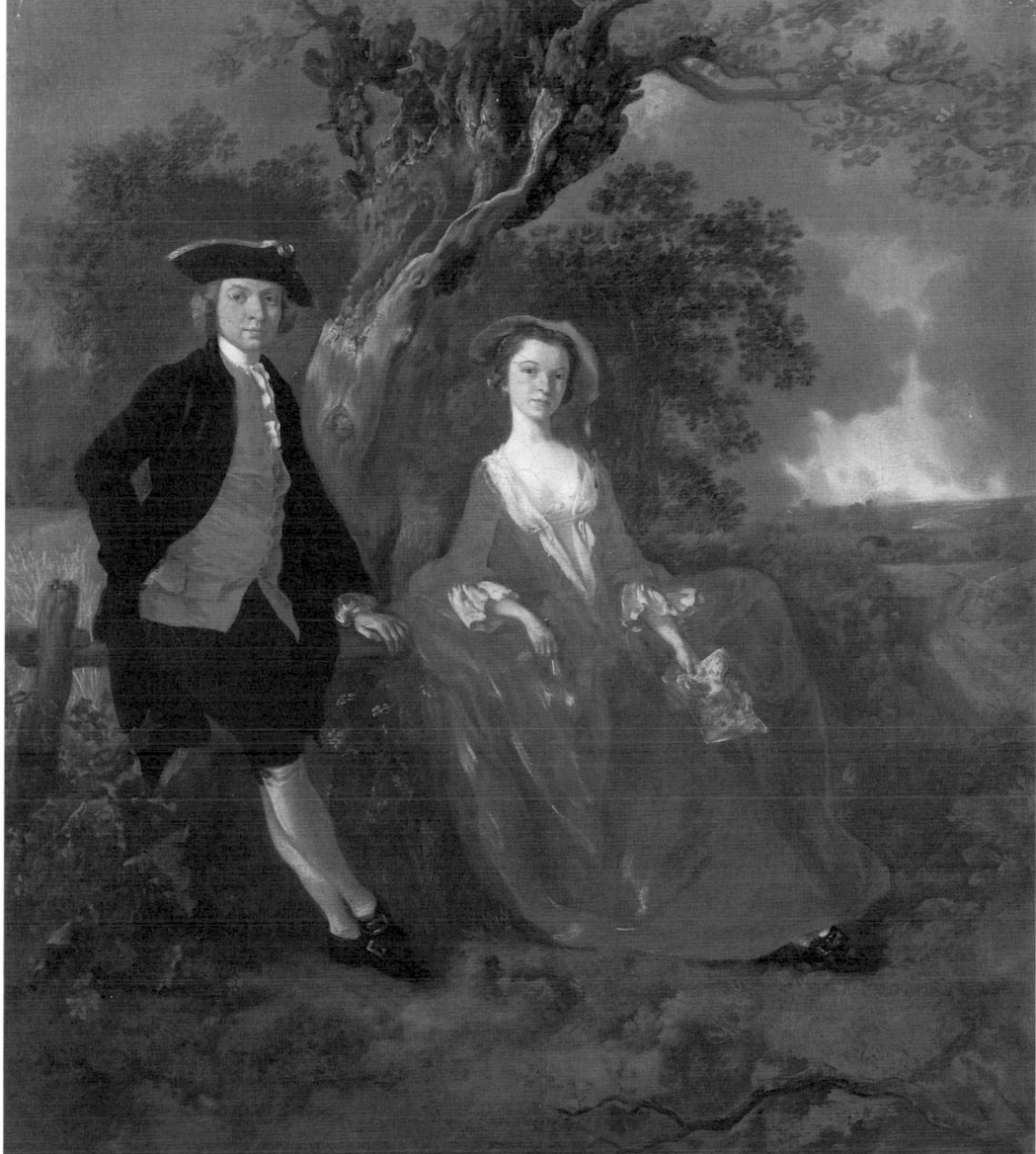

Fig. 8
Unknown Couple in
a Landscape
Early 1750s. Oil on canvas,
76.2 x 67 cm. Dulwich
Picture Gallery, London

was notorious for using fugitive colours. He was unusual in his insistence on normally painting all parts of a portrait himself, rather than employing a drapery painter; his nephew, Gainsborough Dupont (Plate 22), was his only recorded assistant and pupil. Gainsborough realized that the 'lesser parts' of the canvas – the costume and the setting – were as significant to the final effect as the face itself, and described the importance of achieving a unified composition to his friend Jackson with a typical musical analogy: 'One part of a Picture ought to be like the first part of a Tune; that you can guess what follows.' Whenever he could, he used landscape as the background, perhaps as a means of reconciling his duty to his love. Gainsborough's evolving landscape style and his ability, from the very beginning of his career, to suggest a relationship between figure and setting (Fig. 8), ensured his continuing originality and freshness of style, especially in those portraits (which would have formed the bulk of his trade) where the sitter was of no particular consequence to him as a person.

With a rigorousness not shared by all his contemporaries, Gainsborough always insisted on painting the head with the sitter actually before him, in order to achieve a true likeness, which he considered 'the principal beauty and intention of a Portrait'. Even his

earliest efforts were judged to be 'truly drawn, perfectly like', although they were also criticized for being 'stiffly painted and worse coloured'. After the face had been painted, a jointed doll called a lay-figure would serve as the model for pose and drapery. In the conversation pieces of the 1740s and 1750s, such as *Mr and Mrs Andrews* (Plate 5), the peg-like figures, with their quaint stiffness, clearly show Gainsborough's unease with the body. By the time Gainsborough left Ipswich in 1759, he was more confident and could, on occasion, experiment with the expressive possibilities of the whole figure, as with *William Wollaston* (Plate 11). Not that Gainsborough ever mastered anatomy; his bodies are always clothes-horses but he learned to treat costume in a way which suggested the possibility of a graceful form (Fig. 9 and Plate 12), or generous and solid flesh beneath (see Plate 11). In these pictures, it is as if the early little figurines have come vigorously to life.

During the 1760s Gainsborough became aware of the challenge of Reynolds, whose first large-scale portraits in landscape were publicly exhibited from 1760 at the Society of Artists and represented the most sophisticated current taste in portraiture. Inspired by this contemporary example, and under the impact of Sir Anthony van Dyck (1599–1641), the Old Master who was to have the greatest influence on him, Gainsborough evolved a portrait style as well-mannered as his now more urbane clientele. From Van Dyck, whose portraits of melancholy and refined courtiers were well represented in the collections to which he now had access, Gainsborough acquired an easy elegance of pose and saw how glamorous costume could confer an indefinable lustre on the sitter. *Mary, Countess Howe* (Plate 14) and *Isabella, Viscountess Molyneux* (Plate 20) are two spectacular examples of a style which Gainsborough continued to exploit well into the late 1770s. But Gainsborough did not borrow superficially; he reinterpreted Van Dyck's aristocratic mien for the broader market of the late eighteenth century. Gainsborough subsumed Van Dyckian gestures into convincingly natural posture and did not usually portray his sitters in historical costume, despite the famous exceptions (Fig. 5, Plates 21 and 25). He preferred to paint his clients in modern dress, on the grounds that it helped establish their likeness. He did not agree with Reynolds's practice of clothing women in supposedly timeless, classicizing drapery; if necessary, as with *The Linley Sisters* (Plate 24), Gainsborough would take a picture back and alter details of costume and hair to bring them up to date.

Gainsborough's years in Bath saw him emerge as an assured portrait painter with a distinctive and characteristic manner. Compared to the work of his contemporaries, Gainsborough's handling of paint seems much freer, and his compositions are distinguished by their visual unity and sense of colour harmony across the canvas. Like the Flemish masters, Van Dyck and Sir Peter Paul Rubens (1577–1640), and through his observation of their techniques, Gainsborough created images from colour and shadow and light (chiaroscuro), rather than outline. To do this, he employed methods noted at the time for their idiosyncrasy. Ozias Humphry, a young artist, watched Gainsborough painting portraits in the 1760s in 'a kind of darkened Twilight' rather than the usual full north daylight. This gloom, in which sitter and picture were barely discernible to the observer, enabled Gainsborough to perceive the general masses and chiaroscuro. Humphry also described how Gainsborough 'commonly painted standing' and spent considerable time comparing the 'Dimensions and Effect of the Copy [ie the picture], with the original both near and at a distance'. After the face had been painted from life, Gainsborough worked on the

16

canvas as a whole rather than piecemeal – Reynolds called this Gainsborough's 'manner of forming all the parts of his picture together'. Gainsborough often used very thin oil paint, diluted with turpentine, to wash over an area at speed, making this technique of working on the whole canvas at once physically possible. He also used the ground (the layers of paint which primed the canvas) as a halftone to unify the image – letting it show through either uncovered in places, or beneath a transparent colour licked over it.

Gainsborough's marks on the canvas, either the 'hatching style of pencilling' with the very dilute paint (the description given, disapprovingly, by William Jackson), or his thicker strokes of colour, were recognized as being peculiar to him, and attracted comment, both favourable and critical. Gainsborough did not mimic, touch by touch, the object he depicted; his aim was to achieve the illusion of reality through the activity of viewing. An obituary described how 'His portraits are calculated to give effect at a distance…but closely inspected, we wonder at the delusion, and find scumbling scratches that have no appearance of eye-brows or nostrils.' It was suggested that this deliberate imprecision was a key to Gainsborough's ability to capture a likeness. Reynolds, too, expressed wonder at the way in 'this chaos, this uncouth and shapeless appearance, by a kind of magick, at a certain distance assumes form' and grudgingly admitted that it might be the product of diligence rather than 'chance and hasty negligence'. Gainsborough expected, even demanded, that people should place his portraits in an appropriate light and look from the proper distance for the effect of the image to be seen. 'I should be glad', he wrote, '[if] you'd place your picture as far as from the light as possible.' Paintings were not, on the one hand, 'made to smell of', so he chided an owner who looked too closely at the 'roughness' of the surface, nor were they to be placed 'at a Miles Distance'. Gainsborough's rows with the Royal Academy were, on each occasion, prompted by his overriding concern for the correct viewing conditions for his work (see Plate 41).

Gainsborough's mature portrait style underwent no radical changes of direction although its distinctive brushwork and harmonious colour became ever more pronounced. In the final decade of his life, Gainsborough was able to use the genre of portraiture to express his deepest feelings about nature, resulting in some of the most extraordinary and evocative images of the late eighteenth century. An outdoor setting, used to add a sense of casual informality in earlier portraits (see Fig. 8), or the drama of a stormy sky in the work of the 1760s and 1770s (see Plate 14), becomes in *Mrs Sheridan* (Plate 44) or *The Morning Walk* (Plate 45), an enveloping natural force. The figures are literally subsumed into their setting. Passages of paint which almost resemble watercolour bring to mind his daughter's observation that at this 'advanced stage of his life' Gainsborough's 'colours were very liquid, and if he did not hold the palette right would run over'. These thin, sketchy areas, rhythmically brushed in, describe sitter and landscape without establishing a hierarchy between the two. Dashes of impressionistic impasto are equally likely to indicate details of foliage or dress. His late portraits have been called 'romantic' in that they give tangible expression to the idea that the true self is revealed by, and is concomitant with, the natural world. Gainsborough produced at least one finished painting which gave a further twist to his development of the portrait in landscape. In *The Mall* (Plate 38) of 1783, the fashionable figures, reduced in scale so that they are ethereal types rather than individuals, stroll in an urban pleasure garden under towering trees as elegantly as the Hallets in *The Morning Walk* (Plate

45). This type of subject, which is neither portrait nor landscape, but a vision of high society within the embrace of nature, was a wholly original and new venture in English art, although Gainsborough was clearly influenced by the elegant park scenes of the French painters Antoine Watteau (1684–1721) (Figs. 16 and 37) and Jean Honoré Fragonard (1732–1806) (Fig. 38).

Throughout his busy career, Gainsborough did find time to paint numerous pure landscapes and they were the earliest of his works to be singled out for praise. The critic Horace Walpole mentioned the roundel at the Foundling Hospital as 'tho't the best and masterly [in] manner', and he was considered by his contemporaries as one of England's foremost landscape painters. There were, perhaps, advantages in the very fact that Gainsborough did not have to rely on pleasing patrons with the kind of painting that pleased him most. An extraordinary expression of his self-determination in this respect survives in a letter in which Gainsborough declines an uncongenial request for '*real Views* from Nature'. 'If his Lordship wishes to have anything tolerable of the name of G,' he wrote, 'the subject altogether, as well as figures etc. must be of his own Brain; otherwise Lord Hardwicke will only pay for Encouraging a Man out of his way and had much better buy a picture of some of the good Old Masters.'

The period of Gainsborough's lifetime saw immense changes in the perception of landscape as an art form and there was a related growth of interest in the actual countryside. In the earlier part of the century,

Fig. 10
Wooded Landscape
with Peasant Resting
*c*1747. Oil on canvas,
62.5 x 78.1 cm. Tate
Gallery, London

English painters of landscape had been limited to producing either topographical work (exact delineations of a given spot, usually commissioned by the land or property owner for the purposes of record rather than art) or decorative scenes to be placed above doors and fireplaces, known as overmantels. Neither of these types of picture was considered to have much artistic significance and neither could form the background to Gainsborough's own achievement in the genre. But this does not mean that his paintings and drawings of landscape were the outcome of a purely spontaneous reaction to nature. Gainsborough's approach was constantly, and variously, influenced by his growing understanding of earlier landscape traditions, by his participation in the period's increasingly romanticized view of rural life and by his own artistic intentions.

Gainsborough was exceptional among English painters in the extent of his assimilation and appreciation of the work of the Dutch seventeenth-century landscapists, particularly Jacob van Ruisdael (*c*1628–82), Jan Wynants (active 1643–84), and Meindert Hobbema (1638–1709). Dutch landscapes, so very different from the more highly regarded classical landscapes of the French painters Claude Lorraine (1600–82) and Nicolas Poussin (1594–1665), whose paintings had idealized the historically resonant countryside around Rome, were considered to be more like England. This would be especially true of the parts of East Anglia which Gainsborough knew. His early paintings, such as *Wooded Landscape with Peasant Resting* (Fig. 10) combined Dutch staffage (the little figures and animals which enliven the scene) and compositional structure (a screen of imposing trees,

Fig. 11
Herdsmen and Cattle
1780s. Brown chalk and
stump, grey and blue wash
and oil on varnished
paper, 22.2 x 31.3 cm.
Clark Institute,
Williamstown, MA

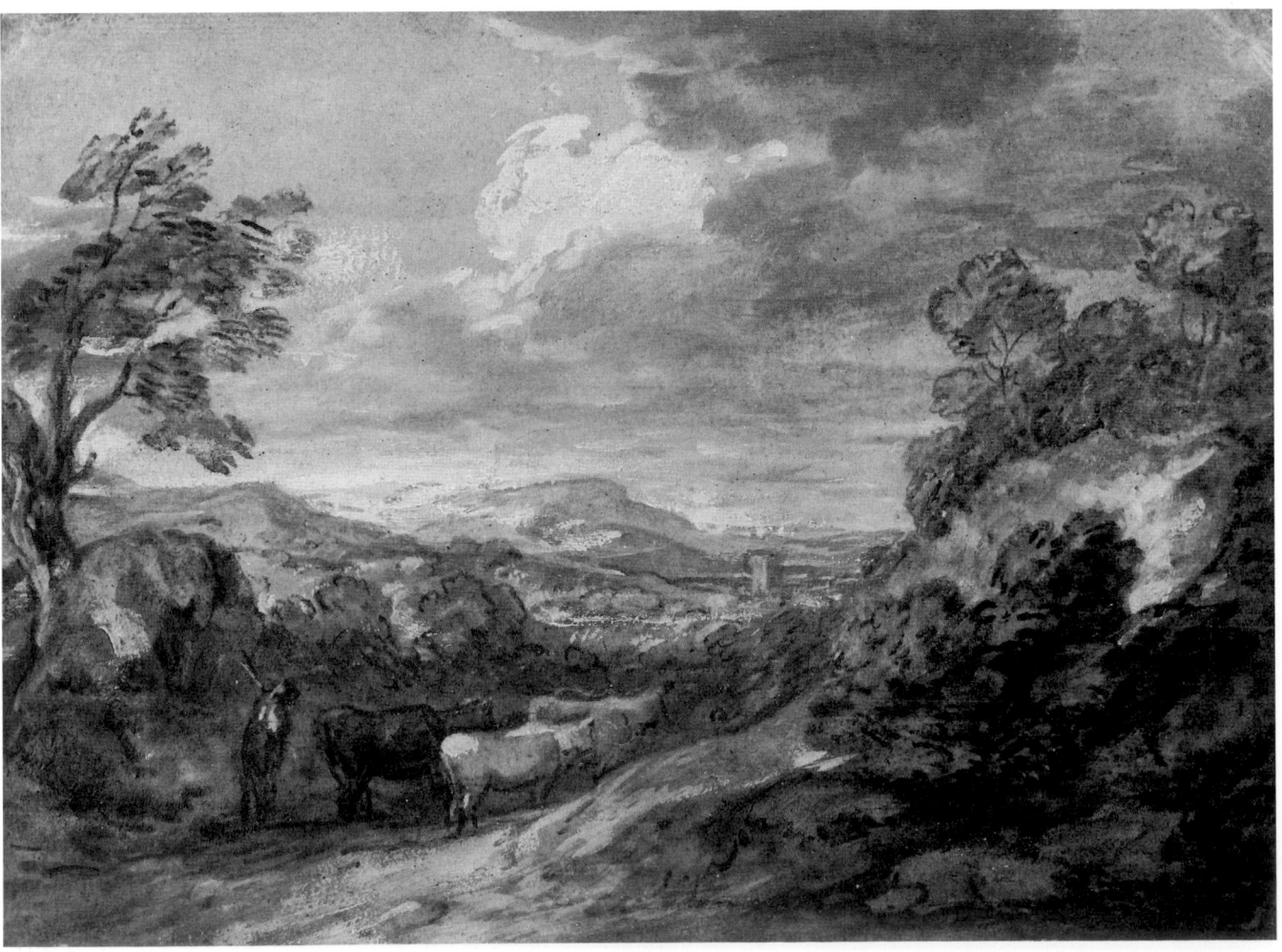

sandy banks, and winding paths leading to the sunlit distance) with his own convincing sense of atmosphere and lively handling of paint. By the mid-1750s, this balance had shifted and Gainsborough began to emphasize the Rococo qualities in his pictures, making them overtly decorative and anecdotal. One of the few actual landscape commissions known from this period is for a pair of overmantels for the Duke of Bedford, which are very similar to *River Landscape with Rustic Lovers* (Plate 8). These pictures, with their bucolic lovers, can be compared with the work of Gainsborough's French contemporaries, François Boucher (1703–70) and Fragonard. With Gainsborough, the landscape setting is always the predominant subject, not the actual swains and shepherdesses as with Boucher (Fig. 23), and the human interest lacks the palpable eroticism of Fragonard (Fig. 24). Yet all three are variations of the pastoral, that is, the countryside as a playground for rustic romance.

Gainsborough's move to Bath had as profound an effect on his landscapes as on his portraits. Just as Van Dyck lent a new sophistication and grace to his sitters, so Gainsborough's growing awareness of Rubens and Claude checked the slight fussiness and repetition of motifs which had appeared in his landscapes during the 1750s. Paintings like *The Harvest Waggon* (Plate 16) or *Peasants Returning from Market* (Plate 17) are less crowded, the compositions are more unified and have a simple grandeur. The impact of the West Country itself (an area which is considerably hillier and more dramatic than Suffolk), harmonized with Gainsborough's growing artistic maturity. Ozias Humphry recalled how he used to accompany Gainsborough on afternoon outings 'to the circumjacent Scenery, which was in many Parts, picturesque, and beautiful in a high Degree'.

Although Gainsborough certainly made studies from nature on his afternoon trips into the local countryside, the majority of his landscape drawings were produced by candlelight in the evenings. Drawing was a form of relaxation for Gainsborough and, of the hundreds of sketches in pencil, chalk and watercolour which survive, the subject is usually landscape (Fig. 11). Uvedale Price, a writer and theorist of the 'Picturesque' movement, who went riding with Gainsborough around his family estate (see Plate 13), remembered how Gainsborough would take home pieces of moss, rock and stone from which he would make miniature landscape models in the evenings. Gainsborough continued this practice when he lived in London, using, according to Reynolds 'broken stones, dried herbs, and pieces of looking glass, which he magnified and improved into rocks, trees, and water'. But, even in London, these models were not so much an *aide-mémoire* as a spur to Gainsborough's imaginative response to the idea of landscape. Serving a similar purpose were Gainsborough's evening experiments with novel techniques which relied on the rapid exploitation of chance effects, such as his 'moppings', where he applied colour with sponges to indicate the general masses of a landscape.

From the late 1760s, by which time Gainsborough was unequivocally established as a highly successful portrait painter, certain recurrent themes begin to appear in his landscapes: peasants going to and from market on horseback or in a cart (Plates 16 and 17), and a peasant family in front of their homely cottage (Plate 33). Gainsborough was to paint variations of these subjects until the end of his life, a preoccupation which has been variously explained as his expression of current philosophical debates on the desirability of retirement from urban life, to evidence of the discomfort and evasions of art before the actual plight of the agricultural poor during a period

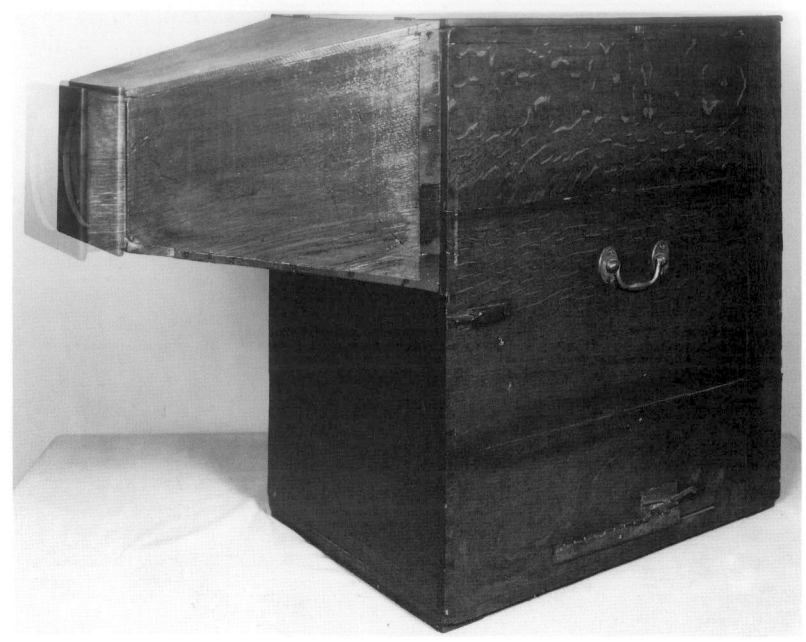

of considerable upheaval. Gainsborough certainly shared his age's general idealization of a good life on the land. Price recalled, during their rides together: 'When we came to cottages or village scenes, to groups of children…I have often remarked in his countenance an expression of particular gentleness and complacency.' However, Gainsborough was neither Jean-Jacques Rousseau, the philosophical originator of the late eighteenth century's ennui with civilization, nor Oliver Goldsmith, the poet who consciously bore witness to the human price extracted by changes in the rural economy in his famous poem *The Deserted Village* (1770). Gainsborough's response to what he saw went no further than a reaction to individuals (there are several examples in his letters of his generosity) and a vague sense of nostalgia for his roots. These feelings were primarily channelled into his art, providing the subject of these unrealistic but beautiful landscapes.

During the final years of his life, as well as continuing to paint ever more magisterial expressions of his favourite country themes (see Plate 48), Gainsborough tried to increase the variety of his landscapes. After making a then fashionable tour to view the picturesque countryside of the Lake District in 1783, Gainsborough added mountain scenery to his repertoire (see Plate 39) and, in 1781, he exhibited his first seascapes, (Fig. 36 and Plate 37). Given his love for technical experimentation and his fascination with the way in which glowing light could add life to a landscape, Gainsborough was predictably swept up in the vogue for literally transparent images painted on gauze or glass (see Plate 28). In the early 1780s, inspired by an exhibition of stained glass and by his friend De Loutherbourg's *Eidophusikon*, an entertainment of painted scenes on a miniature stage (see Plate 31), Gainsborough made his own peepshow box (Fig. 12). Through its magnifying lens one viewed small landscapes and seascapes painted on glass and lit from behind by flickering candles (Fig. 13). The result was 'truly captivating especially in the moonlight pieces, which exhibit the most perfect resemblance of nature'. Interestingly, after Gainsborough's death, this apparatus and 'transparencies', together with a large collection of Gainsborough's landscape drawings, belonged to Dr Thomas Monro, a physician and amateur artist, who held an evening drawing school for aspirant young landscapists, the artist J M W Turner (1775–1851) among them. It is

tempting to think that just as the painter John Constable (1776–1837) was heartened by Gainsborough's infusion of sentiment into ordinary English countryside (see Plate 48), so Turner was inspired by Gainsborough's brilliant improvisations on the theme of nature.

The appearance of the so-called fancy picture in the early 1780s was part of Gainsborough's determination to widen his range, but, like *The Mall* (Plate 38), they defy simple categorization within the usual boundaries and hierarchies of eighteenth-century painting. In the fancy pictures, for example the *Girl with Pigs* (Plate 34), or *Girl with Dog and Pitcher* (Plate 46), Gainsborough took, as it were, one or two people from his landscapes, and treated them on the scale of importance associated with full-length portraits. The figure was usually a child (see Fig. 14), although Gainsborough also painted a woodcutter in this manner. They are portraits in that Gainsborough used specific models: urchins and worn-out labourers he came across. The figures, however, are treated as characters rather than real individuals, and are artificially posed engaged in emblematic tasks or with one or two telling accessories. This depiction (and, we might argue, fiction) of peasants may appear rather cloying today, but, in the context of the period, the feelings of sympathy and interest they aroused were fresh and had something of the force of a discovery. Gainsborough's obituary described his fancy pictures as 'nature…in a mirror…[in which] a story is told that awakens the most pathetick sensations'. Gainsborough also

Fig. 13
Moonlit Landscape
with Cottage
*c*1781–2. Transparency
on glass, 27.9 x 33.7 cm.
Victoria and Albert
Museum, London

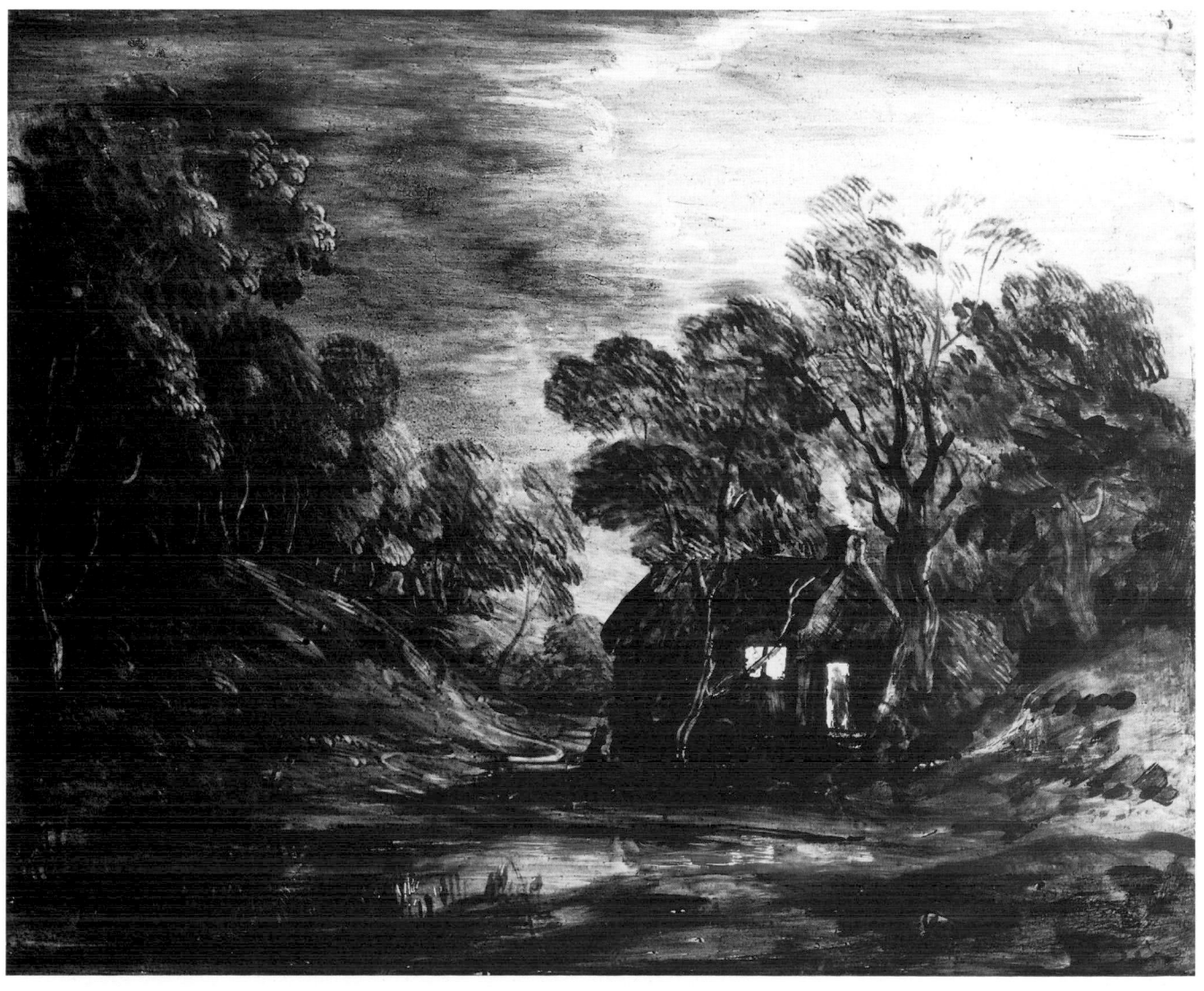

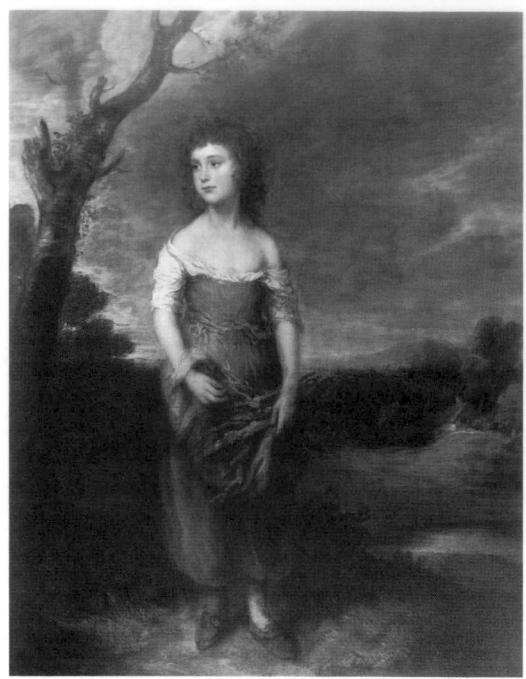

Fig. 14
Peasant Girl
Gathering Sticks in
a Wood
1782. Oil on canvas,
169 x 123 cm.
Manchester City Art
Gallery, Manchester

found direct artistic inspiration in the work of the seventeenth-century Spanish painter, Bartolmé Estebán Murillo (c1617–82) (Fig. 34), whose pictures of ragged peasant youths were generally popular at this time and of specific interest to Gainsborough (see Fig. 15).

Although the fancy pictures were a new departure in English painting, they sold well and at some of Gainsborough's highest prices. The *Girl with Dog and Pitcher* (Plate 46) went for 200 guineas and Reynolds himself bought the *Girl with Pigs* (Plate 34) for 100 guineas. Gainsborough wrote to Reynolds in thanks: 'I may truly say I have brought my Piggs to a fine market.' Out of 16 finished fancy pictures only seven remained in the studio on his death. This should be compared with Gainsborough's consistent failure to sell his landscapes: only ten of the 55 known landscapes of the London period were bought in Gainsborough's lifetime and some of the most praised and famous paintings, for example, *The Watering Place* (Plate 27) remained unsold.

One motive for Gainsborough's exploration of new subject-matter was his sense that, although at the peak of his profession, when judged against the standard of the grand manner, he would still be found wanting. According to this school of thought, which dominated Reynolds's Royal Academy, portraiture and landscape were intrinsically inferior when compared to depictions of significant events from myth, religion and history. The problem for every English painter was, as Gainsborough wrote in an impatient response to one of Reynolds's lectures, that, 'Sir Joshua either forgets, or does not chuse [to] see that his Instruction is all adapted to form the History Painter, which he must know there is no call for in this country.' Such paintings were even less of a practical possibility than landscapes. Gainsborough was also entirely out of sympathy with the literary and philosophical pretentiousness of what passed for modern history painting. He had as deep a respect for the Old Masters as Reynolds, but his attitude towards them was never academic and always remained rooted in his own development as a painter. Gainsborough only ever attempted one painting based on a traditional story, *Diana and Actaeon* (Plate 47 and Fig. 41), and that was never seen by his colleagues or the public. His more characteristic solution to this problem was his fancy picture, which sprang from his specific interests in the world around him and explored themes that were close to his own, and the period's, sentimental heart. Given their size, their price tags and the evident seriousness with which the subjects were treated, it is not unreasonable to see the fancy pictures as Gainsborough's attempt to create an alternative, entirely contemporary grand manner. What English art was, and would become, was as much due to Gainsborough, in whom the spirit of Hogarth's St Martin's Lane school lived on, as the official pronouncements of the Royal Academy. Reynolds himself admitted this: 'If ever this nation should produce genius sufficient to acquire to us the honourable distinction of an English School, the name of Gainsborough will be transmitted to posterity…among the very first of that rising name.'

Fig. 15
Two Beggar Boys
1785. Oil on canvas,
73.7 x 63.5 cm.
Private collection

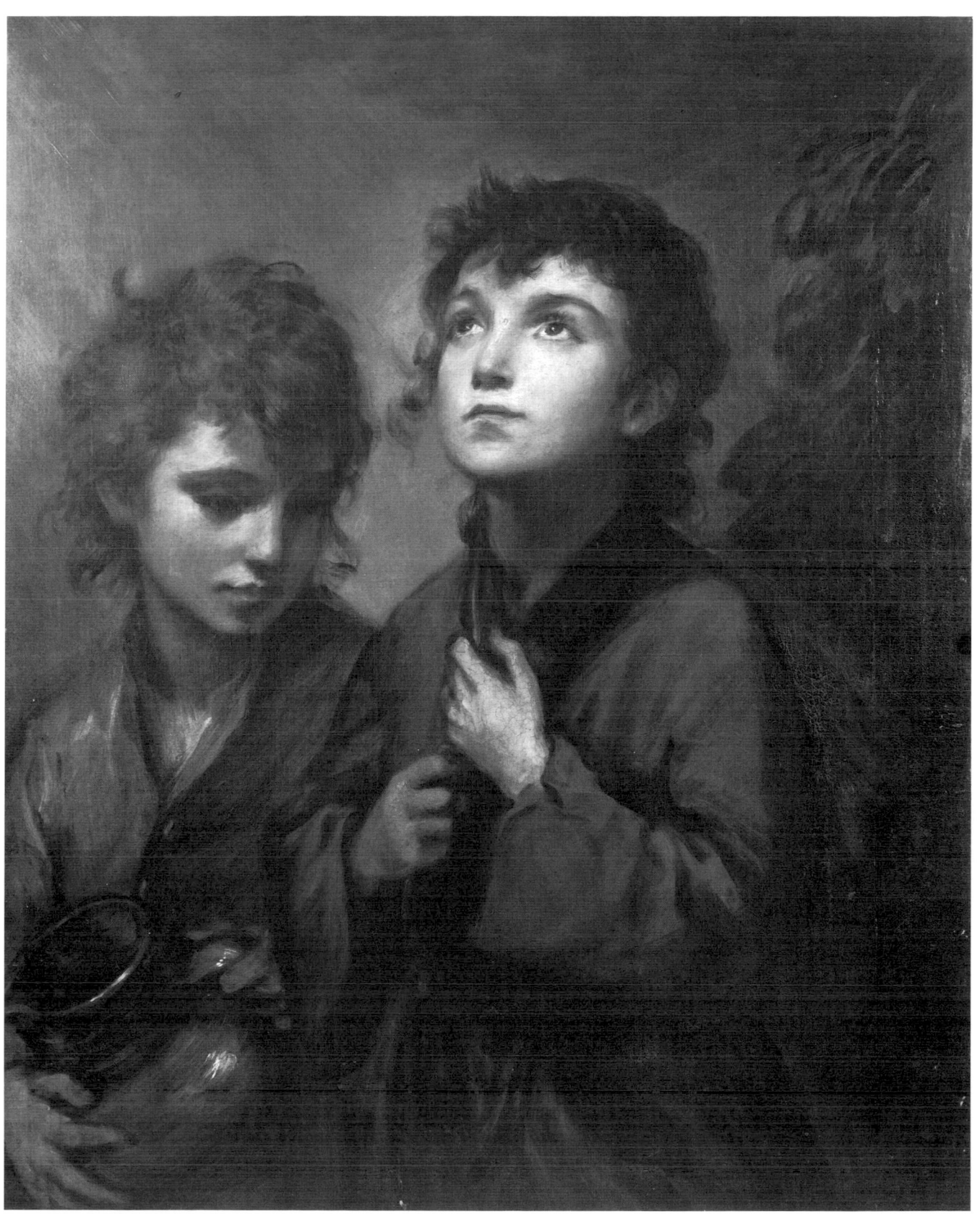

Outline Biography

1727 Thomas Gainsborough born in Sudbury, Suffolk.

1740 Sent to London to train as a painter.

1746 Marries Margaret Burr.

1748 Presents *The Charterhouse* to the Foundling Hospital. Returns to Sudbury.

1752 Moves to Ipswich, Suffolk; befriended by Philip Thicknesse.

1759 Moves to Bath, Somerset.

1761 First painting (a portrait) exhibited at the Society of Artists in London.

1763 Falls seriously ill through overwork.

1768 Invited by Reynolds to become a founder member of the Royal Academy.

1769 Exhibits (portraits and one landscape) at the first Royal Academy show.

1773 Row with Royal Academy over hanging of his pictures, does not exhibit from 1773–76.

1774 Leaves Bath and moves to Schomberg House, London.

1777 Returns triumphantly to the Royal Academy exhibition. Exhibits include a portrait of the King's brother, the Duke of Cumberland.

1781 Exhibits his first fancy picture at the Royal Academy and full-lengths of King George III and Queen Charlotte.

1783 Goes on a sketching trip to the Lake District.

1784 Dispute with Hanging Committee of Royal Academy; withdraws his paintings and never exhibits there again. Holds his own show at Schomberg House in the summer.

1788 Visited by Reynolds during his last illness; dies 2 August and is buried in Kew Churchyard.

Select Bibliography

William T Whitely, *Thomas Gainsborough*, London, 1915

Ellis Waterhouse, *Gainsborough*, 2nd edn, London, 1960

Mary Woodall (ed.), *The Letters of Thomas Gainsborough*, 2nd edn, London, 1963

John Hayes, *The Drawings of Thomas Gainsborough*, 2 vols., London, 1970

Luke Herrmann, *British Landscape Painting of the Eighteenth Century*, London, 1973

John Hayes, *Gainsborough's Paintings and Drawings*, London, 1975

Lindsay Stainton, *Gainsborough and his Musical Friends*, exhibition catalogue, Iveagh Bequest, Kenwood, London, 1977

John Barrell, *The Dark Side of the Landscape*, Cambridge, 1980

John Hayes, *Thomas Gainsborough*, exhibition catalogue, Tate Gallery, London, 1980

Robert R Wark (ed.), *Reynolds's Discourses on Art*, 2nd edn, New Haven and London, 1981

John Hayes, *Gainsborough's Landscape Paintings*, 2 vols., London, 1982

Ann Bermingham, *Landscape and Ideology*, London, 1987

Elizabeth Einberg and Rica Jones, *Manners and Morals*, exhibition catalogue, Tate Gallery, London, 1987

Philippa Bishop and Ann Sumner, *Gainsborough in Bath*, exhibition catalogue, Holburne of Menstrie Museum, Bath, 1988

Malcolm Cormack, *The Paintings of Thomas Gainsborough*, Cambridge, 1991

Ellis Waterhouse, *Painting in Britain 1530–1790*, 5th edn, London, 1993

List of Illustrations

Colour Plates

25 The Hon Frances Duncombe
c1775–7. Oil on canvas, 234.3 x 155.2 cm.
Frick Collection, New York, NY

26 Henry Frederick, Duke of Cumberland
1777. Oil on canvas, 238.1 x142.2 cm.
Royal Collection

27 The Watering Place
1777. Oil on canvas, 147.3 x 180.3 cm.
National Gallery, London

28 Carl Friedrich Abel
1777. Oil on canvas, 223.5 x 147.3 cm.
Henry E Huntington Library and Art Gallery,
San Marino, CA

29 Pomeranian Bitch and Pup
c1777. Oil on canvas, 83.2 x 111 cm.
Tate Gallery, London

30 Louisa, Lady Clarges
1778. Oil on canvas, 126 x 100.5 cm.
Holburne Museum and Crafts Centre, Bath

31 Philip James de Loutherbourg
1778. Oil on canvas, 75.6 x 62.9 cm.
Dulwich Picture Gallery, London

32 Mrs Gainsborough
c1778. Oil on canvas, 76.8 x 64.1 cm. Courtauld
Institute Galleries, University of London, London

33 The Cottage Door
1780. Oil on canvas, 147.3 x 119.4 cm.
Henry E Huntington Library and Art Gallery,
San Marino, CA

34 Girl with Pigs
1782. Oil on canvas, 125.6 x 148.6 cm.
Castle Howard, Yorkshire

35 Miss Haverfield
c1782. Oil on canvas, 126 x 101 cm.
Wallace Collection, London

36 Giovanna Baccelli
1782. Oil on canvas, 226.7 x 148.6 cm.
Tate Gallery, London

37 Coastal Scene – a Calm
1783. Oil on canvas, 156.2 x 190.5 cm.
National Gallery of Victoria, Melbourne

38 The Mall
1783. Oil on canvas, 120.7 x 147 cm.
Frick Collection, New York, NY

39 Mountain Landscape with Shepherd
1783. Oil on canvas, 120 x 148.6 cm.
Neue Pinakothek, Munich (on loan from
Bayerische Landesbank, Munich)

40 Shepherd Boys with Dogs Fighting
1783. Oil on canvas, 223.5 x 157.5 cm.
Iveagh Bequest, Kenwood, London

41 The Three Elder Princesses
1784. Oil on canvas, 129.5 x 179.8 cm.
Royal Collection

42 Dogs Chasing a Fox
1784–5. Oil on canvas, 177.8 x 236.2 cm.
Iveagh Bequest, Kenwood, London

43 Mrs Siddons
1785. Oil on canvas, 126.4 x 99.7cm.
National Gallery, London

44 Mrs Sheridan
1785. Oil on canvas, 219.7 x 153.7 cm.
National Gallery of Art, Washington DC

45 The Morning Walk (Mr and Mrs Hallet)
1785. Oil on canvas, 236.2 x 179.1 cm.
National Gallery, London

46 Girl with Dog and Pitcher
1785. Oil on canvas, 174 x 124.5 cm.
National Gallery of Ireland, Dublin

47 Diana and Actaeon
c1785. Oil on canvas, 158.1 x 188 cm.
Royal Collection

48 The Market Cart
1786. Oil on canvas, 184.2 x 153 cm.
National Gallery, London

Text Illustrations

Comparative Figures

28 SIR PETER PAUL RUBENS
Shepherd with his Flock
*c*1620. Oil on panel, 63.9 x 94.3 cm.
National Gallery, London

29 SIR JOSHUA REYNOLDS
Master Thomas Lister (detail)
1764. Oil on canvas, 231 x 147.5 cm.
Bradford City Art Gallery and Museum, Bradford

30 Lords John and Bernard Stuart
(after Van Dyck)
Mid-1760s. Oil on canvas, 235 x 146.1 cm.
St Louis Art Museum, St Louis, MI

31 Queen Charlotte
1781. Oil on canvas, 238.8 x 158.7 cm.
Royal Collection

32 SIR PETER PAUL RUBENS
The Watering Place
*c*1620. Oil and black chalk on oak panel,
98.7 x 135 cm. National Gallery, London

33 The Cottage Door
*c*1778. White chalk on paper, 27 x 34.5 cm.
Private collection

34 BARTOLOMÉ ESTEBAN MURILLO
The Young Beggar
*c*1645–50. Oil on canvas, 137 x 115 cm.
Musée du Louvre, Paris

35 SIR JOSHUA REYNOLDS
Miss Bowles
*c*1775. Oil on canvas, 91 x 71 cm.
Wallace Collection, London

36 Coast Scene, Selling Fish
1781. Oil on canvas, 100.3 x 127 cm.
Grosvenor Estates Company, London

37 ANTOINE WATTEAU
Gathering in a Park
1716–17. Oil on panel, 32.4 x 46.4 cm.
Musée du Louvre, Paris

38 JEAN HONORÉ FRAGONARD
The Shady Avenue
*c*1773. Oil on panel, 29 x 24 cm.
Metropolitan Museum of Art, New York, NY

39 FRANS SYNDERS
The Fox Hunt
*c*1640. Oil on canvas, 202 x 330 cm.
Methuen Collection, Corsham Court, Wiltshire

40 SIR JOSHUA REYNOLDS
Mrs Siddons as the Tragic Muse
1784. Oil on canvas, 236.2 x 146 cm. Henry E
Huntington Library and Art Gallery, San Marino, CA

41 Study for Diana and Actaeon
1784–5. Black chalk, grey and brown wash and
gouache on paper, 27.5 x 35.6 cm.
Cecil Higgins Art Gallery, Bedford

42 JOHN CONSTABLE
The Haywain
1821. Oil on canvas, 130 x 185 cm.
National Gallery, London

The Painter and his Wife(?)

*c*1746–7. Oil on canvas, 73 x 68 cm. Musée du Louvre, Paris

This couple, traditionally identified as Gainsborough and his new wife Margaret, could almost be from a painting by the creator of the *fête-galante*, Watteau (Fig. 16). Gainsborough said Watteau was 'a very fine Painter' and the Frenchman's park scenes with gallant lovers were a recurrent source of inspiration to him (see Plate 38). Here, the decorative leafy setting, complete with an Arcadian temple, and Gainsborough's scintillating handling of paint, are all qualities characteristic of Watteau and the French Rococo. Gainsborough received his earliest training at the heart of England's own Rococo movement, and, through his teacher, the French designer Gravelot, he had a direct link to the source of this style.

The opportunity to engage in amorous conversation in the natural charms of a park existed in fact as well as in painted fiction. Pleasure-gardens, such as Vauxhall (Fig. 17), were popular London entertainments.

Fig. 16
ANTOINE WATTEAU
Pilgrimage to the
Island of Cythera
1717. Oil on canvas,
129 x 194 cm. Musée du
Louvre, Paris

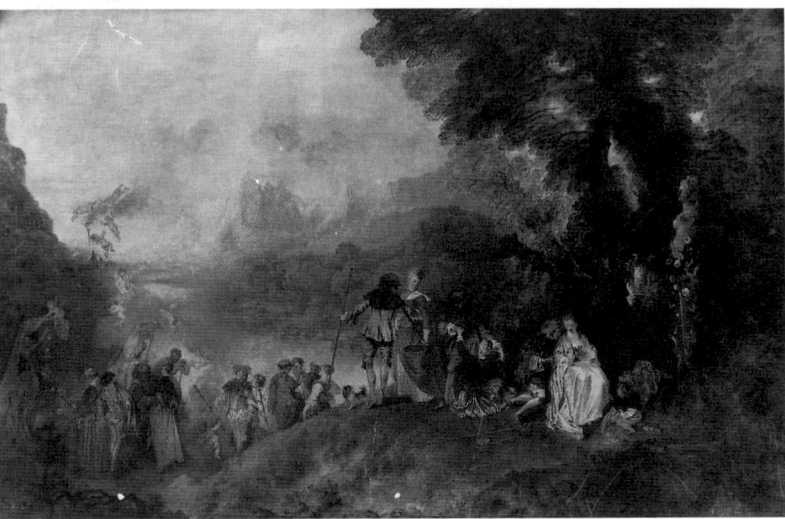

Fig. 17
EDWARD ROOKER
(after Canaletto)
View of the Centre
Walk at Vauxhall
Gardens
1751. Engraving and
etching, 22.9 x 38.8 cm.
Museum of London,
London

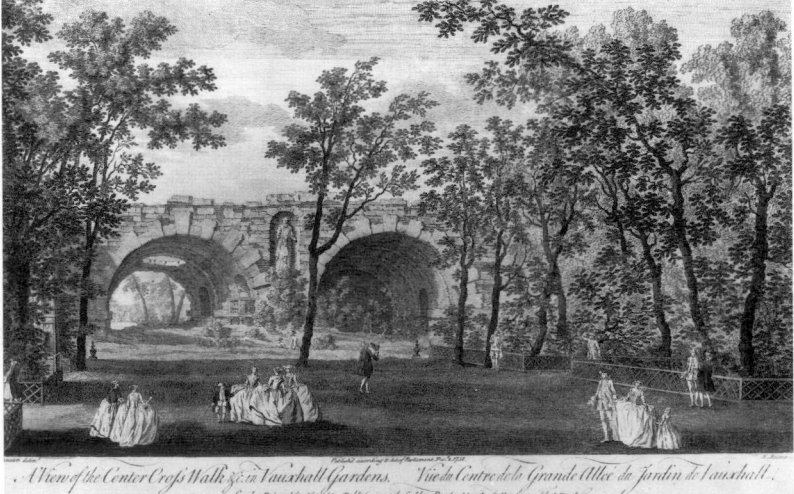

Gainsborough's Forest (Cornard Wood)

*c*1746–7. Oil on canvas, 121.9 x 154.9 cm. National Gallery, London

In 1788 Gainsborough wrote to his friend, the newspaper editor, Henry Bate, describing this picture as 'an early instance how strong my inclination stood for Landskip'. The overwhelming influence on Gainsborough's first landscapes were the pictures of the Dutch seventeenth-century painters, in particular, Ruisdael and Wynants. It was in the 1740s that Dutch landscapes first entered the London art market in any number and Gainsborough may have earned some hack money at this time by repairing and adding figures to them in the salerooms.

In this example, the idea of a massive screen of towering trees, opening to reveal a view in the far distance seems to derive from Ruisdael (Fig. 18). The sandy bank and vegetation of dock leaves and thistles are reminiscent of Wynant's foregrounds. Gainsborough, of course, also made his own studies from nature when he could (see Plate 3) and all the contemporary accounts emphasize his love for the rural surroundings of his childhood. The various people and animals scattered around the picture – the staffage – are again Dutch in inspiration. The forest does seem a little overcrowded with activity, and it is hard to suggest a specific visual focus, a judgment Gainsborough himself made: 'It may be worth remark that though there is very little idea of composition in the picture, the touch and closeness to nature in the study of the parts and *minutiae* are equal to any of my latter productions.'

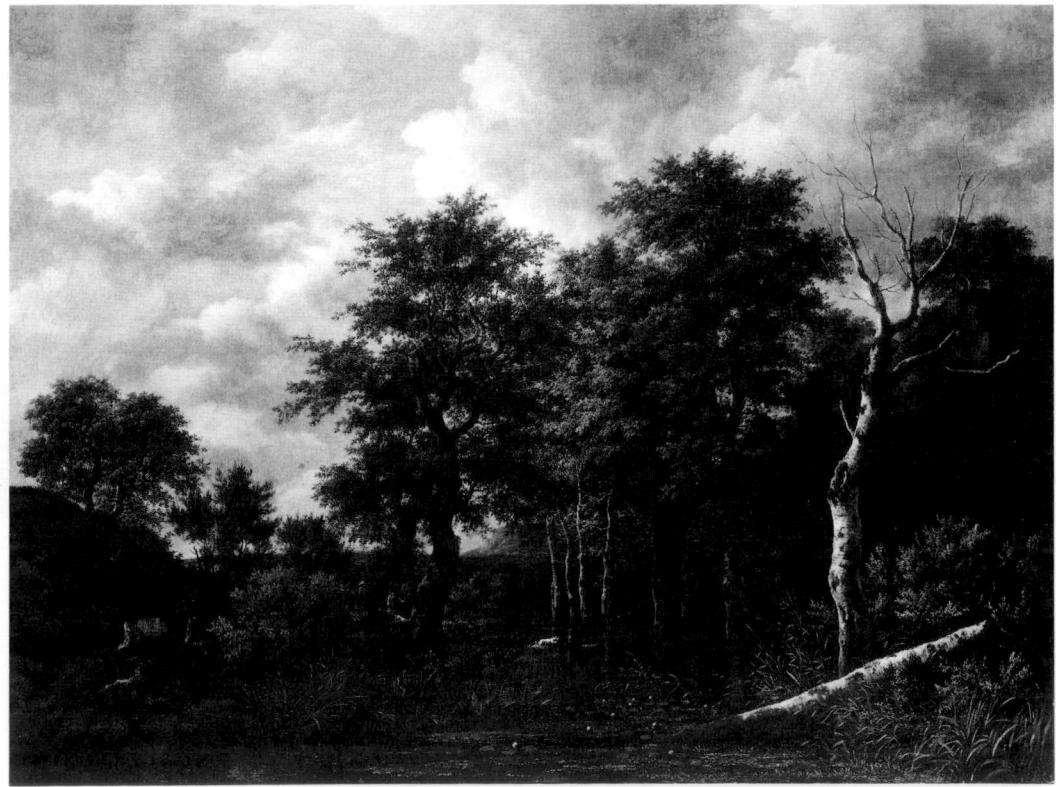

Fig. 18
JACOB VAN RUISDAEL
A Pool Surrounded
by Trees
*c*1665–70. Oil on canvas,
107.5 x 142.9 cm.
National Gallery, London

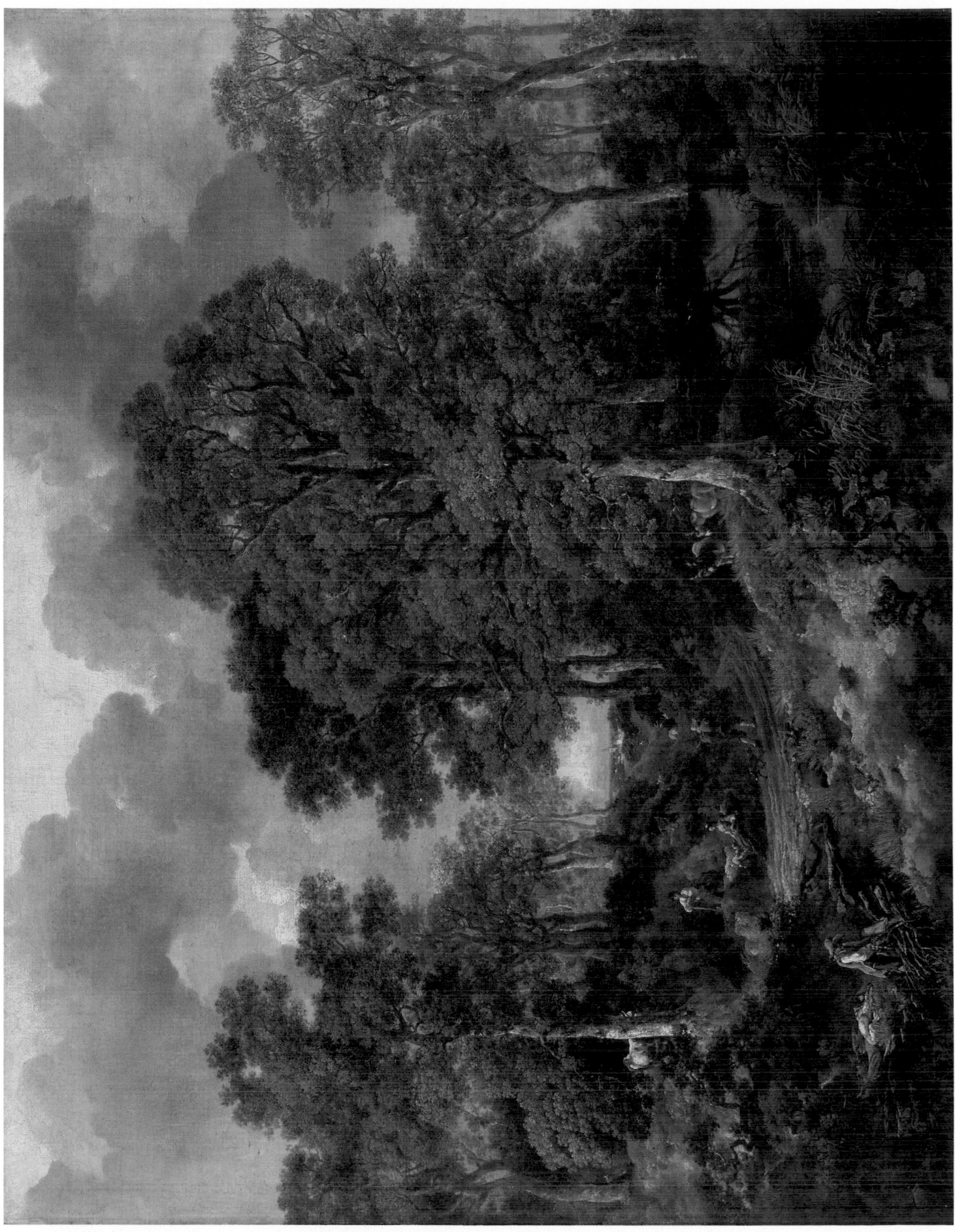

Study of Burdock Leaves

Late 1740s. Black chalk on paper, 13.8 x 18.6 cm. British Museum, London

Although Gainsborough undoubtedly sketched outdoors in front of the motif, he always saw nature with the eye of an artist, not a botanist. This tiny vignette of landscape is a composition, not a random patch of vegetation; the control of the artist is evident in the arrangement of form and in the play of light and shade across the paper. The burdock leaves, surrounded by swiftly executed indications of grass and tree trunk, show Gainsborough's exploitation of the plant's curvilinear and asymmetrical form. The scalloped bottom edge of the middle leaf, and the irregular silhouette of the largest leaf, could almost have been drawn by a Rococo draughtsman for some decorative design.

Broad, handsome leaves such as these were also a common feature in the foregrounds of the Dutch seventeenth-century landscapes which greatly influenced Gainsborough at this time. He frequently included similar plants in his own landscapes, such as *Gainsborough's Forest (Cornard Wood)* (Plate 2).

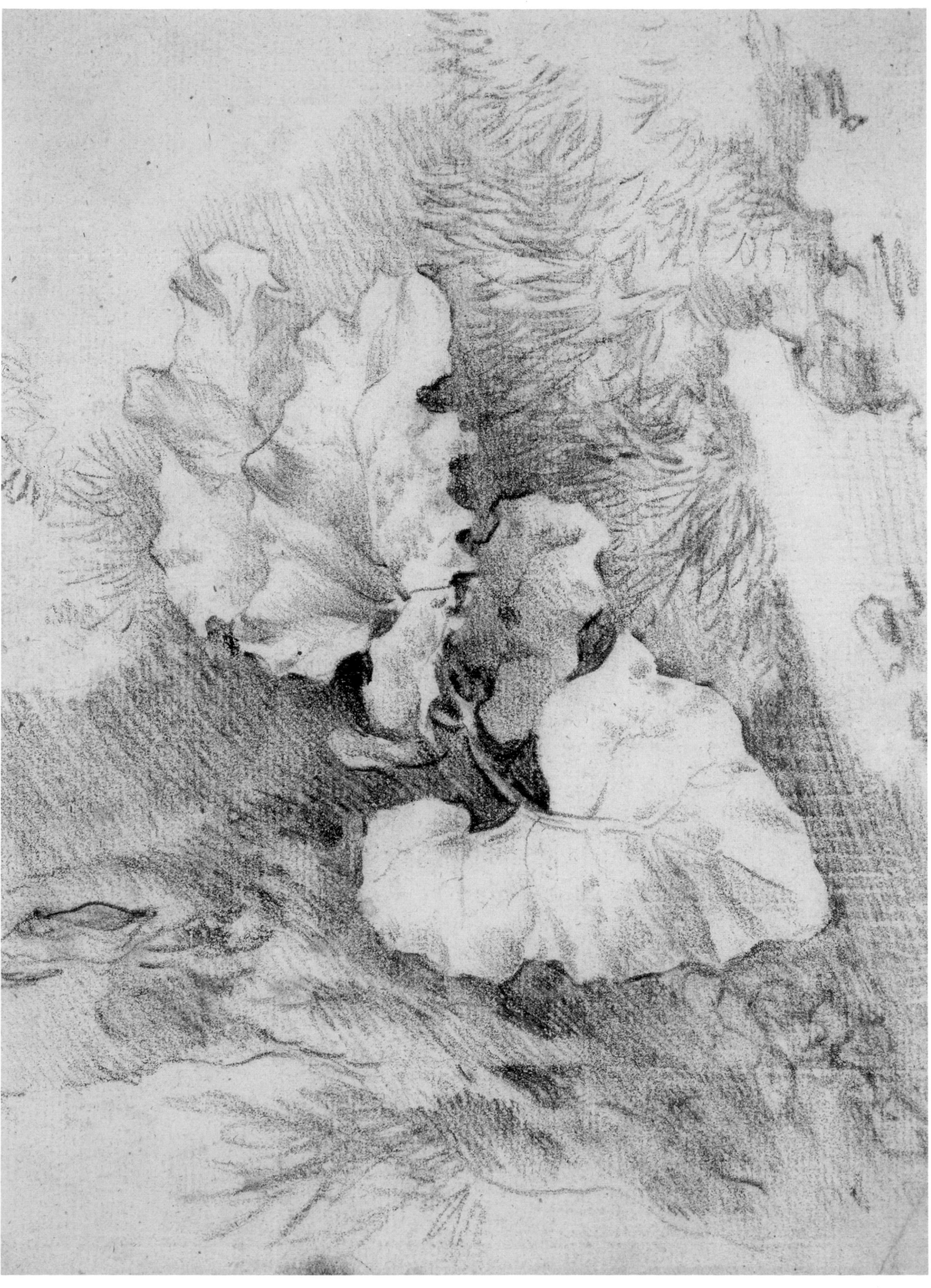

Landscape with Sandpit

*c*1746–7. Oil on canvas, 47 x 61 cm. National Gallery of Ireland, Dublin

Like *Gainsborough's Forest (Cornard Wood)* (Plate 2), this picture demonstrates Gainsborough's skillful absorption of the compositional structure and motifs he saw in Dutch landscapes of the preceding century. Here, the sandy banks and twisting rutted track are particularly reminiscent of the work of Wynants (Fig. 19), although Gainsborough's handling of paint is less tight (especially in the sky) and his colours have a lightness typical of the Rococo style. Gainsborough, like Wynants before him, has painted a very ordinary scene, in that it is without significant human action and has no dramatic landscape features nor vast panoramas to scan. Gainsborough finds his subject in the constant movement and life of nature, suggested by the scudding clouds, windswept scrub and fitful patterns of light and shade. Although relatively small, both these pictures convey a palpable sense of space and atmosphere.

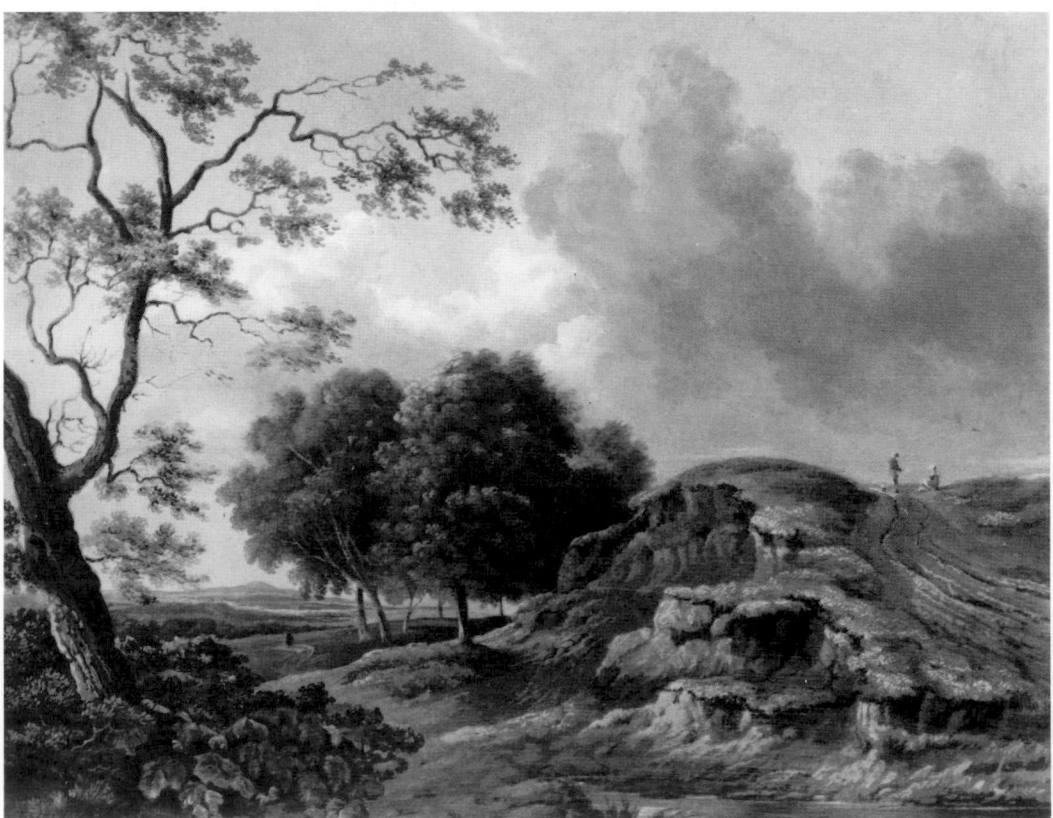

Fig. 19
JAN WYNANTS
Landscape
1660s. Oil on panel,
15.8 x 18.8 cm. Dulwich
Picture Gallery, London

*c*1748–9. Oil on canvas, 69.9 x 119.4 cm. National Gallery, London

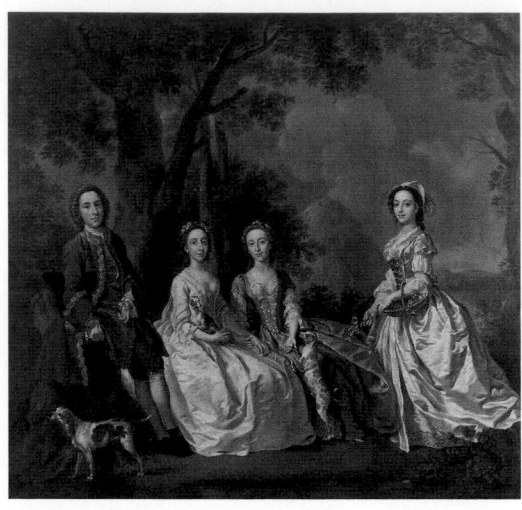

Fig. 20
FRANCIS HAYMAN
The Jacob Family
*c*1743–4. Oil on canvas,
96.5 x 108 cm.
Private collection

Painted soon after Gainsborough's return to Suffolk, this picture was probably commissioned to mark the marriage of Robert Andrews (?1726–1806) to Frances Carter (*c*1723–80) which took place in November 1748 at All Saints, Sudbury.

Small-scale groups of figures in outdoor settings, popular since the early 1730s, can be seen as an anglicization of the French park scenes of Watteau and his followers, transformed to serve the needs of portraiture, the staple of English art. Hogarth and Hayman, who set the fashion for the earlier generation, popularized these conversation pieces (Fig. 20), which suited both the customers' desire for a more informal image of themselves and the artists' allegiance to avant-garde style. In its mood, detail and overall silvery tonality, Gainsborough's painting is, on one level, a perfect expression of this essentially Rococo type of portrait. Mr Andrews is negligently slouched, a conventional pose of contemporary deportment, while Mrs Andrews is daintily prim in icing sugar pink slippers, her powder-blue skirts echoing the twisting curves of the garden seat and a ribbon casually straying from her modish shepherdess's bonnet. Cool beige ground can be seen in the unfinished patch on Mrs Andrews's lap. But this image is much more than a charming and fashionable souvenir of two newlyweds. The setting, given a prominence equal to the doll-like figures, is not a backdrop of fictitious parkland, but a freshly observed depiction of well-managed and productive fields, presumably the Auberies, the Andrews's estate outside Sudbury. For both the period in general, and for Gainsborough himself, this is an exceptionally naturalistic landscape.

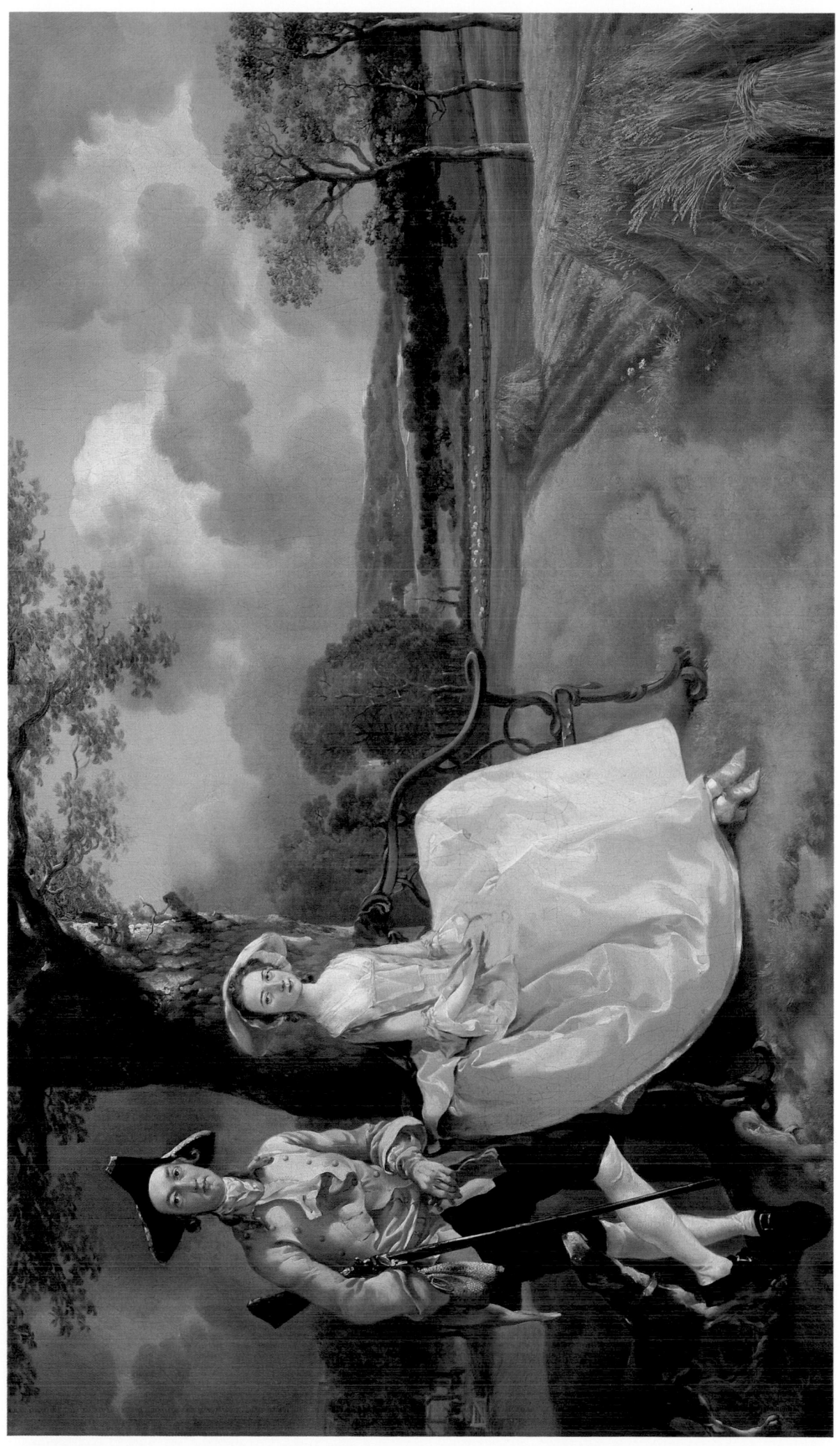

John Kirby

*c*1752–3. Oil on canvas, 75.9 x 63.5 cm. Fitzwilliam Museum, Cambridge

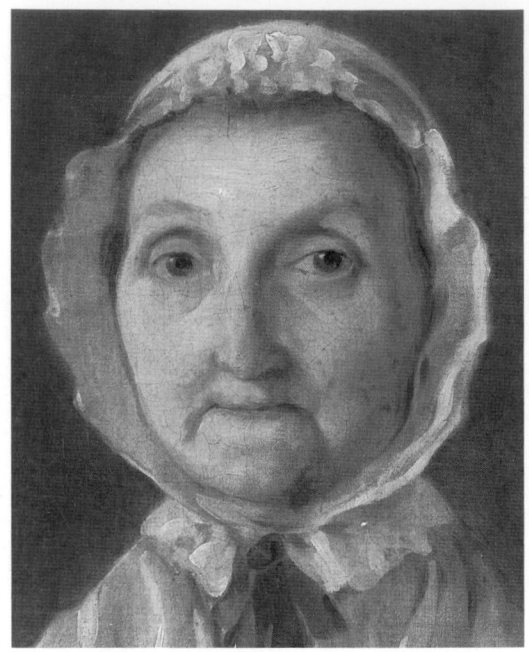

Fig. 21
Alice Kirby (detail)
1759. Oil on canvas,
76.2 x 63.5 cm.
Fitzwilliam Museum,
Cambridge

John Kirby (1690–1753) and Alice Kirby (Fig. 21) were the parents of Gainsborough's lifelong friend, the Ipswich painter, Joshua Kirby (1716–74). It was through Joshua, who had taught George III perspective, that Gainsborough probably received his first introduction to the Royal Family. Joshua Kirby's son may have studied painting for a short time with Gainsborough in the 1750s.

In comparison with conversation pieces of this period, which create an image of the sitter with the aid of charming accessories, setting and a sense of fashion (see Plate 7), this portrait is very straightforward and naturalistic. John Kirby is shown at a slight angle against a plain coloured background. Light coming in obliquely from the left emphasizes the slight turn of his head, an effect which gives the face great immediacy and liveliness. Although the flesh is not highly finished (the texture is rough, with slabs of colour broadly painted in) the delineation of his features is quite definite. Indeterminacy of outline was often used by Gainsborough to create the likeness and suggest fleeting expression (see Plate 19), but on this occasion he has transcribed his subject with certainty, as if to convey his confidence in Kirby's intelligence, kindness and firmness of character.

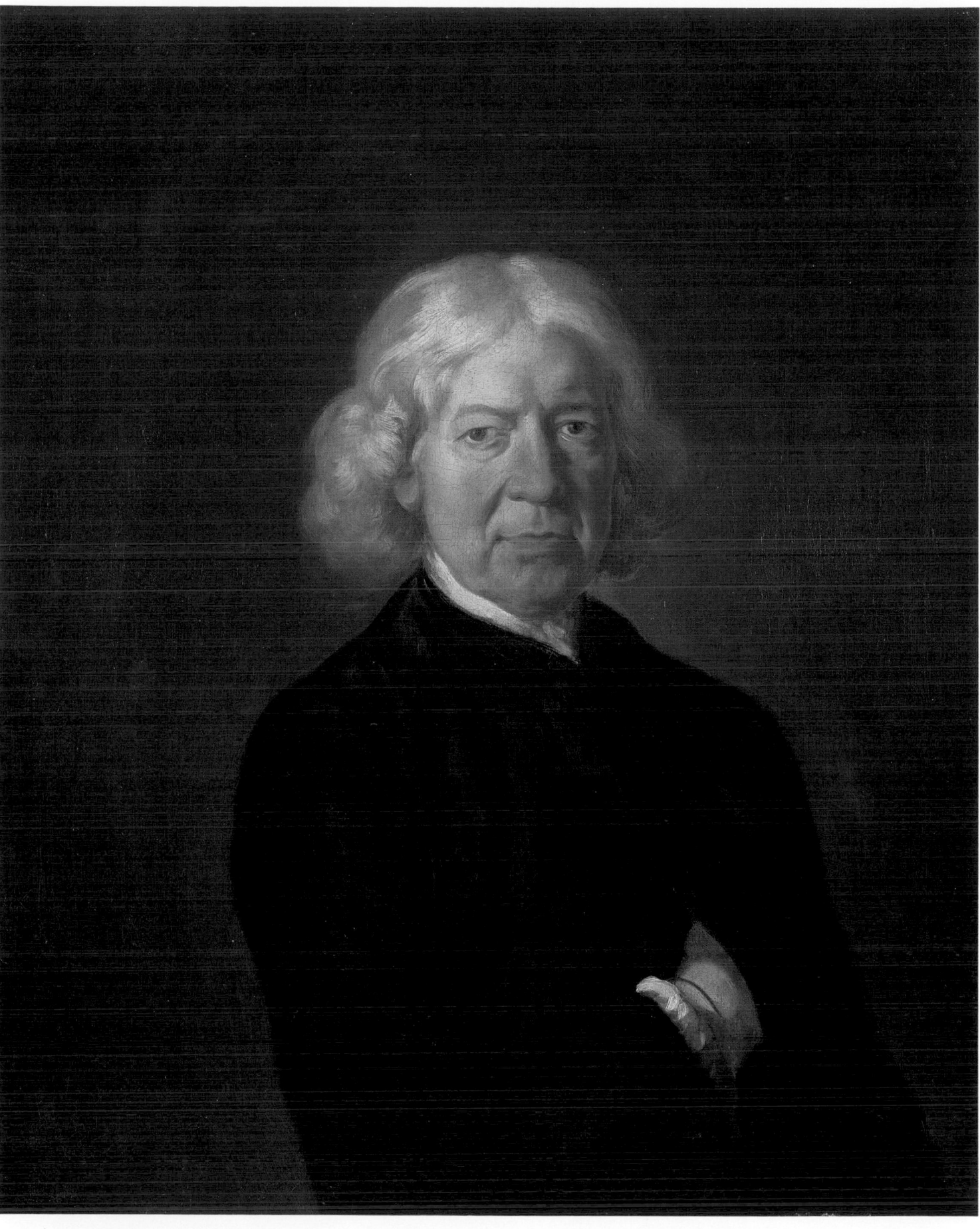

John Plampin

*c*1753–4. Oil on canvas, 50.2 x 60.3 cm. National Gallery, London

In contrast to *Mr and Mrs Andrews* (Plate 5), the outdoor setting in this portrait of another local landowner, John Plampin (*c*1727–1805), is generalized, in keeping with the intended ambience and style of the picture. Sitter and landscape are in perfect harmony; nature echoes the naturally casual man, the radiating branches of the tree continuing the pattern set by Plampin's extended legs. The distinctive pose, emblematic of the insouciance of Rococo portraiture, ultimately derives from Watteau's portrait of Antoine de la Roque, which was well known through an engraving. Closer to home, Hayman had used this position several times in his supper-box paintings for Vauxhall Gardens in the early 1740s, a project with which Gainsborough may have been involved as an assistant. When Hayman returned to the pose in the mid-1750s (see Fig. 22), the influence had become reciprocal, with Hayman learning from the younger man how to enhance the figure's air of informal abandon with a rustic setting. Hayman's portrait was once attributed to Gainsborough and is traditionally supposed to be of Gainsborough's Ipswich friend, Philip Thicknesse, but the work lacks the sense of unity between man and nature that Gainsborough, unlike most of his contemporaries, seemed to achieve with ease.

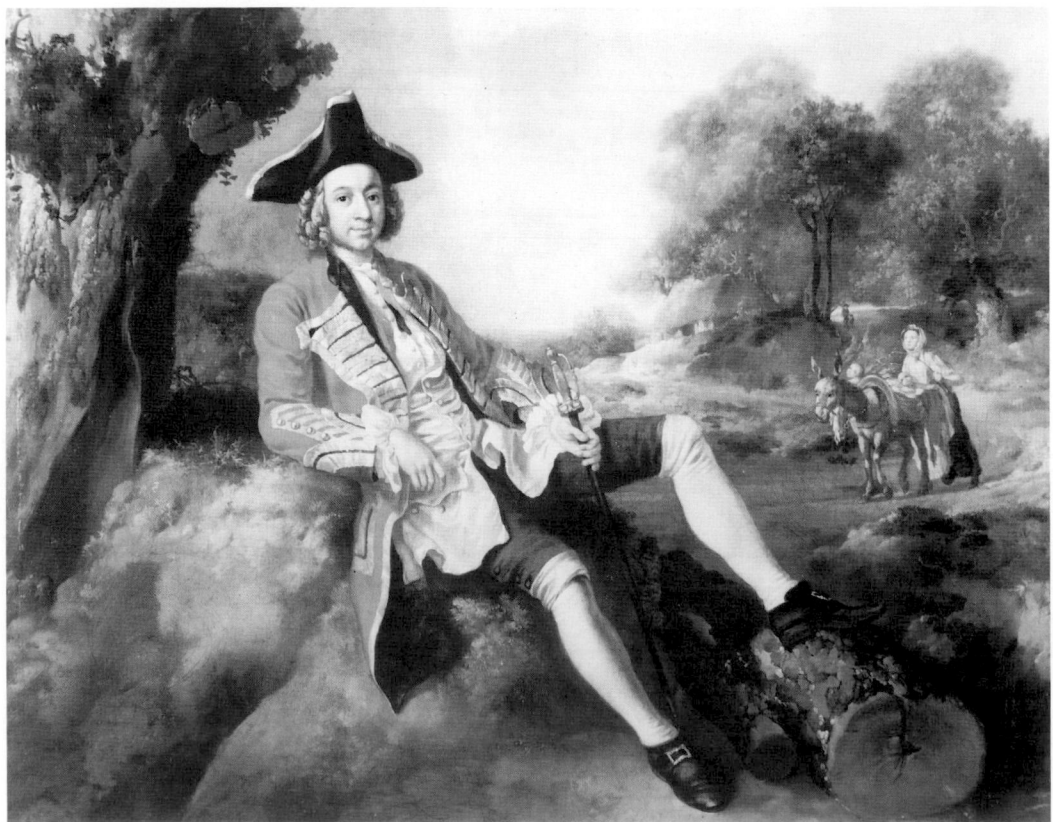

Fig. 22
FRANCIS HAYMAN
Philip Thicknesse
Mid-1750s. Oil on canvas,
62.3 x 74.3 cm. St Louis
Art Museum, St Louis, MI

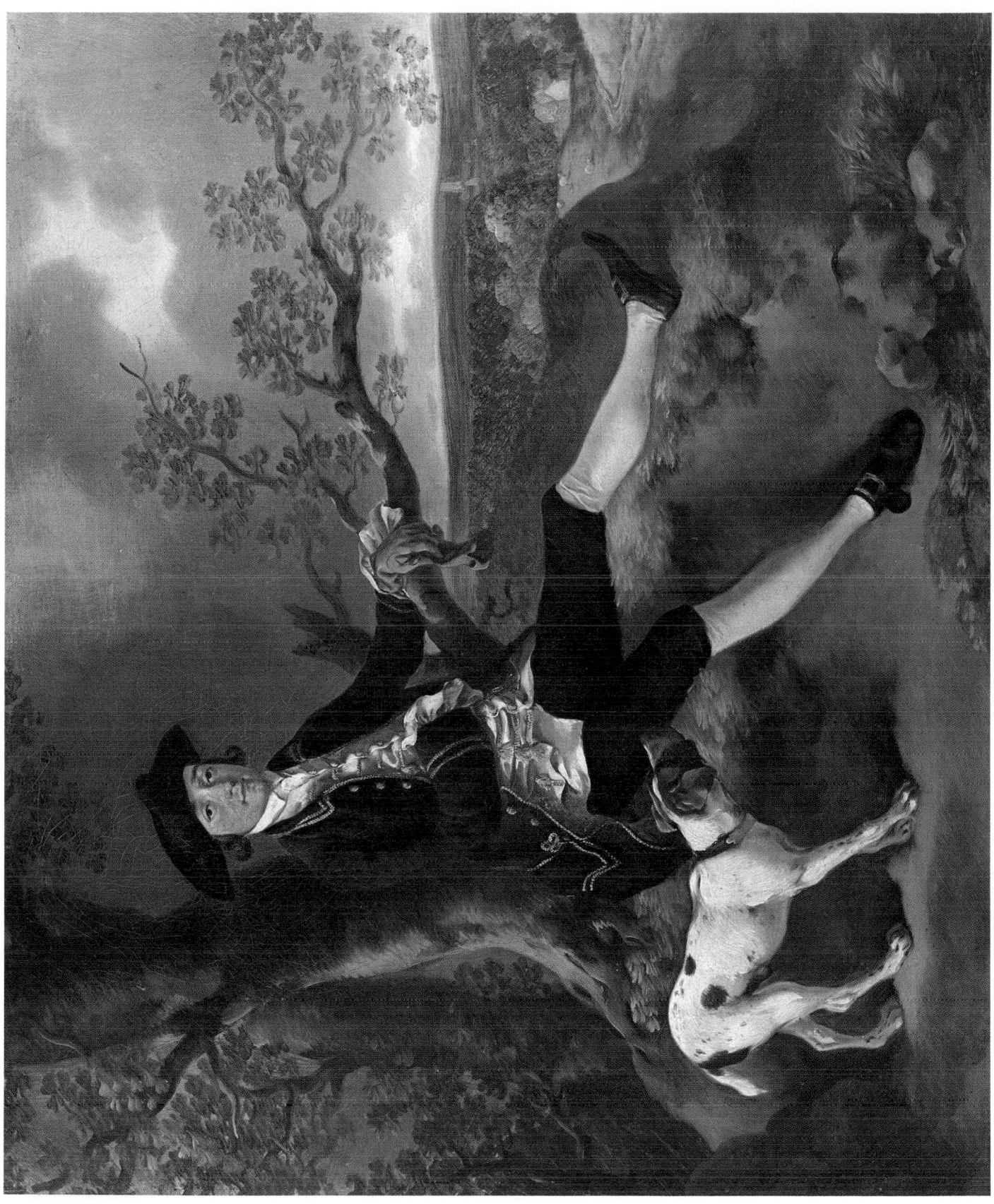

River Landscape with Rustic Lovers

*c*1754–6. Oil on canvas, 94 x 125.7 cm. St Louis Art Museum, St Louis, MI

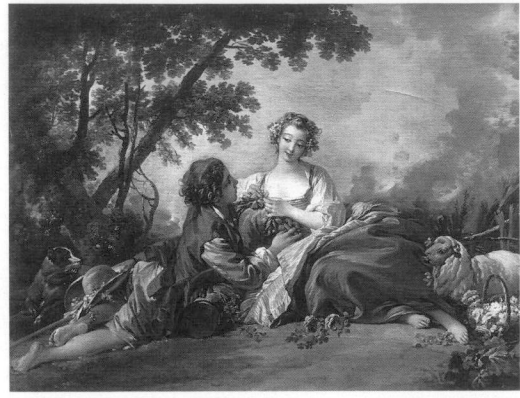

Gainsborough's landscapes of the 1750s are more playful and Rococo in terms of composition than his works of the previous decade, but they still include his repertoire of Dutch motifs perfected in the late 1740s – sandy banks, dock leaves, rutted tracks and gnarled trees (see Plates 2 and 4). Here, the tree on the left is an obvious framing device, mirrored by the fallen trunk on the right. The numerous, and highly artificial, protuberances of the landscape are structured to visual effect, rather than attempting the illusion of a naturalistic view. The young couple, quite unobtrusive in the foreground, are the key to Gainsborough's shift in style. Like the lovers in paintings by Boucher (Fig. 23) or Fragonard (Fig. 24), the country setting creates the conditions for their encounter. But, unlike his French counterparts, Gainsborough is still primarily interested in the landscape, using it to express his new decorative intent rather than exploring pastoral romance itself.

Fig. 23
FRANÇOIS BOUCHER
The Bagpipes
1753. Oil on canvas,
88 x 115 cm. L'Assemblée
Nationale, Paris

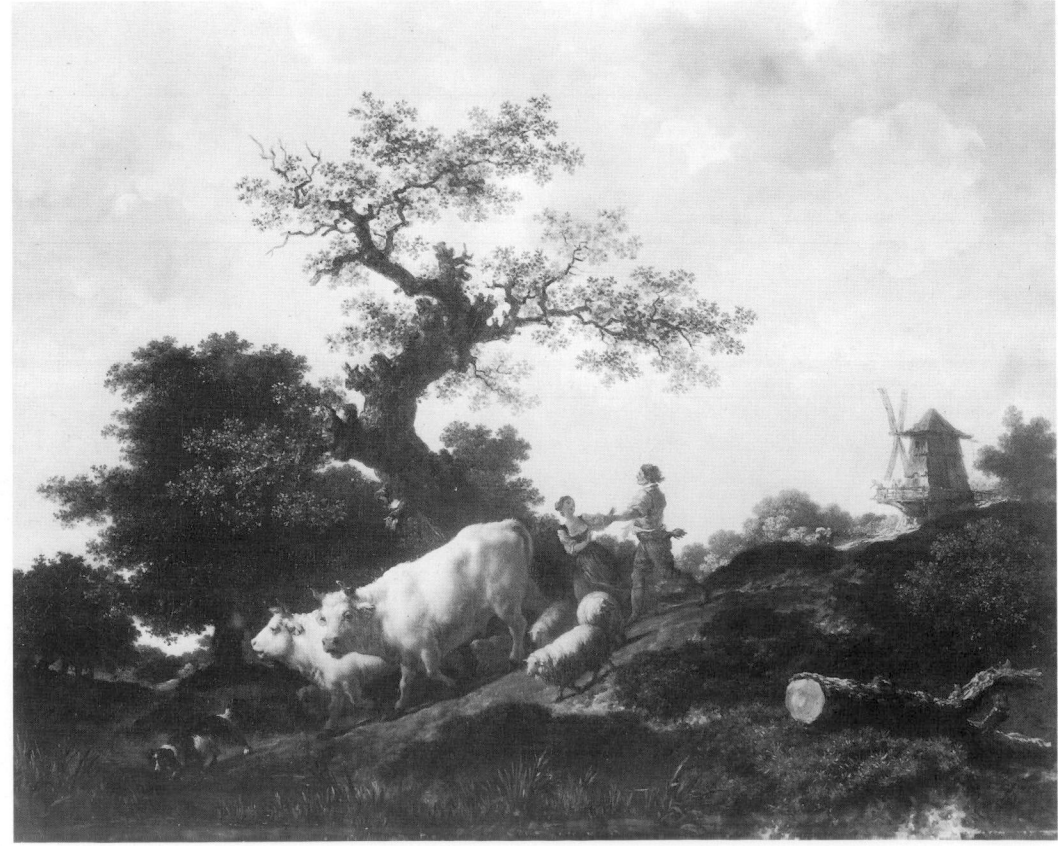

Fig. 24
JEAN HONORÉ
FRAGONARD
Return of the Herd
*c*1765. Oil on canvas,
65 x 80 cm. Worcester Art
Museum, Worcester, MA

*c*1756. Oil on canvas, 113.5 x 105 cm. National Gallery, London

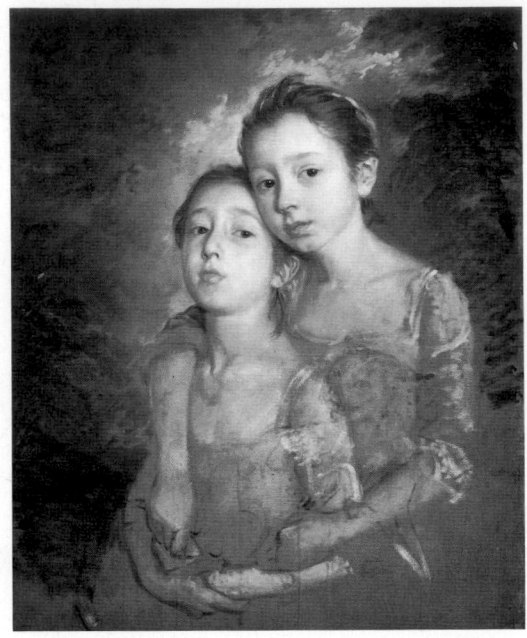

Fig. 25
The Painter's
Daughters Holding
a Cat
*c*1759. Oil on canvas,
75 x 62 cm. National
Gallery, London

Mary (1748–1826) and Margaret (1752–1820) were frequently painted by Gainsborough (see Fig. 25), who seems to have been a devoted father, frequently referring to them as 'Molly' and 'the Captain' in his letters. The image of the sisters pursuing a butterfly is suggestive of the transience of childhood, but the action is also persuasively natural and reveals the different characters of the girls, making this a compelling double portrait, Margaret, a mere baby, grasps at the butterfly with no sense of consequence while Mary is more reserved and self-conscious. Sadly, the girls, when adult, caused Gainsborough considerable parental woe. In a letter to his sister, Mrs Gibbon, in 1775, Gainsborough complains that Margaret is 'Insolent and proud in her behaviour to me at times' and describes how Mary had been corresponding secretly with the oboist, Johann Christian Fischer: 'Oh, d–n him, he must take care how he trips me off the foot of all happiness.' Mary's brief marriage to Fischer was a disaster and both daughters were affected by what seems to have been an hereditary mental instability.

This painting, like *The Painter's Daughters Holding a Cat* (Fig. 25), is unfinished. Both demonstrate that at this period Gainsborough brought the head up to a high finish before completing the canvas, then the normal practice in portraiture. The warm reddish-brown ground in both these pictures is typical of the 1750s and should be contrasted with cooler hue of *Mr and Mrs Andrews* (Plate 5).

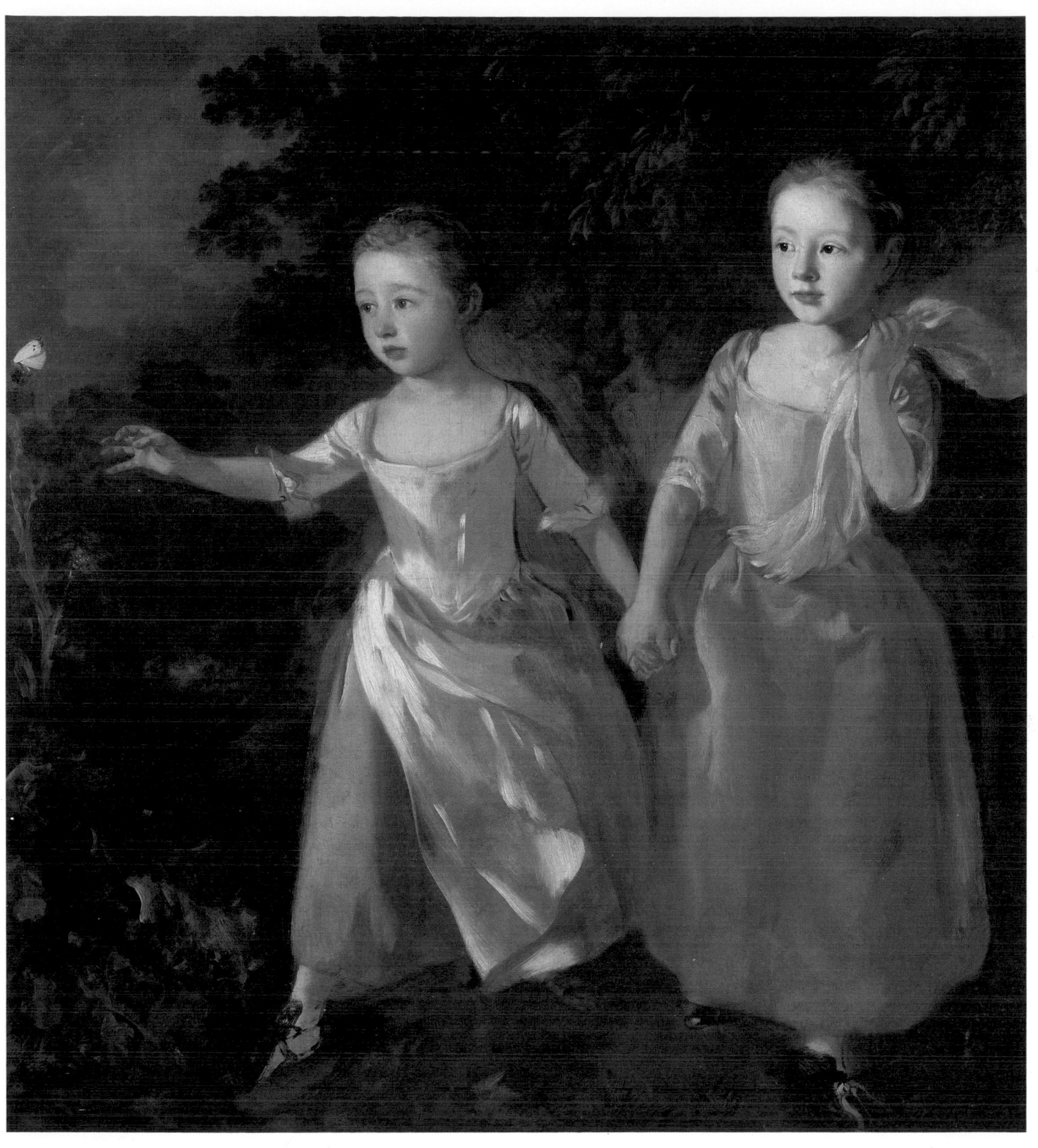

Self-portrait

*c*1759. Oil on canvas, 76.2 x 63.5 cm. National Portrait Gallery, London

Although Gainsborough frequently railed against the drudgery of face-painting as a livelihood, he was capable of intensely thoughtful speculation about portraiture. Writing to the Earl of Dartmouth in 1771, he voiced some of the limitations and difficulties of the genre as a means of truly capturing a sitter: 'Had a picture voice, action, etc. to make itself known as Actors have upon the Stage, no disguise would be sufficient to conceal a person; but only a face confined to one view and not a muscle to move to say, "Here I am" falls very hard upon the poor Painter who perhaps is not within a mile of the truth in painting the Face only.' In this self-portrait, painted in his early thirties, Gainsborough gives us (and himself) 'the Face only' quite literally. He has added absolutely nothing to the image to say 'Here I am, Gainsborough'. All we see is a brown-haired man standing against a generalized brownish backdrop in quiet, if elegant, brown clothes. We do not even see the hands of the painter, one of which is tucked, gentleman-style, into his jacket. Gainsborough's efforts concentrate on the face, not as a map of features nor as a dramatic presentation of self, but as an enquiry into the puzzle of an individual, perhaps even to himself. The gaze of this fairly handsome but not robust-looking man engages the viewer directly but coolly. One might read a hint of determination in the strong nose and a slightly quizzical challenge in the arch of the right brow, but the expression remains equivocal.

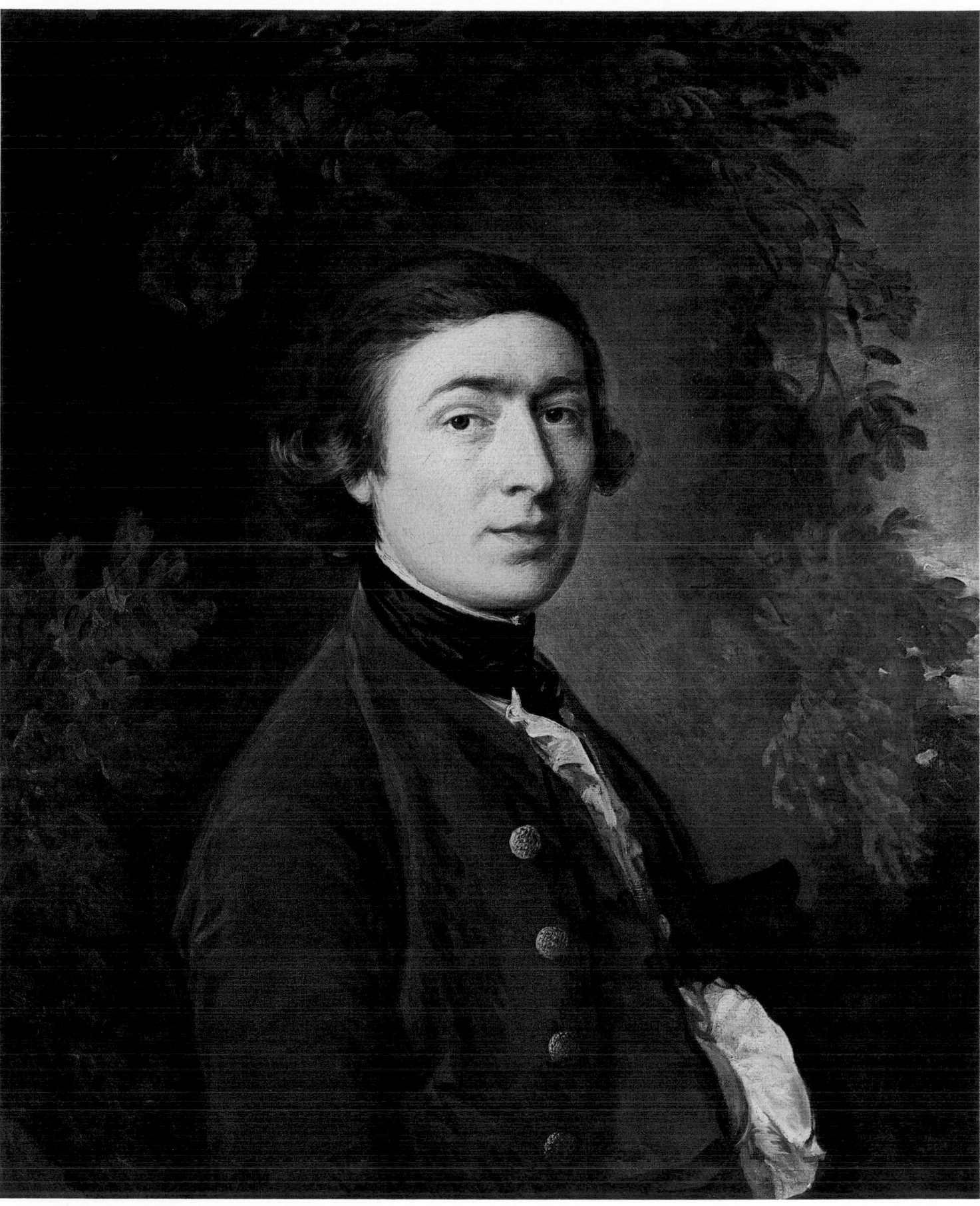

William Wollaston

*c*1758–9. Oil on canvas, 120.7 x 97.8 cm. Christchurch Mansion, Ipswich

This portrait must have been one of the last Gainsborough undertook in Suffolk before he moved from Ipswich. Wollaston (1730–97), a local landowner and, from 1768, MP for Ipswich, was an amateur flautist and a common love of music suggests that, at the very least, Gainsborough found this man a sympathetic sitter. Gainsborough also painted a life-size full-length portrait of Wollaston, his first such commission. Taken together, the Wollaston portraits mark the growing confidence of Gainsborough; any earlier stiffness is replaced by ease, and the groundwork is prepared for the great full-lengths of the Bath years.

The overwhelming impression of this image is its immediacy and its success in capturing a complex and highly individual character, achieved largely through the bold contrast of the sitter's face and his body. Wollaston, below the neck, is richly and solidly corporeal, a twisting, velvet-waistcoated bulk that seems about to slide off the chair towards the viewer. The area between his hands and around the last buttons of his waistcoat is one focus of the canvas. On top of this swelling, pyramid-like torso, which is constrained by the strong diagonal of the flute, Wollaston's face is momentarily in a distant reverie, perhaps inspired by the passage he has just been playing. This work, more than many of the later society portraits, justifies the obituarist's claim that Gainsborough did not give 'merely the map of the face, but the character, the soul of the original'.

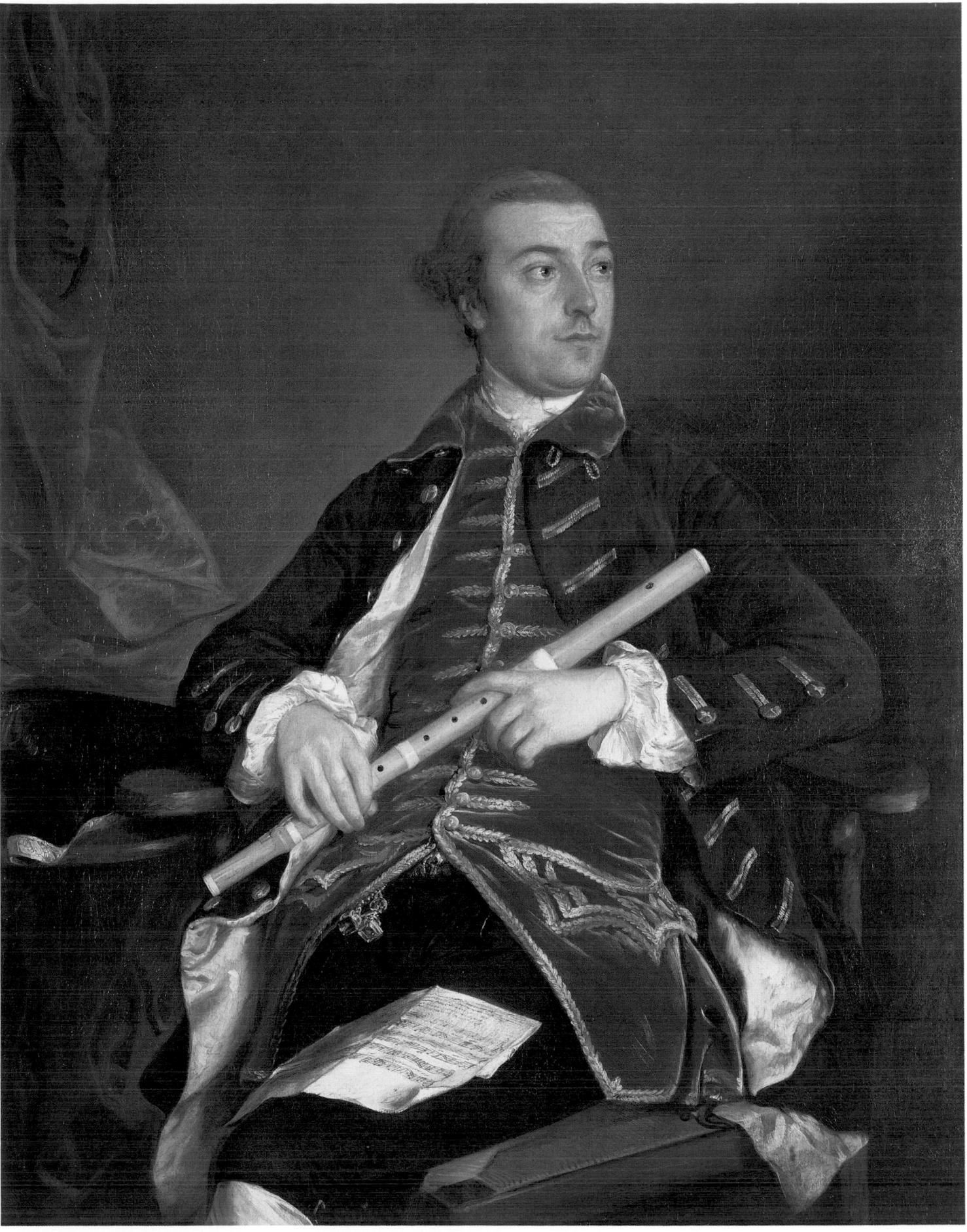

Ann Ford

1760. Oil on canvas, 196.9 x 134.6 cm. Cincinnati Art Museum, Cincinnati, OH

After moving to Bath, Gainsborough's portraits became more ambitious but this particular work continues the flamboyant and highly physical style seen in *William Wollaston* (Plate 11). The pose is ultimately derived from Van Dyck but Gainsborough has twisted the figure into a dramatic spiral that is quite out of keeping with the regal demeanour of Van Dyckian portraiture. The counterpoint of diagonals and the curvaceous sweeps of fabric certainly give the image enormous verve and life. However, the comment made by a visitor to Gainsborough's studio in 1760 suggests he had gone rather beyond what the average person thought acceptable: 'a most extraordinary figure, handsome and bold; but I should be very sorry to have any one I loved set forth in such a manner.' Subsequent portraits were, without exception, less experimental and more decorous.

Ann Ford (1732–1824) married Gainsborough's friend Philip Thicknesse in 1762. She was a talented amateur musician who infuriated her respectable relatives by giving public concerts. Gainsborough described her as 'partly admired & partly laugh'd at at every Tea Table' and the portrait suggests something of her volatile and unconventional nature. Thicknesse, who wrote the first biography of Gainsborough, maintained that it was the row over his wife's viola da gamba which made the artist leave Bath in 1774. Gainsborough had fallen in love with the instrument, perhaps the one depicted behind Ann Ford in this painting, and she gave it to him on condition he painted a full-length portrait of her husband. Gainsborough never completed his side of the bargain and a certain amount of unpleasantness ensued. However, the version of events given by Thicknesse, 'a soldier by profession, a blackmailer by vocation', is not to be trusted.

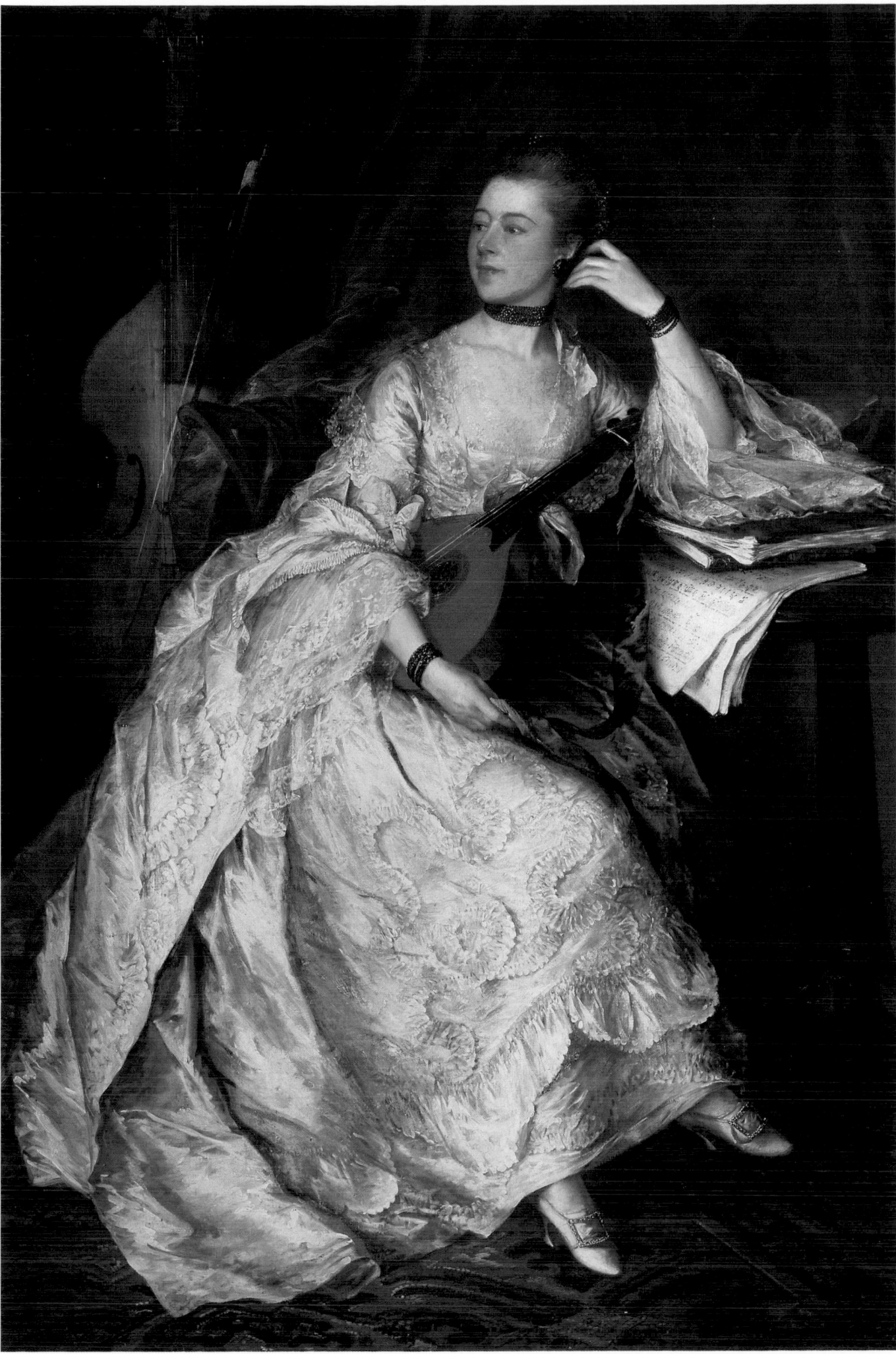

13 Robert Price

*c*1760. Oil on canvas, 124.5 x 99.1 cm. Neue Pinakothek, Munich

Gainsborough often went to country houses to undertake portrait commissions. This would be a more or less agreeable experience depending on the hosts. Philip Thicknesse, perhaps not the ideal house guest, recalled a stay he and Gainsborough made at Shobdon, when Lord Bateman 'brought the worst port to the Table and did not even open a bottle of Champagne which was upon the side Board'. Gainsborough's visits to the Price's home, Foxley, in Herefordshire, sound more agreeable. Robert Price (1717–61) was a collector, musician and a competent amateur artist and his son, Uvedale Price (1747–1829), used to accompany Gainsborough on 'frequent excursions…into the country'. He was later to become an important theorist of the 'Picturesque' movement and his ideas on the aesthetics of landscape were highly influenced by Gainsborough's paintings.

This portrait was traditionally identified as the grandfather, Uvedale Tomkyns Price (1685–1764), but, on the evidence of the likely age of the sitter, Robert Price seems a more obvious candidate. Whichever member of the Price family this is, he is clearly a connoisseur of landscape art, that of Gainsborough in particular. A framed drawing, obviously a 'Gainsborough', hangs on the wall, and he is holding a pen and a landscape sketch, as if in the process of cataloguing his collection, stored in the portfolios behind him.

Mary, Countess Howe

*c*1763–4. Oil on canvas, 243.2 x 154.3 cm. Iveagh Bequest, Kenwood, London

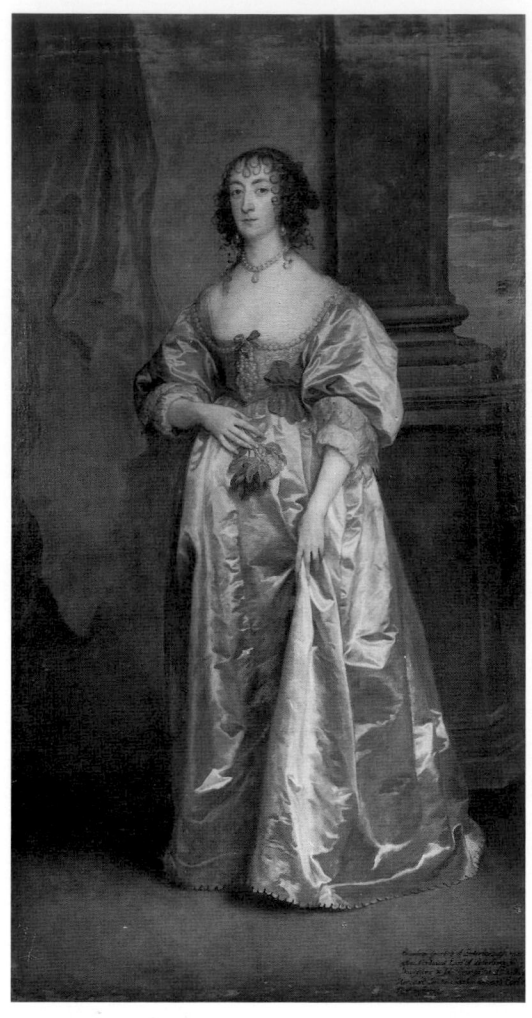

Fig. 26
SIR ANTHONY VAN
DYCK
Elizabeth Howard,
Countess of
Peterborough
*c*1636–9. Oil on canvas,
232 x 125 cm.
Private collection

This imposing full-length portrait was one of Gainsborough's earliest experiments in the grand manner after his move to Bath (see also Plate 12). Gainsborough quickly absorbed the lessons of Van Dyck's portraits, which were now available to him in important country collections. Here, costume, pose and setting are indebted to Van Dyck but equally, all these elements are transformed by Gainsborough's unmistakable stamp of modernity. For example, Gainsborough usually preferred to depict the current fashions rather than ape seventeenth-century styles. While Countess Howe's extraordinary rose-pink silk and silvery-white lace confection may appear today as improbable as any fancy dress, she is, in fact, dressed entirely à la mode, in a gown which would, in the 1760s, have been considered informal and suitable for a stroll. Similarly, although the hand on hip pose has precedents in portraits by Van Dyck (see Figs. 26 and 30), it also functions naturally, holding the apron up to allow forward movement and suggests the forceful character of the subject. The parkland setting with deer and distant mountains is less fussy than Gainsborough's landscape backgrounds of the 1750s and lends grandeur to the figure which is thrown dramatically forward by the contrasting mass of dark, threatening storm clouds. The image as a whole has an almost abstract sense of unity of colour and paint, a quality which sets apart Gainsborough's full-lengths in landscape from the more pedestrian work of his contemporaries.

Countess Howe, née Mary Hartopp (1732–1800), the wife of an important naval officer, exemplifies the better class of sitter Gainsborough was able to attract in Bath. Little evidence of her character survives apart from this portrait, which suggests a woman of considerable determination. The painting was not publicly exhibited until the twentieth century.

15 Wooded Landscape with a Waggon
 in the Shade

Mid-1760s. Black chalk and watercolour on paper, heightened with white,
23.7 x 31.7 cm. British Museum, London

This idyllic study, like *Boy Reclining in a Cart* (Fig. 6), expresses Gainsborough's vision of the countryside as a place of rest and naturalness, the antithesis, in every way, to the pressures of his busy portrait practice. Gainsborough regularly went out into the countryside around Bath; in one letter, written shortly after his illness in 1763, he says that he intends to 'Ride every minute in the Day unless it rains pouring'. Most of his finished landscape drawings, however, are not records taken on the spot but compositions worked up in the evenings, when he drew by candlelight to relax after the irritations of a day spent painting faces.

In this picture, the effect of bright noonday sun creating sharp contrasts between light and shade shows Gainsborough's acute observation of natural phenomena, even in recollection, during the tranquillity of his evenings. Gainsborough has pared down the scene to its essence. He does not offer a view into an expansive landscape; rather the tall trees act as an impenetrable screen and the curving track leads nowhere in particular. The dozy horses are not properly attached to the waggon and there is a sense of a moment existing outside the normal rules of time.

1767. Oil on canvas, 120.7 x 144.8 cm. Barber Institute of Fine Arts,
University of Birmingham, Birmingham

Fig. 27
SIR PETER PAUL
RUBENS
The Deposition
1611–14. Oil on canvas,
420 x 310 cm. Cathedral,
Antwerp

Gainsborough's landscapes of the late 1760s (see also Plates 17 and 18) are much grander than either the work of the late 1740s, inspired by Dutch painting, or the more decorative pictures of the 1750s. The compositions now have greater unity and Gainsborough seems more confident in using landscape as the subject of important canvases. The main reason for this change in style was the influence of Claude and Rubens, some of whose paintings were now available to Gainsborough in local collections. In this picture, the overall structure of the scene, with its magisterial trees on the left acting as a wing to the open view in the centre, derives from Claude. But more important is the influence of Rubens, and not one of his landscapes, but a religious work – the famous Antwerp altarpiece of *The Deposition* (Fig. 27). Gainsborough's reaction to Rubens's tragic painting is revealing. The sorrowful downward droop of the linked figures in the altarpiece becomes the inspiration for an upwardly thrusting movement, from the tip of the shoe of the girl being lifted into the waggon, up to the two peasants fighting over a barrel of drink. Gainsborough, fully alert to the compositional brilliance of Rubens, and the beauty of his colour and his paint, creates an idyll which is light-hearted and even comic in mood. Gainsborough did not, of course, see the actual altarpiece in Antwerp, but he had made a copy of Rubens's *modello* (an oil sketch), then at Corsham Court in Wiltshire. He may also have been familiar with the composition through its well-known engraving.

When Gainsborough left Bath in 1774, he presented this landscape to Walter Wiltshire, the man whose 'flying waggon' had delivered Gainsborough's paintings to their new owners, and to and from the London exhibitions. Margaret Gainsborough, the artist's younger daughter, probably posed for the figure of the girl climbing into the waggon, and the girl looking upwards at the brawling peasants may be Mary.

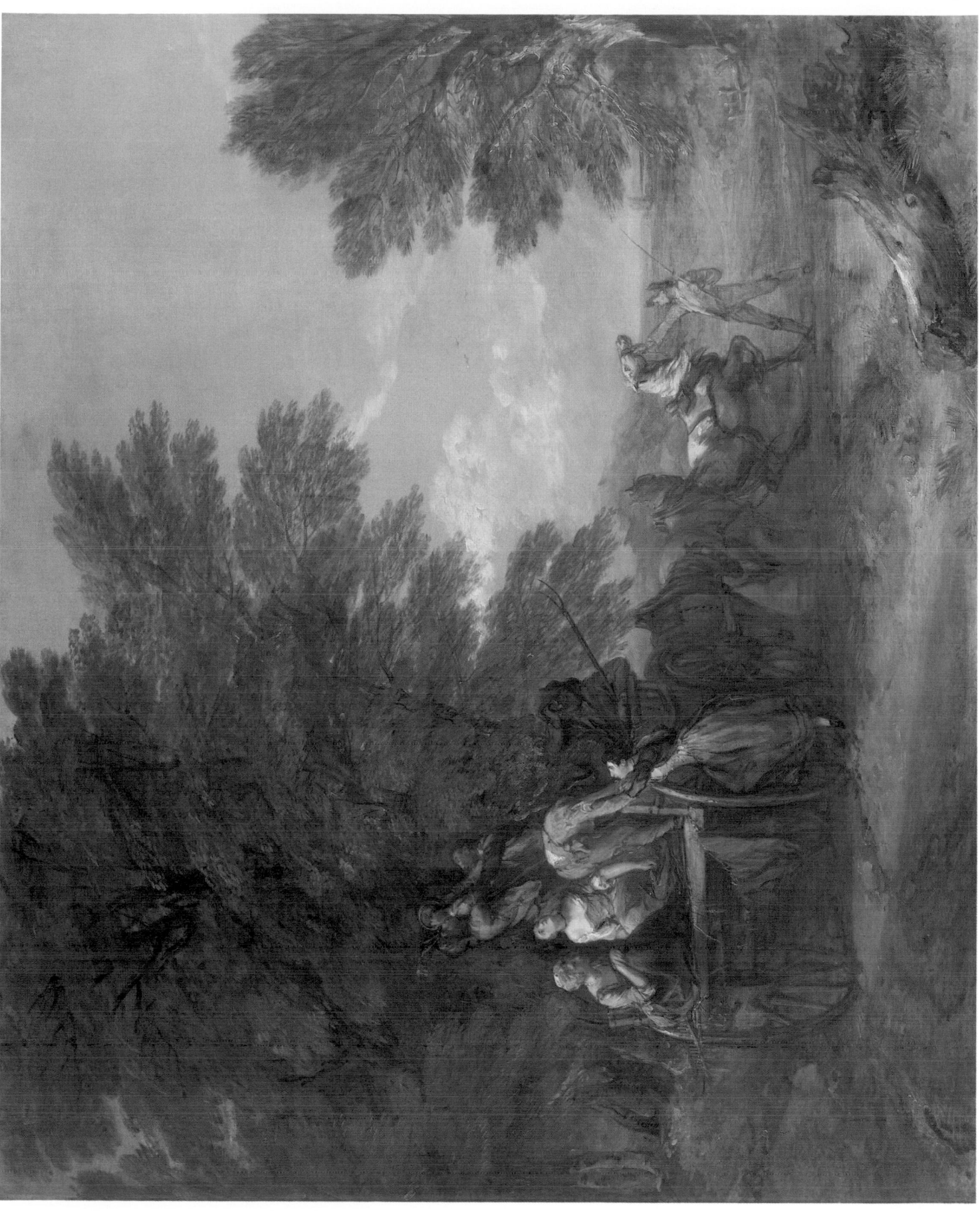

Peasants Returning from Market

*c*1767–8. Oil on canvas, 121.3 x 170.2 cm. Toledo Museum of Art, Toledo, OH

The subject of this painting was of particular significance to Gainsborough. This is the first appearance of a theme which he explored in several other major canvases. Whereas in his Rococo landscapes of the 1750s (see Plate 8), rustic couples competed with a wide, and perhaps distracting, variety of 'business for the Eye', here Gainsborough has found a image which is simultaneously unified as an action, harmonious with the glowing surroundings and evocative of a dream-like rural idyll. The mounted peasants, disappearing into the curve of the forest, are not random staffage but as much a part of the mood and composition of the landscape as the trees. The gnarled trunk on the left and the blasted tree on the right form the ends of an arching composition with the rather elegant young peasant girl mounted on the white horse at its centre.

This picture is unusual in being one of Gainsborough's few commissioned landscapes. It was probably one of three contemporary works painted for Lord Shelburne of Bowood House, Wiltshire, who aimed to lay 'the foundation of a school of British landscape'. On the whole, as Gainsborough knew to his cost, there were few patrons of modern landscape, but this particular subject seems to have been popular. *Peasants Going to Market: Early Morning* (Private collection; previously in Royal Holloway College, London) was bought by the banker Henry Hoare and *Peasants Going to Market* (Iveagh Bequest, Kenwood, London) was painted for Viscount Bateman.

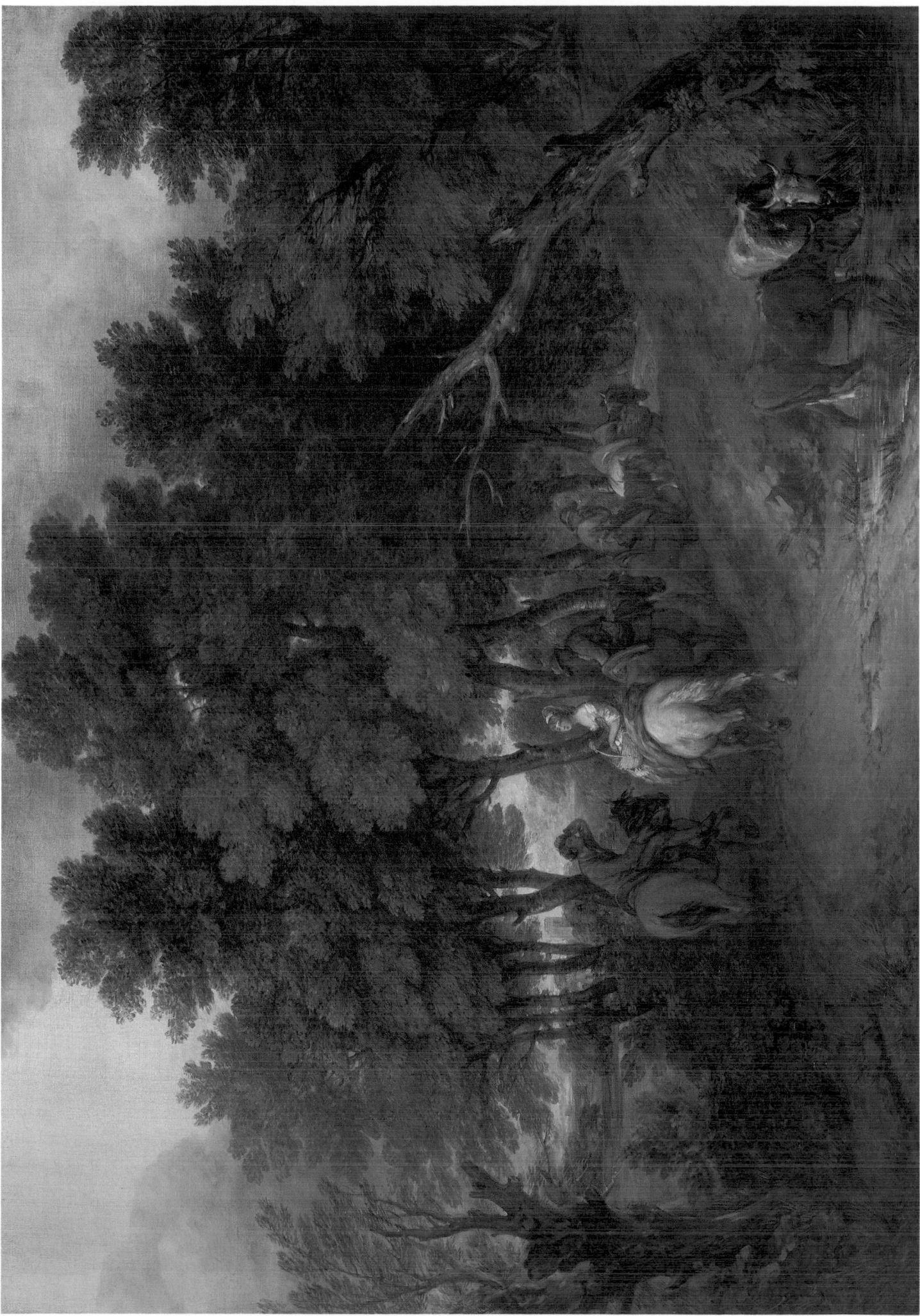

c1768–71. Oil on canvas, 117.5 x 168.3cm. Philadelphia Museum of Art, Philadelphia, PA

In contrast to the overwhelming majority of Gainsborough's landscapes and, at first sight, contradicting his declared refusal to paint '*real Views*', this scene is now considered to be based upon a stretch of the River Trent in Staffordshire, near the country seat of the painting's first owner. However, the landscape is very far from being an exercise in topographical exactness. Gainsborough has used the actual place as an inspiration for exploring watery space and creating magnificent trees, so full of character they seem possessed of souls. Cows coming down to drink and the lovers in the boat enhance the peaceful and pastoral mood. The meandering and extensive structure of the composition, the light and the handling of paint are all indebted to Rubens's landscapes (Fig. 28).

Fig. 28
SIR PETER PAUL
RUBENS
Shepherd with his
Flock
c1620. Oil on panel,
63.9 x 94.3 cm. National
Gallery, London

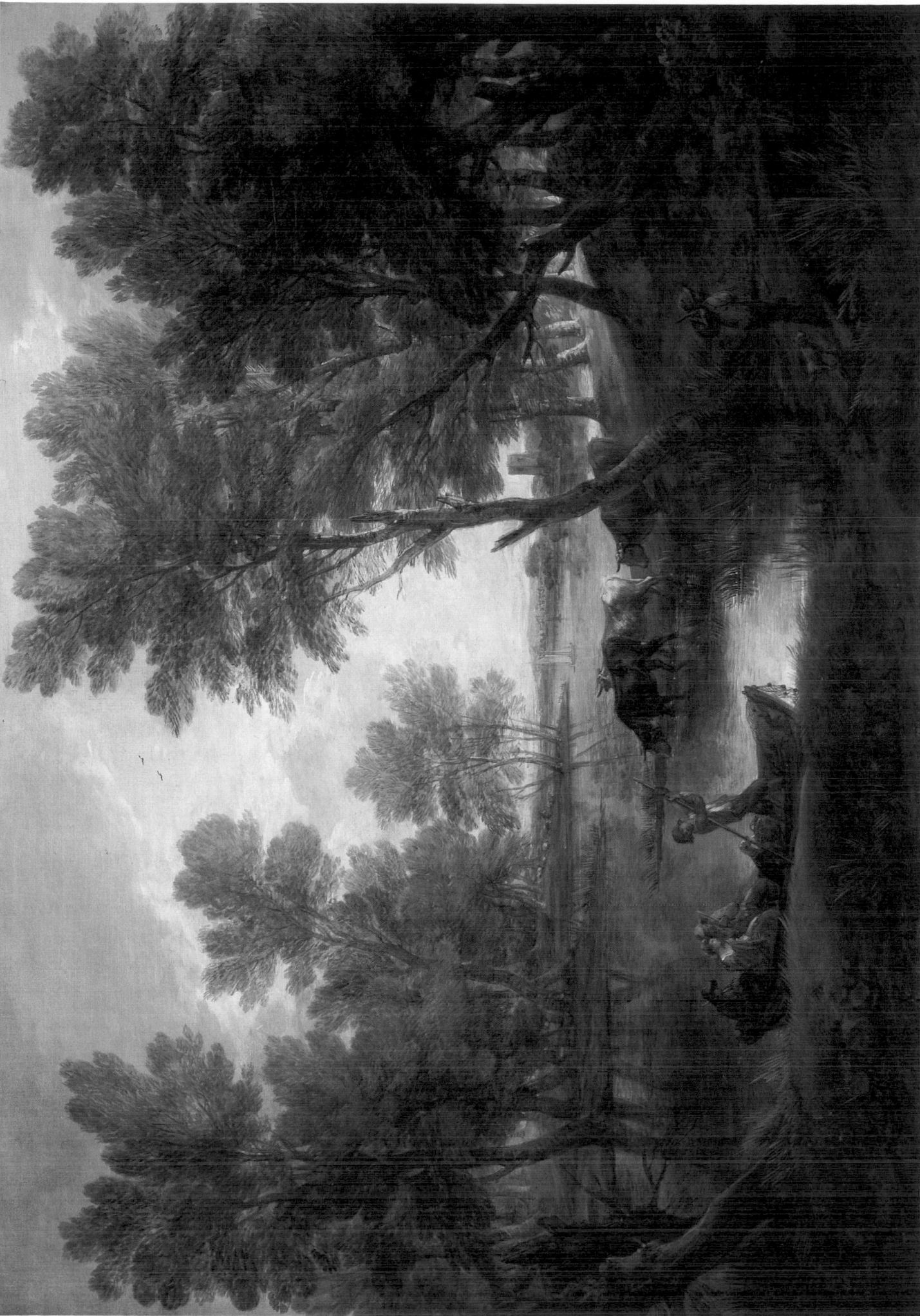

John, Viscount Kilmorey

*c*1768. Oil on canvas, 233.7 x 156.2 cm. Tate Gallery, London

Not all of Gainsborough's full-lengths in landscapes were of society beauties painted with Van Dyckian elegance. Gainsborough could also make a very satisfying picture of an older man, as we see in this portrait of John, Viscount Kilmorey (1710–91). Kilmorey's face, painted from life, as was Gainsborough's custom, is a good example of Gainsborough achieving likeness and a sense of living character 'by the indecision more than the precision of the outlines'. The features are not etched in with linear absoluteness; the boundaries of the nose, eyes and mouth are a little blurred and indeterminate which suggests the fleeting nature of expression. If we look at his anatomy (and Gainsborough did not paint the body from life), we can see that Viscount Kilmorey is a rather strange shape, swelling out to his comfortable, but not slack, middle, encased in a red waistcoat, and diminishing downwards to tapering legs that seem to belong to a smaller man. However, this figure has, literally, a huge presence, centred in the canvas, and suggests the Viscount's solid dependability as a man and a member of the ruling class. The lines of gold braid on the waistcoat, turning sharply at angles of 45 and 90 degrees, add an almost abstract interest in pattern and colour.

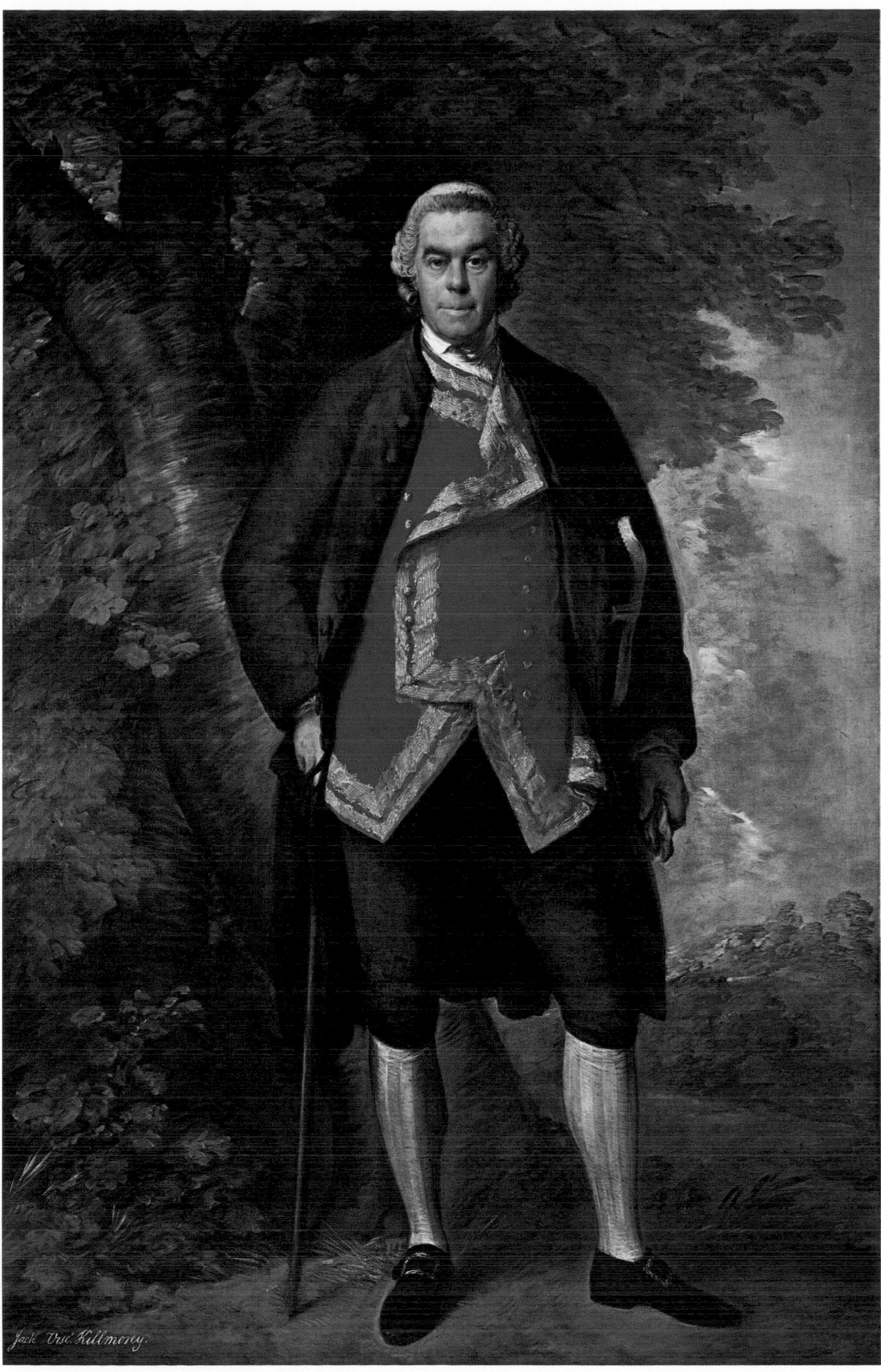

Jack Visc.Killmory.

Isabella, Viscountess Molyneux

1769. Oil on canvas, 233.7 x 152.4 cm. Walker Art Gallery, Liverpool

Gainsborough sent this impressive full-length to the first annual exhibition of the newly-formed Royal Academy in 1769. As well as revealing the maturity of his Van Dyckian manner, evolved over the ten year period since his move to Bath, this picture would have demonstrated to the viewers Gainsborough's distinctive qualities as a portraitist in comparison to Reynolds, whose exhibited portraits included a Duchess and her baby son 'in the character of Diana disarming Love' and a lady posing as the Goddess Juno. Gainsborough's image of this young Viscountess is the epitome of unpretentious elegance and graceful ease. She is dressed in a fashionable gown with an arm outstretched and a hand against her breast, a pose derived from Van Dyck which is also persuasively natural. The broadly sketched stormy landscape adds a touch of drama to an otherwise serene figure. Compared to *Mary, Countess Howe* (Plate 14), Viscountess Molyneux seems, perhaps, less of a character and more of a type, but it is easy to see why Gainsborough's clients would have wished to be painted as precisely this type, an aristocratic ideal for the modern age.

The commission for this portrait would have followed soon after the marriage of Isabella Stanhope (1748–1819) to Viscount Molyneux in 1768, during the couple's visit to Bath in 1769.

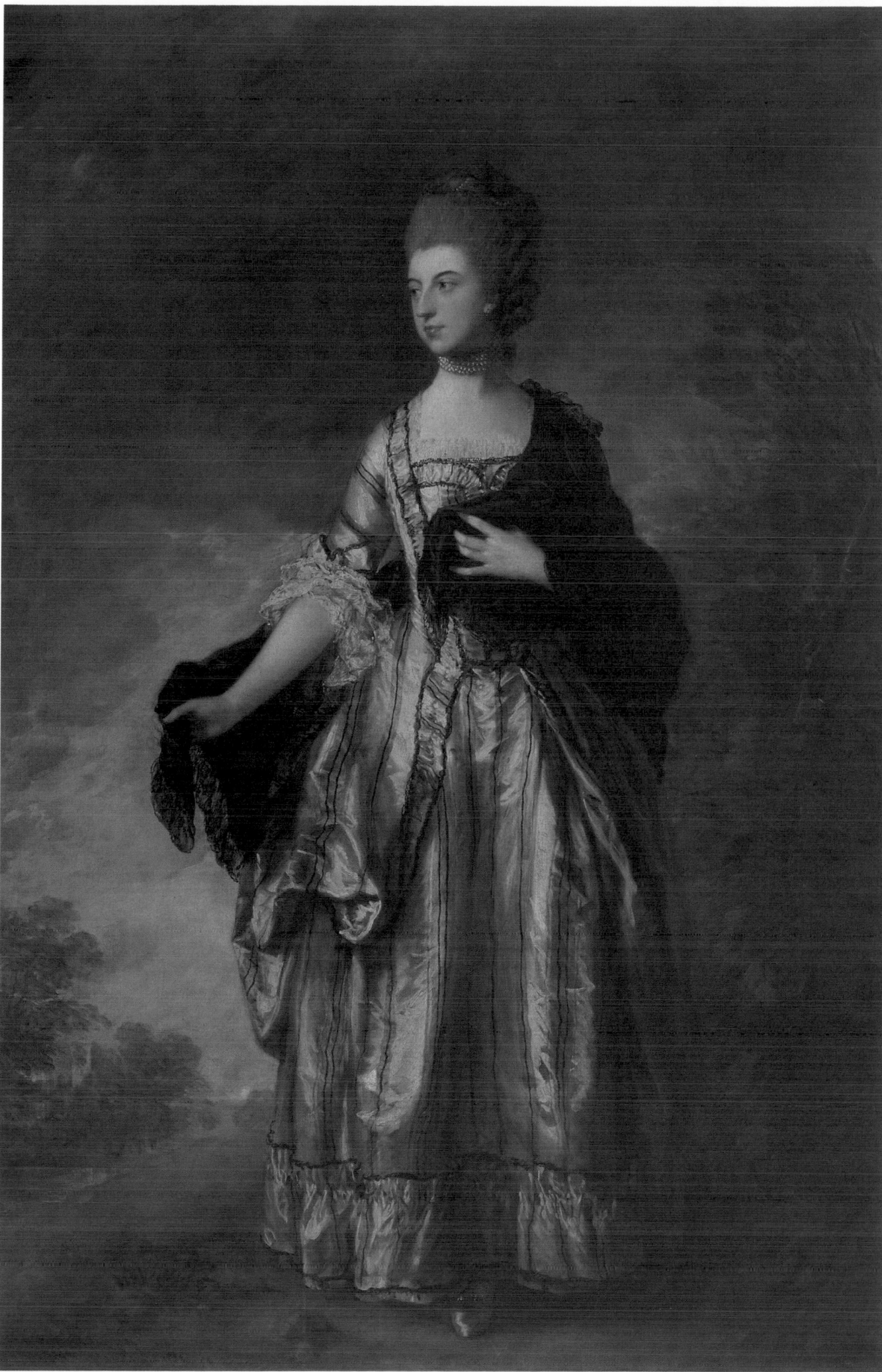

The Blue Boy

*c*1770. Oil on canvas, 177.8 x 121.9 cm. Henry E Huntington Library and Art Gallery, San Marino, CA

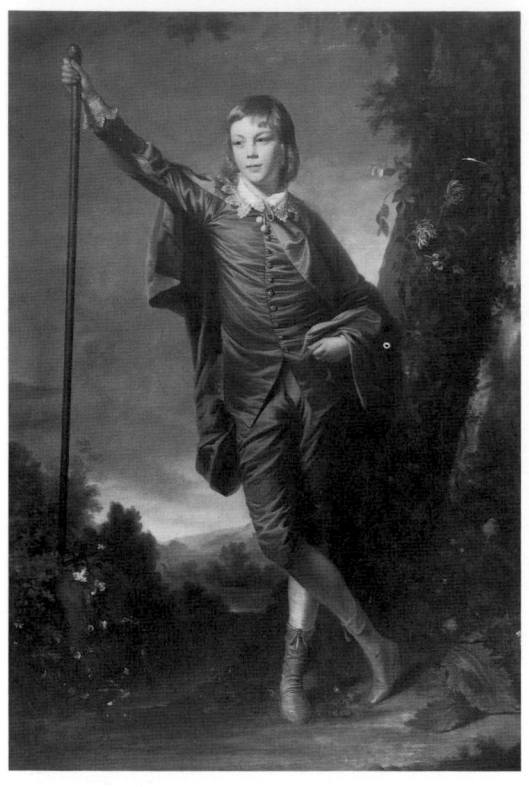

Fig. 29
SIR JOSHUA REYNOLDS
Master Thomas Lister
(detail)
1764. Oil on canvas,
231 x 147.5 cm.
Bradford City Art Gallery
and Museum, Bradford

This most famous of Gainsborough's images has, since the early nineteenth century, invariably been called the 'Blue Boy'. Gainsborough's contemporaries were unaware of the boy's identity even though they knew the painting belonged, in Gainsborough's lifetime, to the Buttall family. The 'Blue Boy' is now assumed to be Jonathan Buttall (d.1805), the son of a close friend of Gainsborough who owned an ironmongery in Soho, London.

The kind of Van Dyckian masquerade costume worn by Buttall enjoyed huge popularity in the 1760s and 1770s. Gainsborough occasionally used it in portraits, perhaps when he felt the sitter was striking enough to bear the conceit (see Plate 25 and Fig. 5) but, on the whole, he positively discouraged the wearing of full fancy dress, feeling strongly that it distracted from the likeness of a portrait. Reynolds also protested against the use of 'this fantastic dress' in paintings, but used similar costume on occasion (Fig. 29). The 'Blue Boy' was probably not a commissioned work at all (the painting is on top of an earlier, abandoned portrait). Using Jonathan Buttall really as no more than an appropriately handsome face, the painting is a spirited exercise in deliberate emulation of Gainsborough's hero, Van Dyck.

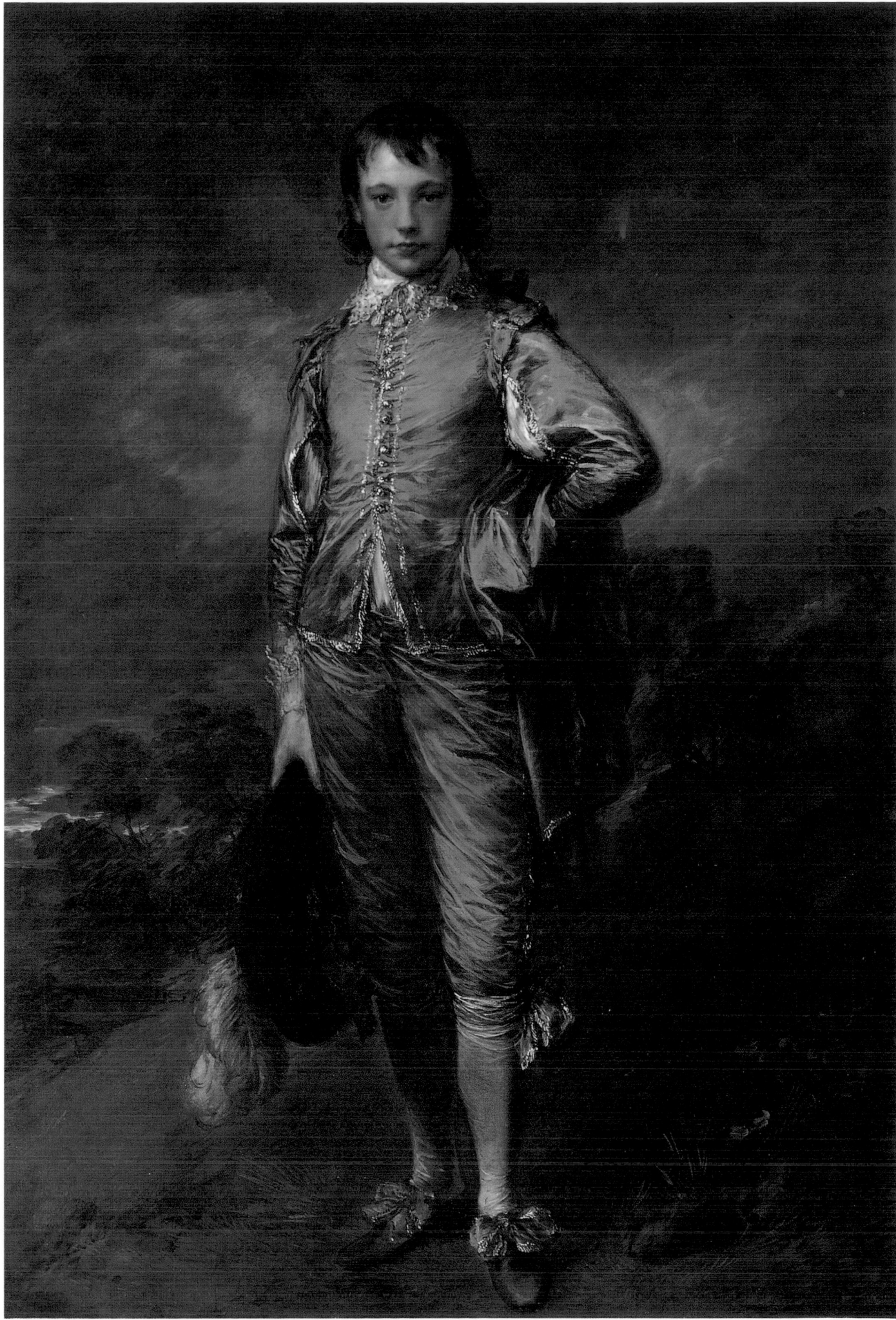

Gainsborough Dupont

Early 1770s. Oil on canvas, 44.5 x 36.2 cm. Tate Gallery, London

Gainsborough Dupont (1754–94) was the son of Gainsborough's sister, Sarah, and her husband, Philip Dupont, a carpenter in Sudbury. Dupont must have shown artistic talent as a child, and he was sent to live with the Gainsborough family in Bath. He was formally apprenticed to his uncle in January 1772, a legally binding agreement in which Thomas Gainsborough promised to teach the boy 'the Art or Mystery of a painter'. He was Gainsborough's only documented pupil and he stayed on after the period of apprenticeship was complete, living and working at Schomberg House as a studio assistant. Dupont helped Gainsborough with large areas of drapery and together they painted Queen Charlotte's gown in one night (see Fig. 31). He also made copies of portraits and produced mezzotints after his uncle's works. After Gainsborough's death, he pursued a career as a portrait painter and a landscapist, working in a style almost wholly indebted to his uncle.

Although when adult Gainsborough Dupont seems to have been a retiring and diffident man, described invariably as 'modest', this portrait suggests a certain youthful spirit of rebellion. In a letter to William Jackson, written in 1777, Gainsborough refers to his young nephew as a 'blockhead', humorously describing how a parcel to Jackson missed the Exeter coach because Dupont was 'too proud to carry a bundle *under his arm*'.

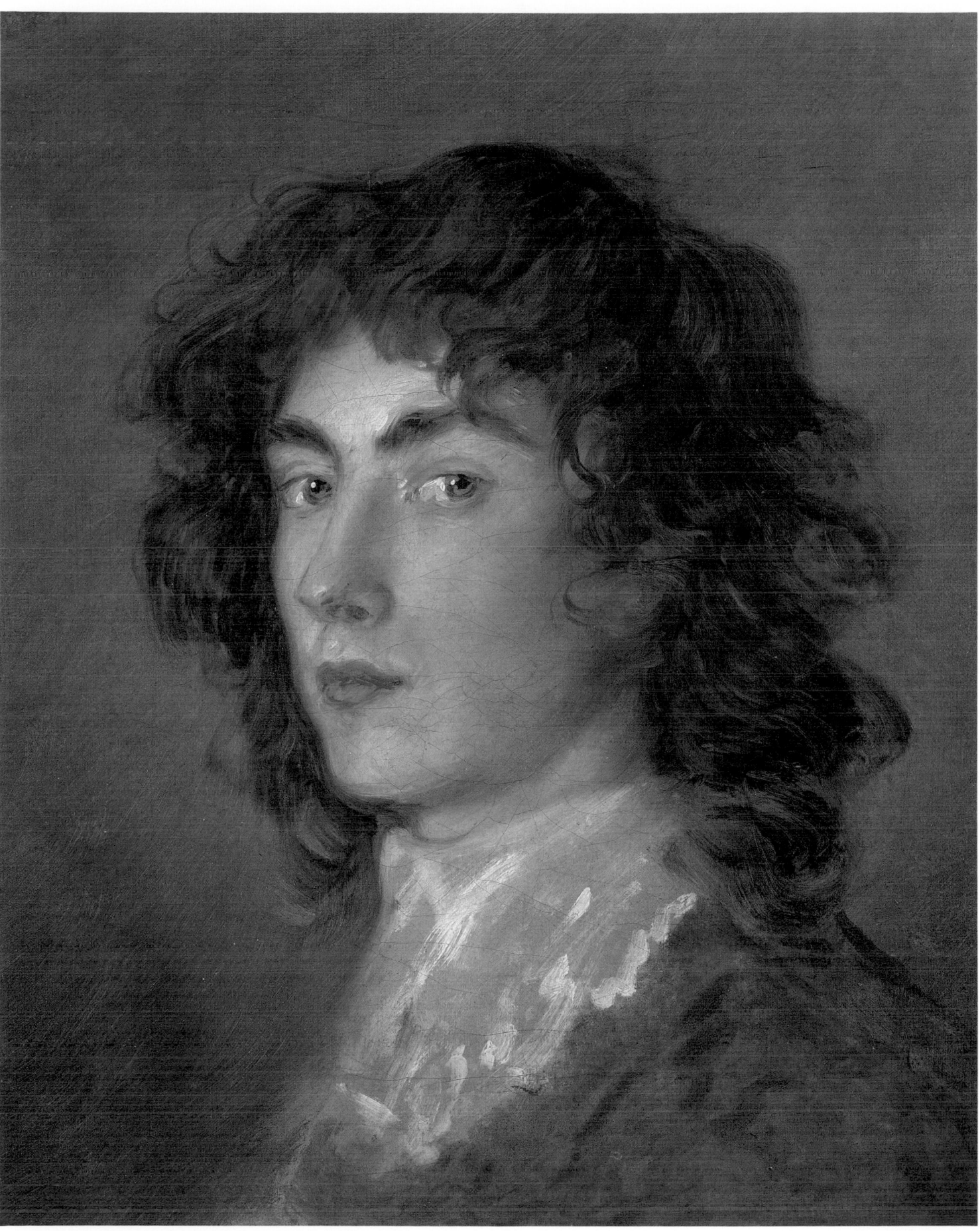

Captain William Wade

1771. Oil on canvas, 231 x 149 cm. Victoria Art Gallery, Bath City Council, Bath

Gainsborough presented this portrait to the shareholders of the New Assembly Rooms at Bath to celebrate the completion of the building in 1771. In return, he received tickets for the opening entertainment, a *ridotto*, a form of concert and dance. The New Assembly Rooms were used by visitors and residents of the Spa town for elegant socializing – listening to music, card-playing, tea-drinking and balls. These activities were overseen by the 'Master of Ceremonies', a post occupied by Captain William Wade (d.1809) from 1769 until 1777, when he was named as the co-respondent in a messy society divorce suit. His badge of office in the form of a medallion can be seen around his neck.

This is one of Gainsborough's most refined portraits of a man. Wade, renowned for his handsome looks, stands with his hand on his hip, looking immensely proud and pleased with himself. The pose is based upon a Van Dyck painting of James Stuart, cousin of Charles I, which Gainsborough had seen in the collection of Paul Cobb Methuen at Corsham Court in Wiltshire (now at the Metropolitan Museum of Art, New York). Wade's elongated body adds to his graceful demeanour and should be compared to the substantial proportions of Viscount Kilmorey (Plate 19). The house and steps from which Wade appears to be descending were added in response to contemporary criticism; Gainsborough had originally painted a pure landscape background, but this was felt to be too rural for such an urbane creature as Captain Wade.

The Linley Sisters

1772. Oil on canvas, 199.1 x 153 cm. Dulwich Picture Gallery, London

Fig. 30
Lords John and
Bernard Stuart
(after Van Dyck)
Mid-1760s. Oil on canvas,
235 x 146.1 cm. St Louis
Art Museum, St Louis, MI

Gainsborough made friends with the Linleys soon after he moved to Bath. Thomas Linley, a composer who organized concerts in the Assembly Rooms, presided over a family of exceptional musical talent. His two elder daughters are depicted here: Elizabeth (1754–92), standing, who was already renowned as a leading soprano and Mary (1758–87), who had just begun her own career as a professional singer. Gainsborough, who adored music and female beauty equally, painted Elizabeth on several occasions (see Plate 44).

Gainsborough has placed the girls within a spring woodland setting, with primroses blooming profusely by Mary's side, as if they have just paused in an alfresco concert. This is, of course, a charming and appropriate fiction conjured up in the studio. To achieve both the unity of composition and contrast of character essential in a double portrait, Gainsborough looked to the example of Van Dyck, specifically his *Lords John and Bernard Stuart*, which he had copied in the 1760s (Fig. 30). Elizabeth wears cool blue and looks away, preoccupied (as well she might have been, for while Gainsborough was finishing this picture, she eloped with Richard Brinsley Sheridan, the playwright and future politician). Mary wears warm golden-brown and her vivacious expression directly engages with the viewer.

This picture was probably painted as a present for Thomas Linley. Gainsborough took the painting back to his studio in 1785 and retouched it, altering the hairstyles and details of clothing. Mary, who had never felt flattered by her likeness, was delighted: 'When I came home last night I found *our* picture come home from Gainsbro's very much improved and freshened up.' Some of these later additions, such as a black velvet sash around Elizabeth's waist, were removed during cleaning in the 1950s.

The Hon Frances Duncombe

*c*1775–7. Oil on canvas, 234.3 x 155.2 cm. Frick Collection, New York, NY

This painting may have been commissioned to celebrate the engagement, subsequently broken, between the Hon Frances Duncombe (1757–1827) and Jacob Bouverie. The Bouverie family had a particular liking for being portrayed in seventeenth-century dress, Jacob had been painted in a Van Dyck suit by Reynolds in 1757. Gainsborough is known to have disliked the use of fancy costume in portraits (see Plate 21), protesting to the Earl of Dartmouth in 1771 that 'nothing can be more absurd than the foolish custom of painters dressing people like Scaramouches, and expecting the likeness to appear'. Reading the Dartmouth correspondence and looking at the portrait of the Countess (Private collection) which was the subject of their discussion (it was considered to be a poor likeness), one feels that the main problem was the inappropriateness of the stolid sitter, already in middle life. Here, the use of fanciful clothing seems more fitting, with the dress adding to the fairy-tale romanticism of the image. This particular style of gown was derived from a picture, then thought to be by Van Dyck, of Rubens's wife, Helena Fourment, but now ascribed to Rubens himself. The painting was in an English collection and was also well known through an engraving. This costume was probably (like the Van Dyck suit in Plate 21) a studio prop rather than an item in Frances Duncombe's own wardrobe; the Hon Mrs Graham of 1777 (Fig. 5) wears the same dress, although the sleeves have been altered.

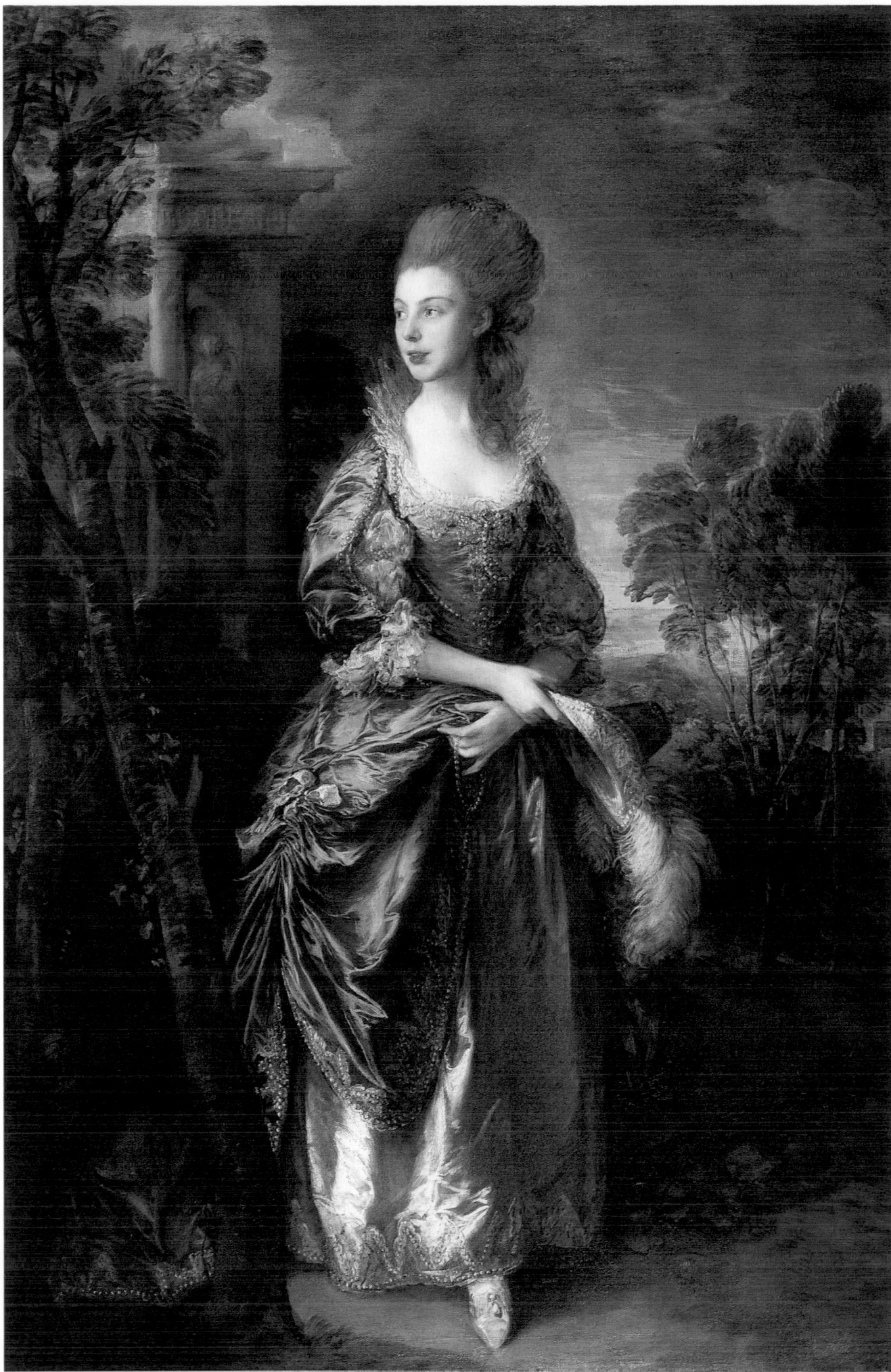

Henry Frederick, Duke of Cumberland

1777. Oil on canvas, 238.1 x 142.2 cm. Royal Collection

Although Reynolds, through the political machinations of his supporters, was appointed Principal Painter to the King, Gainsborough was undoubtedly the favourite painter of the Royal Family. They seemed not to have liked Reynolds, while Gainsborough with his unpretentious charm happily 'talked bawdy to the King, & morality to the Prince of Wales'. Gainsborough probably received his introduction to the Palace from his friend and fellow Ipswich artist, Joshua Kirby, who had taught perspective to George III.

His first Royal commission came from Henry Frederick (1745–90), the King's youngest brother. The Duke of Cumberland was the exception to the general good nature of the Hanoverian family; an eminent historian has described how 'his own family spoke of him with horror. By the time he died the public was convinced that he had begotten a child by his sister and murdered his valet.' After a dissolute youth, he married the 'fascinating Mrs. Horton', a widow so notorious that Queen Charlotte refused to meet her. Gainsborough was clearly able to cope with the Duke and Duchess, painting them on several occasions, but this image of Henry Frederick does hint at his viciousness.

Gainsborough was to paint virtually all the Royal Family, and most of the portraits are extremely sympathetic. His picture of Queen Charlotte (Fig. 31) is an image of eighteenth-century monarchy at its most alluring. The setting and costume give her the appearance of a queen in a fantastic opera, but Gainsborough's observation of this middle-aged woman's 'amiableness of character' tempers any tendency to pure escapism.

Fig. 31
Queen Charlotte
1781. Oil on canvas,
238.8 x 158.7 cm.
Royal Collection

The Watering Place

1777. Oil on canvas, 147.3 x 180.3 cm. National Gallery, London

In 1777, after an absence of four years, Gainsborough returned to the Royal Academy with a group of paintings that demonstrated the range and ambition of his work (see also Plates 26 and 28 and Fig. 5). *The Watering Place* was one of those exhibited and it received considerable critical acclaim. The critic Horace Walpole wrote that it was 'in the Style of Rubens, & by far the finest Landscape ever painted in England, & equal to the great Masters'. The effect of this work, shown alongside the more usual classicizing manner which consistituted the British contribution to elevated landscape style, must have been considerable. It was both an overtly individual and unmistakably modern statement from Gainsborough, and an image which invited comparison with some of the most honoured artists of the past.

The influence of Rubens was noted by other critics as well as Walpole: the painting has many points of similarity with Rubens's canvas of the same name (Fig. 32), which Gainsborough had enthused over nearly ten years previously in the collection of the Duke of Montagu. But time and experience had enriched this relationship; *The Watering Place* repays its debt to Rubens and, in a complex, but fully resolved composition, also engages with two other heroes of landscape art. Gainsborough respects Claude in the unity of the scene, and, in mood and monumentality, nods to Titian. The paint has a Venetian richness. Hot but dark light glows from the depths of the canvas, prefiguring the effects of Gainsborough's transparency experiments of the early 1780s. The pool, seen close to, is streaked with solid impasto, but viewed from a correct distance, the water becomes a perfectly convincing liquid. Gainsborough was unable to find a buyer for this landcape.

Fig. 32.
SIR PETER PAUL
RUBENS
The Watering Place
*c*1620. Oil and black
chalk on oak panel,
98.7 x 135 cm.
National Gallery, London

Carl Friedrich Abel

1777. Oil on canvas, 223.5 x 147.3 cm. Henry E Huntington Library and Art Gallery, San Marino, CA

Carl Friedrich Abel (1725–87) was a German-born and trained musician and composer who came to London in 1759 and pursued a successful career in England. His name is always linked to that of his inseparable companion, Johann Christian Bach (Fig. 2), another important German musician. They shared a house until Bach's marriage, and, in 1775, they opened their own concert hall in Hanover Square. The room was decorated with transparent paintings (none of which survive) lit dramatically from behind. Gainsborough contributed a highly admired 'Comic Muse' to this scheme. Gainsborough and Abel were close friends, sharing their love of music and spending enjoyable evenings together with other musicians and artists such as Bach, Cipriani and Francesco Bartolozzi (c1725–1815). When Abel died in 1787, Gainsborough was inconsolable, writing that he would 'never cease looking up to heaven – the little while I have to stay behind – in hopes of getting one more glance of the man I loved from the moment I heard him touch the string. Poor Abel! -'tis not a week since we were gay together, and that he wrote the sweetest air I have in my collection of his happiest thoughts. My heart is too full to say more.'

This portrait, exhibited at the Royal Academy in 1777, is evidence both of the warmth between the two men and Gainsborough's respect for Abel's musical genius. Abel was best known for his virtuoso perfomances on the viola da gamba and it is this instrument that Gainsborough places prominently in the foreground. Gainsborough admired Abel's viols and bought one at the posthumous sale of his friend's possessions in December 1787. This same sale included this painting, the separate canvas of Abel's Pomeranian bitch with her pup (Plate 29), and over 30 drawings by Gainsborough.

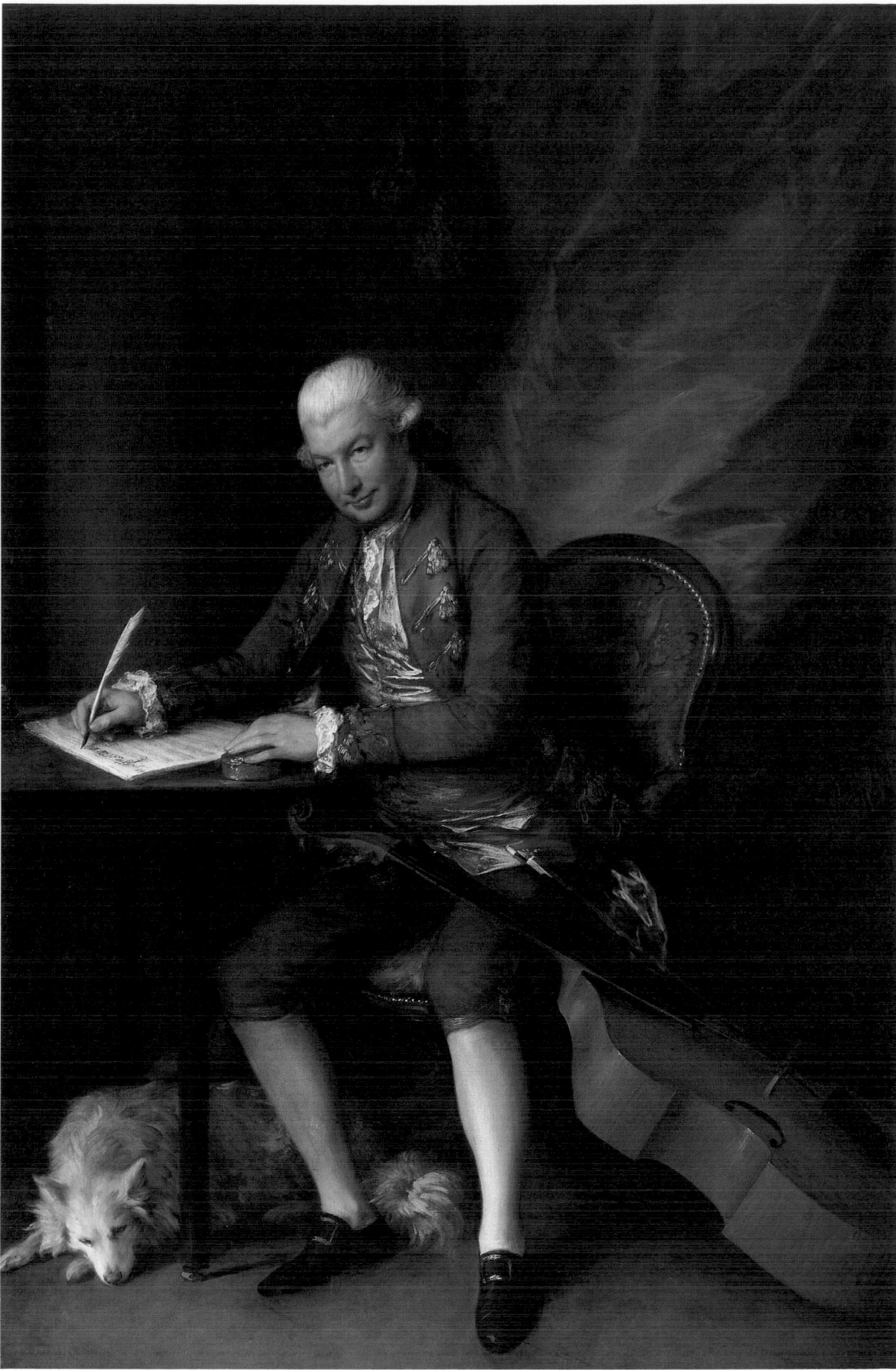

Pomeranian Bitch and Pup

c1777. Oil on canvas, 83.2 x 111 cm. Tate Gallery, London

These dogs belonged to Gainsborough's friend, the musician Carl Friedrich Abel, and the bitch can be seen at Abel's feet in Gainsborough's portrait of 1777 (Plate 28). This picture was probably painted as a gift to Abel in return for the lessons Gainsborough received on the viola da gamba.

Gainsborough's reputation for capturing a likeness in his portraits was such that his obituary claimed 'the picture may almost be mistaken for the original' and an amusing anecdote illustrates this with reference to this painting. When the picture was first delivered to Abel's house 'the deception was so complete that the elder subject, irritated at the presence of a supposed rival, flew at her own resemblance with such fury that it was found necessary to place the picture in a situation where it was free from her jealous anger.' Gainsborough's depictions of animals are always sympathetic, and often, as in this example, individual enough to be considered as portraits.

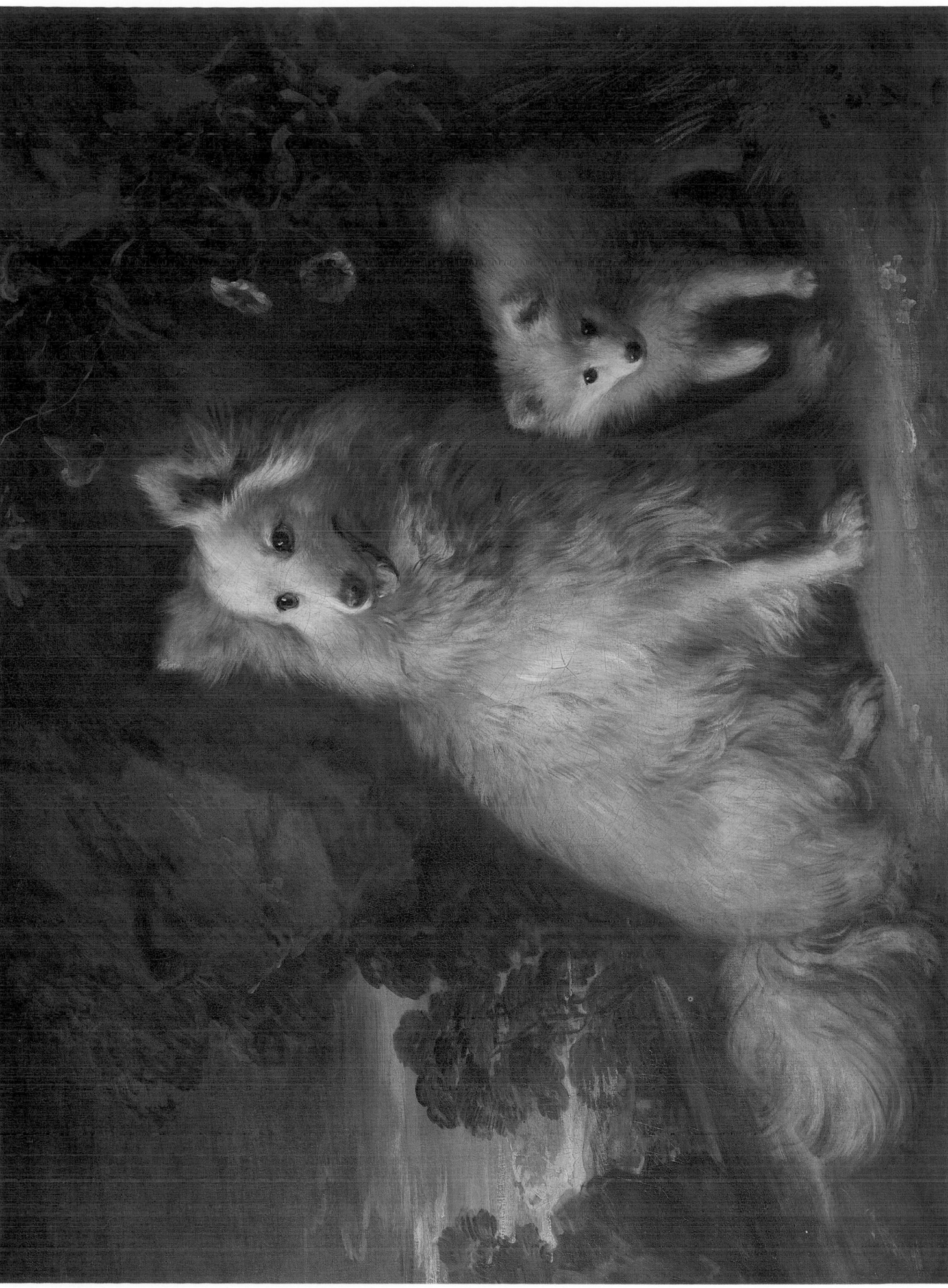

Louisa, Lady Clarges

1778. Oil on canvas, 126 x 100.5 cm. Holburne Museum and Crafts Centre, Bath

Sir Thomas Clarges, 'a modest young baronet', was one of the many visitors to Bath who fell in love with the singer Elizabeth Linley (see Plates 24 and 44). He proposed unsuccessfully to the 'siren' in 1772 and was so overcome by her refusal that he had to go abroad. However, by 1777 he had recovered sufficiently to marry Louisa Skrine and this portrait was probably commissioned to mark their union. Lady Clarges (d.1809) was a talented harpist and she and Sir Thomas patronized many of the leading professional musicians of the day, including Gainsborough's friend, Felice de Giardini.

The subject of this portrait was ideal for Gainsborough – a beautiful young woman, who was, furthermore, musical, and possessed of a fine instrument in the shape of a French harp. Given this happy coincidence, Gainsborough did not need to expend effort and imagination on creating a diverting background. Indeed, a dog which appears in a compositional sketch was dismissed as a distraction. The vague curtain and column function merely as blocks of colour against which woman and harp share the canvas as equal subjects. Louisa Clarges' hands are at the centre of the composition. Whereas the harp itself, and the strings, are depicted with straightforward accuracy and appreciation of workmanship, the edges of the fingers are fuzzy and without definite outline. This deliberate imprecision, which conveys both the movement and the delicacy of her plucking motion, is suggestive of the very creation of music.

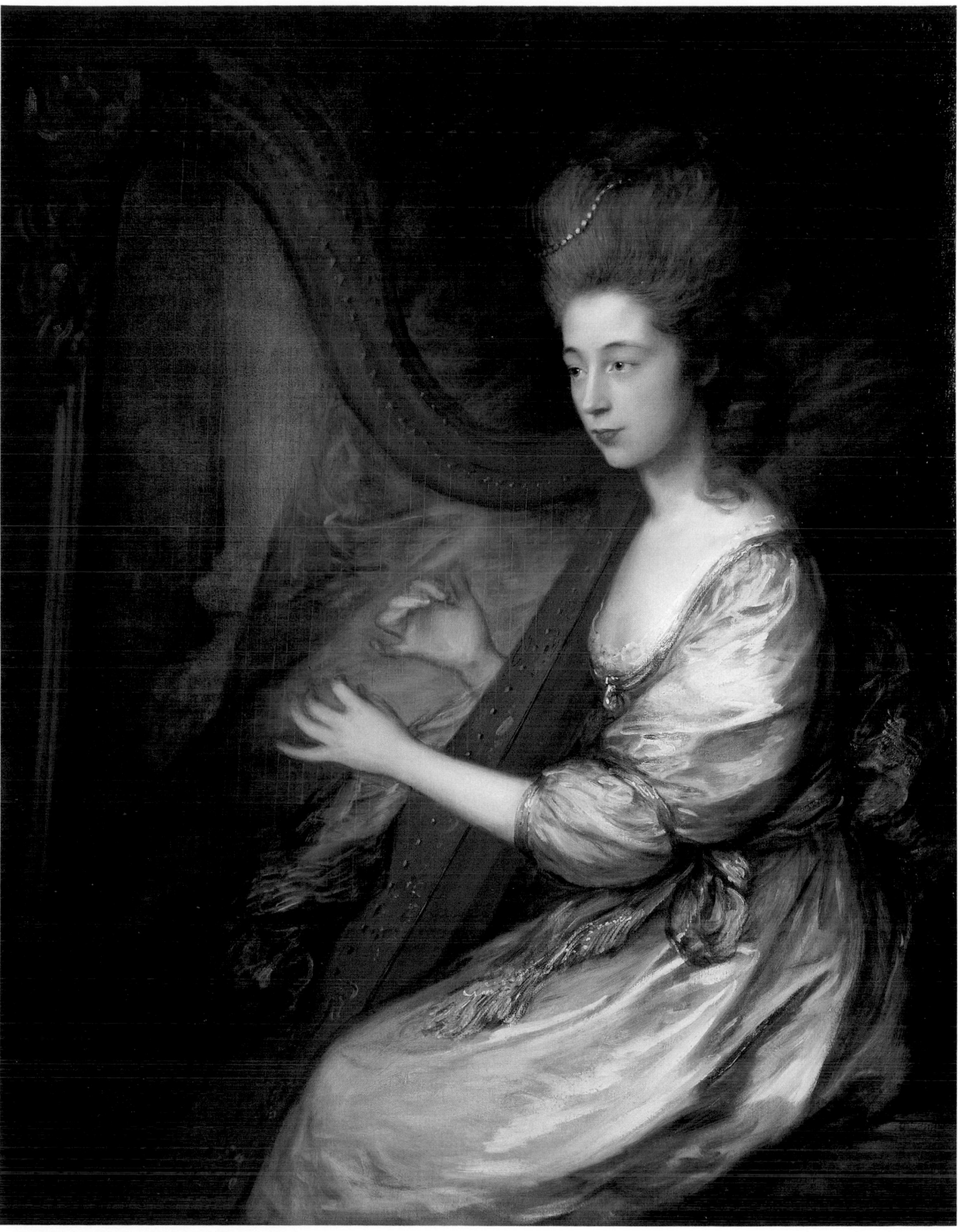

1778. Oil on canvas, 75.6 x 62.9 cm. Dulwich Picture Gallery, London

De Loutherbourg (1740–1812) was a German-born painter who had trained and worked in Paris. After moving to London in 1771, he made his reputation as a designer of innovative stage sets for the theatre. He also regularly exhibited landscapes and subject paintings at the Royal Academy. De Loutherbourg and Gainsborough knew each other well. Gainsborough was influenced by his friend's experiments with transparent images, especially the famous *Eidophusikon* – an entertainment of painted scenes on a miniature stage accompanied by dramatic effects of light, sound, movement and music. The *Eidophusikon* was first shown in February 1781 and Gainsborough was so impressed that 'for a time he talked of nothing else'. His own peepshow box and transparency paintings (see Figs. 12 and 13) were at least partially inspired by De Loutherbourg's presentation.

Here, while there is nothing specifically to indicate De Loutherbourg's profession, Gainsborough has captured the man's spirit and unusual intelligence. His torso is neatly tucked in upon itself and angled slightly away from the viewer. The faraway gaze is that of a man absorbed in his own world of speculative thoughts. Nothing is overworked in this portrait – a few swift strokes create the fine eyebrows, nose and mouth. The jacket has been quickly washed in with thin liquid browns barely covering the ground layer; two or three fat streaks of yellow impasto suggest the embroidery of the waistcoat.

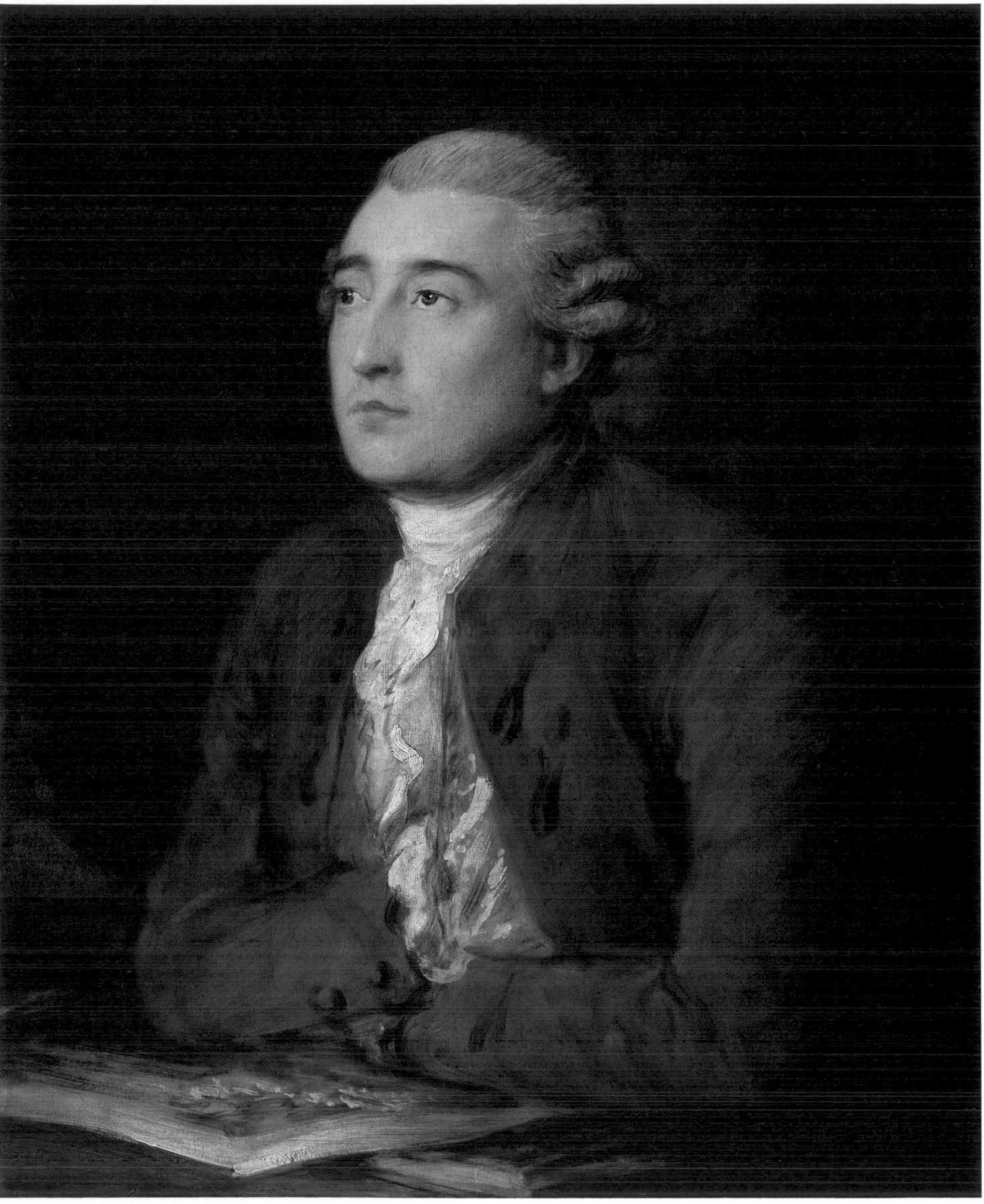

Mrs Gainsborough

*c*1778. Oil on canvas, 76.8 x 64.1 cm. Courtauld Institute Galleries, University of London, London

Gainsborough had been married for over 30 years by the date of this portrait. His marriage to Margaret Burr (1728–98) in London and away from parental influence, was, presumably, a love match, but the evidence of his letters suggests that while he loved her dearly, he was, with time, to judge her 'weak but good, and never much formed to humour my Happiness'. Gainsborough, who once described himself as 'deeply read in petticoats', remained susceptible to female charms all his life and did not resist temptation on jaunts to town with his male friends.

Nevertheless, this is a supremely tender portrait, imbued with the painter's intimate knowledge of his subject. Not that the image flatters: Mrs Gainsborough, though still handsome and striking, is quite definitely a woman on the cusp of being elderly. There are blue veins in her hands and her eyes have begun to sink into the bone structure. The slight hint of vanity in the gesture of her fingers entwining the lace mantle that frames her face is touchingly observed. Mrs Gainsborough's own expression, sweetly patient but also knowing and not uncritical, is Gainsborough's returned: no sitter, presumably, ever knew the painter as well as she did.

The quality of the paint is exquisite. In images such as this, Gainsborough, whose debt to Van Dyck is sometimes confined to a discussion of elegant poses, equals the Flemish painter in his ability to convey the translucence of fair skin.

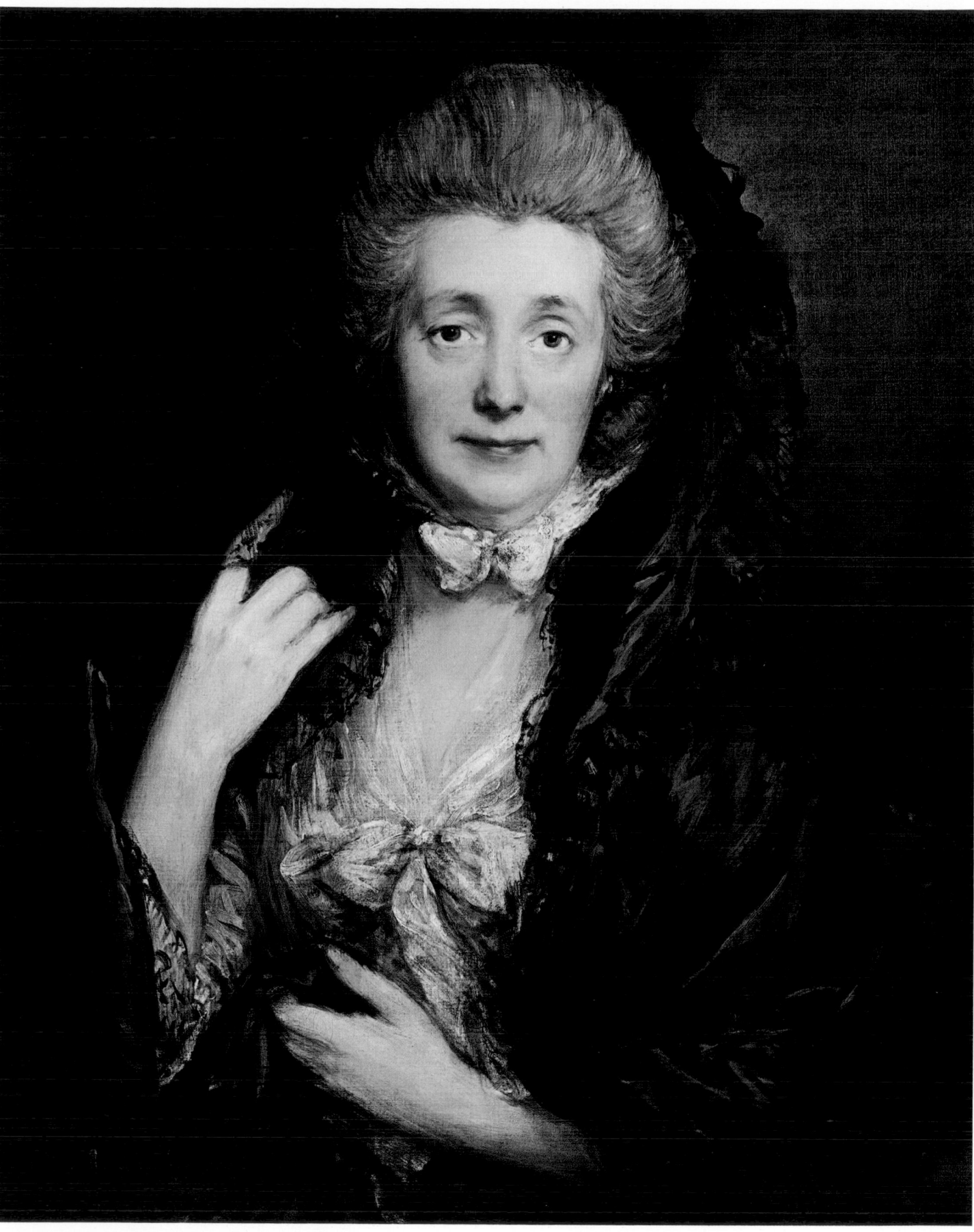

The Cottage Door

1780. Oil on canvas, 147.3 x 119.4 cm. Henry E Huntington Library and Art Gallery, San Marino, CA

Variations on the cottage door theme occupied Gainsborough from the early 1770s until the year of his death. All (see Fig. 33) are typified by the large size of the peasant family and the youthful elegance of the mother. In this example, the woman is particularly beautiful, with a fashionable high hair-style and *decolleté* neckline to her gown; her children, though overtly ragged, are cherubic and plump. The figures are framed by the arching structure of the tree on the left and the blasted trunk on the right, a structural device we see in other landscapes by Gainsborough (see Plate 17). A warm glowing light seems to radiate out from the depths of the canvas, an effect similar to Gainsborough's more experimental transparency paintings of this period.

A contemporary critic described this picture as 'a scene of happiness that may truly be called Adam's paradise' and the image does suggest a sentiment for a lost rural ideal. The family's tiny cottage is positively organic, a primitive home which has grown up beneath the sheltering trees, rather than a built structure. However, there is something almost threatening in the enormous size of the turbulent trees and the isolation of the family group.

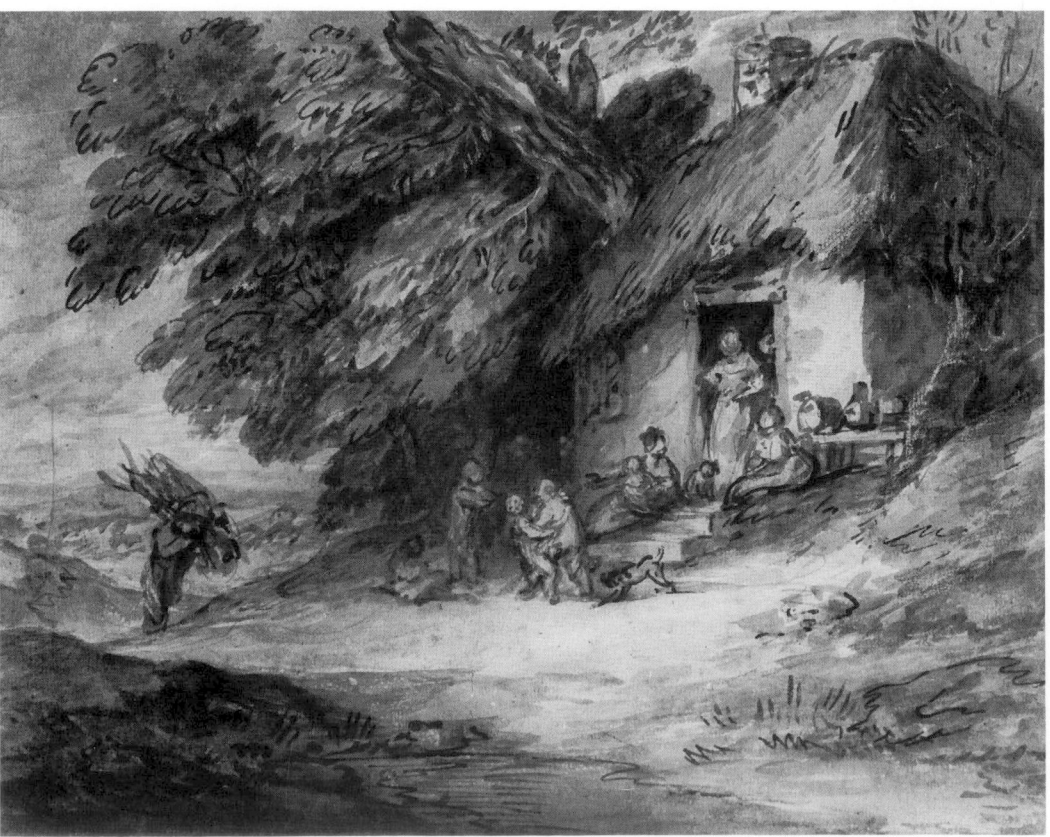

Fig. 33
The Cottage Door
*c*1778. White chalk on paper, 27 x 34.5 cm. Private collection

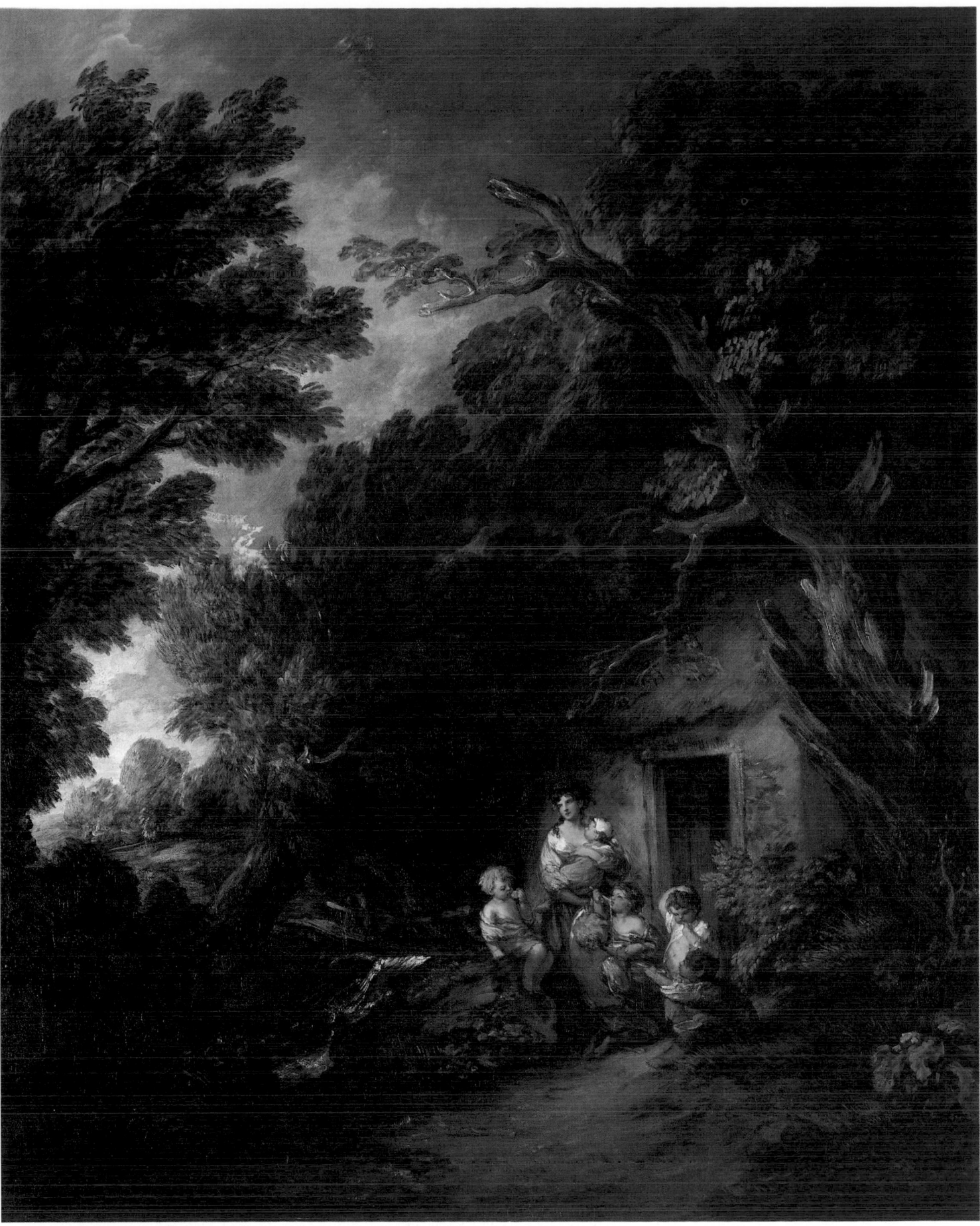

Girl with Pigs

1782. Oil on canvas, 125.6 x 148.6 cm. Castle Howard, Yorkshire

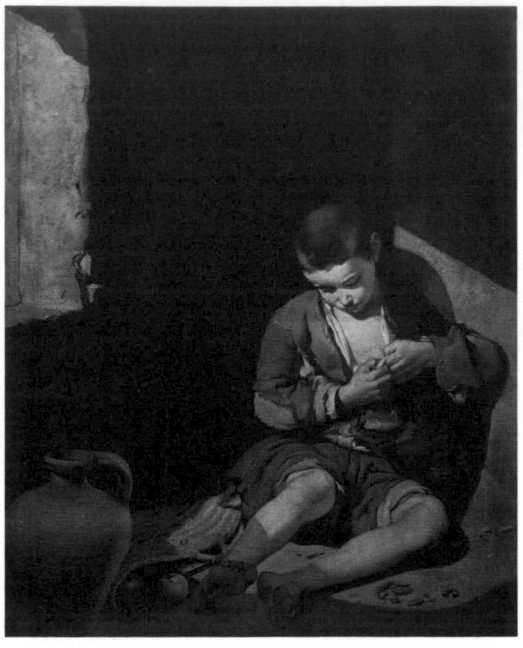

Fig. 34
BARTOLOMÉ ESTEBAN
MURILLO
The Young Beggar
*c*1645–50. Oil on canvas,
137 x 115 cm. Musée du
Louvre, Paris

This is an example of a fancy picture, the new type of subject which Gainsborough developed in the 1780s (see also Plate 46). The fancy pictures focus on the sort of peasant child found in Gainsborough's landscapes. They were among Gainsborough's most popular works. This painting, publicly shown at Schomberg House in 1782, was snapped up by no less a buyer than Reynolds, who felt that it was 'by far the best picture he [Gainsborough] ever painted'.

Gainsborough did not paint his fancy pictures from imagination. Many contemporary anecdotes record how he brought children in off the street as models, and, in this case, one visitor to the studio recalled the little pigs 'gambolling about his painting room'. But this direct observation of the object should not be confused with realism. This was not rural documentary – pigs and girl were posed in Gainsborough's studio in Pall Mall, London, in the manner of a Murillo painting (see Fig. 34). One country man who saw the picture praised the verisimilitude of the animals, remarking, 'they be deadly like pigs', but, with the practical wisdom of a stockman overcoming admiration of artistic decorum, he added, 'but nobody ever saw pigs feeding together but what one on' em had a foot in the trough.'

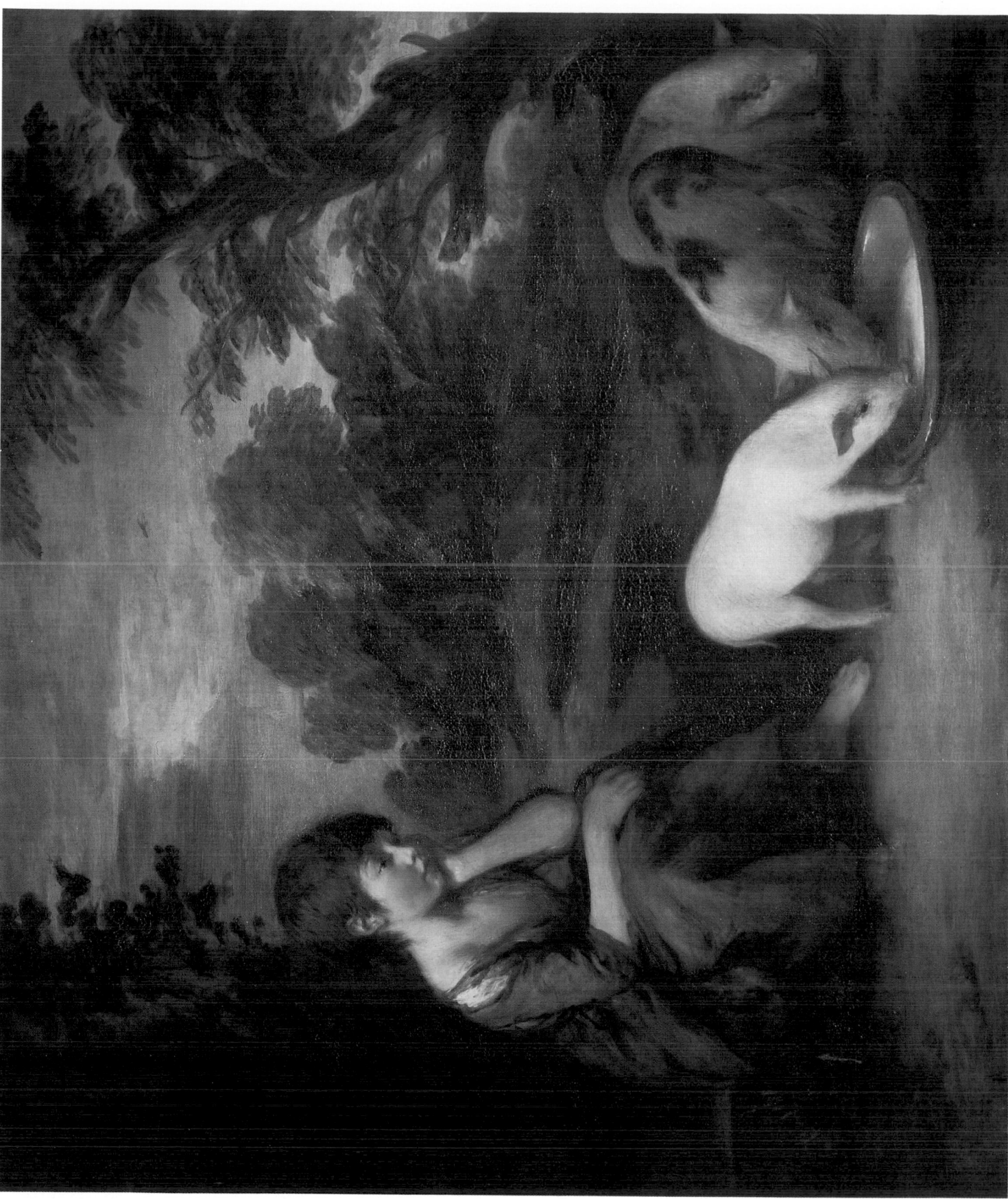

Miss Haverfield

*c*1782. Oil on canvas, 126 x 101 cm. Wallace Collection, London

Fig. 35
SIR JOSHUA REYNOLDS
Miss Bowles
*c*1775. Oil on canvas,
91 x 71 cm. Wallace
Collection, London

In the latter part of the eighteenth century, it became increasingly common for children to be the independent subjects of portraits and Gainsborough and Reynolds received numerous such commissions. In the past, children had usually been painted as miniature adults, but in the work of Reynolds the period's discovery and enjoyment of childhood as a separate state of cherishable innocence is clearly manifest. *Miss Bowles* (Fig. 35) is a typical example. Reynolds makes much of Miss Bowles's impulsive gesture and draws a parallel between the face of the little girl and her pet. The effect is charming and sentimental. Gainsborough's portrait of Elizabeth Haverfield, the daughter of the superintendent gardener at Kew, adopts a very different approach. The image is understandably more formal than his paintings of his own girls (see Plate 9 and Fig. 25) but Gainsborough has depicted Miss Haverfield almost as he would a grown woman. There is nothing specifically childish about her pose or her serious expression, as she ties her mantle about her shoulders. Arguably, this shows a particular sensitivity to the individuality of the child and, for the adult painter and viewer, there is a slightly melancholy awareness of the contrast between Miss Haverfield's evident composure and her extreme youth.

The portrait is typical of Gainsborough's late style. Thin paint in harmonious pinky-greys, greens and browns has been quickly washed in to suggest the landscape background. The trees, full of movement, are no more than summary strokes of the brush. Although Miss Haverfield's face is, as ever, quite finely painted, her costume is an arena for Gainsborough's bold technique, for example, in the black and grey zigzag lines of paint which indicate the folds of the mantle. Gainsborough clearly enjoyed painting Miss Haverfield's bonnet.

Giovanna Baccelli

1782. Oil on canvas, 226.7 x 148.6 cm. Tate Gallery, London

Gainsborough exhibited this portrait of the Italian dancer, Giovanna Baccelli (d.1801), at the Royal Academy exhibition in 1782. Baccelli was notorious as the mistress of the Duke of Dorset, and when she danced in Paris she wore his blue ribbon of the Garter on her leg. Gainsborough seems to have had a particular affinity with the glamorous adventuresses of the late eighteenth century, and was very popular with them. One rather judgmental commentator felt that because Gainsborough depicted so many 'women that were painted', all his females had an air of the *demi-monde*. Baccelli is literally painted, according to the fashion of the day, with a whitened face and high-coloured cheeks and lips.

The picture is a superb example of Gainsborough's skillful use of paint to create a harmony of colour across the whole canvas. The blue, white and pinky-grey of Baccelli's extravagantly pretty dress are used in the sky. Greeny-brown sketchy strokes on her skirts above her right foot echo the shades of the feathery trees. Through the complex position of her body, the fluttering of ribbon and shimmering of light on her skirts, Gainsborough has created an illusion of Baccelli, the dancer, in graceful movement rather than in a static pose.

Coastal Scene – a Calm

1783. Oil on canvas, 156.2 x 190.5 cm. National Gallery of Victoria, Melbourne

In the last decade of his life, Gainsborough deliberately extended the range of his landscapes (see Plate 39), and 1781 saw his first exhibited seascape, *Coast Scene, Selling Fish* (Fig. 36). Two years later, Gainsborough sent this picture to the Royal Academy where it was described as 'Sea-piece – A Calm'. The painting is also known as 'A View of the Mouth of the Thames', a title first given to it in the nineteenth century. However, this identification to a specific locale seems unlikely given Gainsborough's usual approach to landscape. This scene is perhaps best understood as an imaginative homage to the work of the Dutch seventeenth-century sea-painters, especially the Van de Velde family and Ludolf Bakhuyzen (1631–1708).

On the whole, Gainsborough's forays into this genre received considerable acclaim. Walpole felt that they were 'so free and natural that one steps back for fear of being splashed' and Gainsborough's obituarist judged them as proof of his 'power in painting water' and added that 'nothing can exceed them in transparency and air'. Interestingly, two paintings on glass of this same scene survive. These, used in the peepshow box (Fig. 12), would have helped Gainsborough explore the effects of watery translucence which he then translated with fluid oil onto canvas.

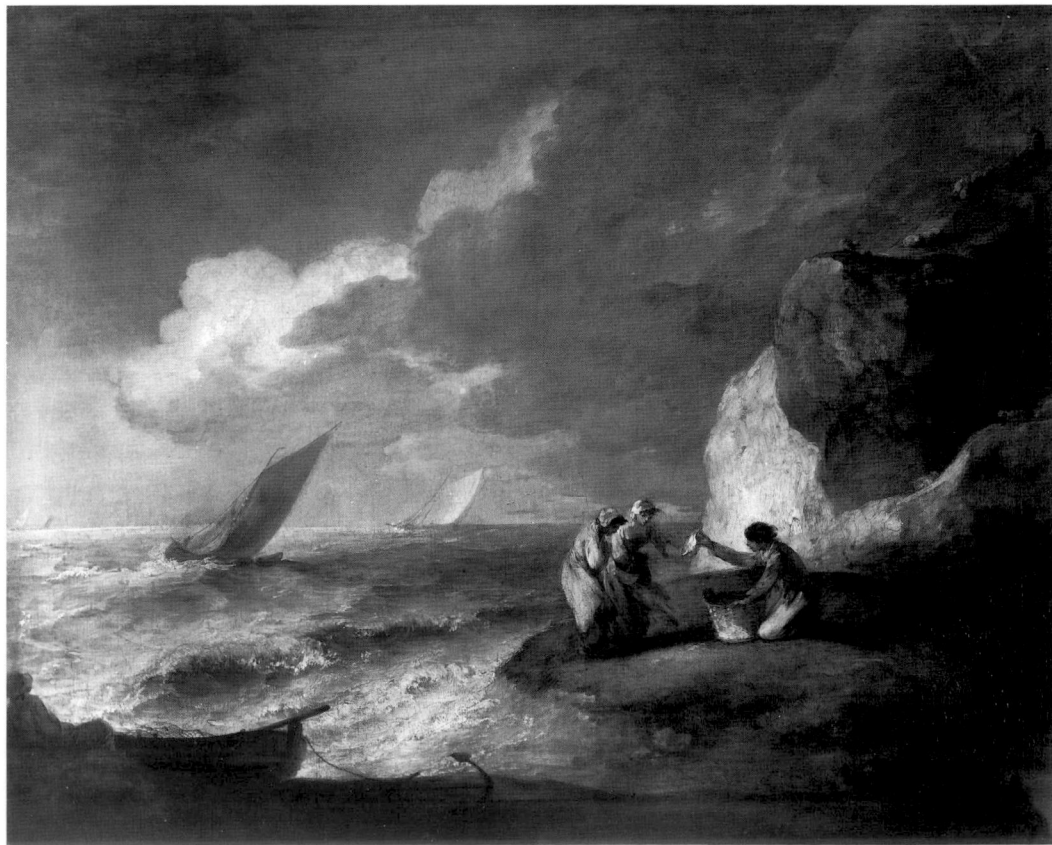

Fig. 36
Coast Scene,
Selling Fish
1781. Oil on canvas,
100.3 x 127 cm. Grosvenor
Estates Company,
London

1783. Oil on canvas, 120.7 x 147 cm. Frick Collection, New York, NY

Fig. 38
JEAN HONORÉ
FRAGONARD
The Shady Avenue
*c*1773. Oil on panel,
29 x 24 cm.
Metropolitan Museum of
Art, New York, NY

In November 1783, Henry Bate, the editor of the *Morning Herald*, wrote: '*Gainsborough* is at work on a magnificent picture, in a stile new to his hand...a park with a number of figures walking in it.' The following summer, when the painting was exhibited at Schomberg House he explained it as a '*view*, altho' not taken from *St. James's Park*, will perfectly well apply to that resort of gaiety...The *mall* appears full of Company.' Bate classified the elegant strollers as 'women of *fashion*, women of *frolic*, *military beaus*, and *petit maitres*; with a grave *keeper* or two...' As to action: 'Looks of *characteristic* signification, appear to be mutually exchanged by some of the groupe in passing: and others on the benches, appear making their comments.' This contemporary description conveys the flirtatious and amusing atmosphere of London's pleasure grounds, gardens and fashionable promenades.

Gainsborough was keen to emphasize that his subject was 'strictly from nature', correcting his friend Bate, who, in his earlier report had made an understandable reference to work of Watteau (Fig. 37). But the two claims were not mutually exclusive – society mirrored the amorous park scenes found in the paintings of Watteau and his followers. Gainsborough's painting can also be compared to the work of his nearer French contemporary, Fragonard. In both Gainsborough and Fragonard's work, the super-abundant foliage seems charged with a vital force (see Fig. 38). *The Mall*, despite rumours that it had been painted at the request of George III, remained in Gainsborough's studio and was not sold until after his death.

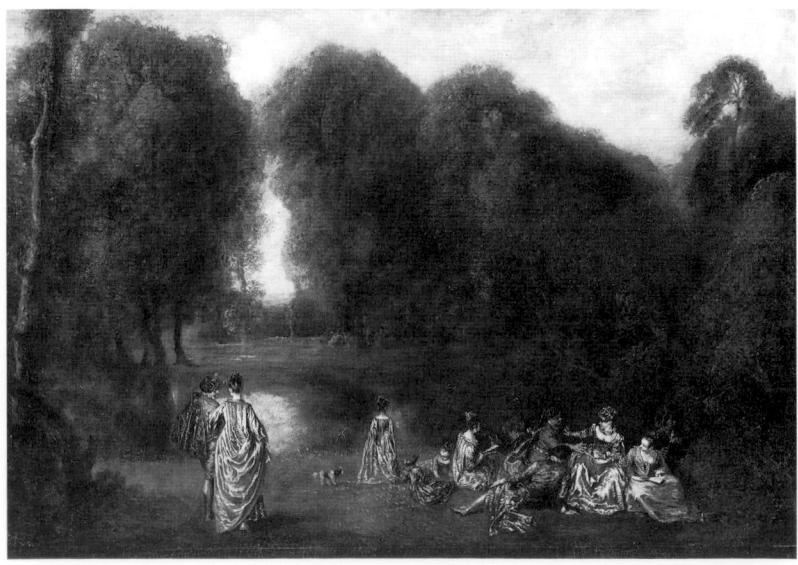

Fig. 37
ANTOINE WATTEAU
Gathering in a Park
1716–17. Oil on panel,
32.4 x 46.4 cm.
Musée du Louvre, Paris

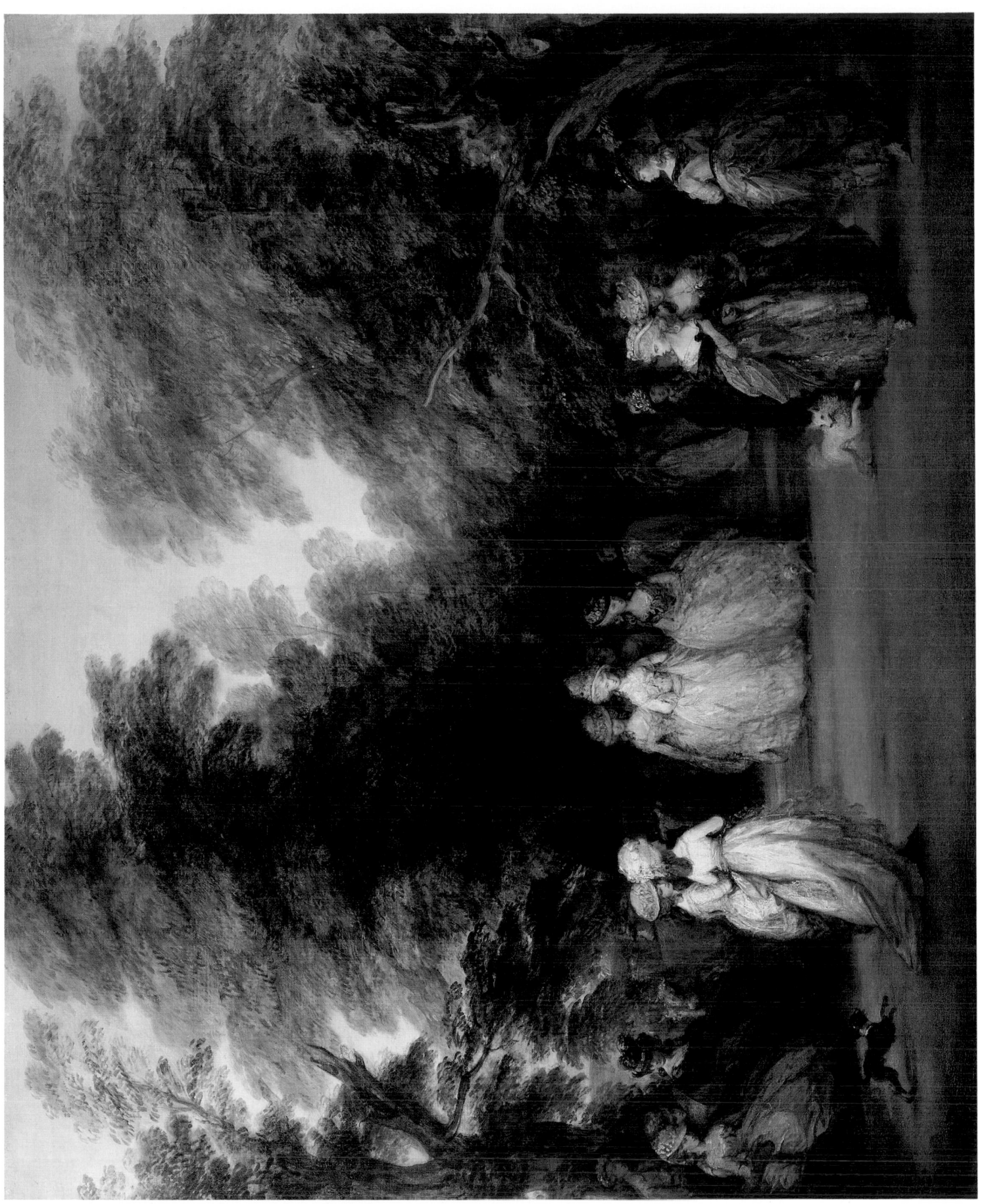

1783. Oil on canvas, 120 x 148.6 cm. Neue Pinakothek, Munich
(on loan from Bayerische Landesbank, Munich)

One of the most significant effects of the eighteenth century's discovery of nature was the growth of interest in, and appreciation of, savage and mountainous scenery, which had previously been both feared and avoided. Gainsborough went on a sketching tour to the Lake District, the wildest part of England, in the summer of 1783. In a letter written before the trip, he declared his intention 'to show you that your Grays and Dr. Brownes [sic] were tawdry fan-Painters. I purpose to mount all the Lakes at the next Exhibition, in the great stile.' These references show that Gainsborough was well aware of current taste and was keen to experiment with a new and popular theme in his future landscapes. Thomas Gray, the lyric poet, had written a journal of his visit to the Lake District in 1769, which was published in 1775, and Dr John Brown's *Description of the Lake at Keswick* had appeared in 1772.

Gainsborough did not, in fact, exhibit at the next Royal Academy exhibition (see Plate 41) and whether or not his pictures of mountain scenery are fully successful is debatable. As an idyllic evocation of an upland pastoral scene, this painting has undoubted charm, but the atmosphere has none of the impressive, awesome grandeur which visitors to the Lake District expected. The overriding impression is that the artist has created the composition and John Hayes, the leading authority on Gainsborough's landscapes, has suggested that this is an instance where we can observe the result of Gainsborough's little models of rocks and mosses intervening between 'idea and execution'. Certainly there is none of Gray's specific description of the characteristic detail of the Lake District, nor is there any attempt by Gainsborough to convey the insignificance of man before the sublimity of nature, as the Romantic poet William Wordsworth was shortly to do. This picture was painted for the Prince of Wales but remained in the studio and was not paid for until after Gainsborough's death.

1783. Oil on canvas, 223.5 x 157.5 cm. Iveagh Bequest, Kenwood, London

Gainsborough exhibited this picture at the Royal Academy in 1783. In a letter to the treasurer of the Royal Academy, the architect Sir William Chambers, he described it thus: 'I sent my fighting dogs to divert you. I believe next exhibition I shall make the boys fighting & the dogs looking on – you know my cunning way of avoiding great subjects in painting & of concealing my ignorance by a flash in the pan.' These comments are typically self-deprecating and underline Gainsborough's conscious distance from the traditional themes of high art, which was concerned with history and religious painting. At a time when many British painters felt that only these subjects were truly important, and Reynolds was proclaiming exactly this to the future generation of artists in his annual lectures at the Royal Academy, Gainsborough never lost his impatience with 'Poetical impossibilities'. However, this image is not the simple rustic scene Gainsborough claimed.

The fight is no squabble over a bone; the reddish-brown animal is literally the underdog and the jaws of the aggressor, the black dog, will in the next second close on his throat and blood will be spilled. The shepherd boys match the colour of their dogs and the auburn-haired boy, his face contorted with effort, is desperately trying to break up the fight. The figure of the dark-haired boy, who prevents his companion from separating the dogs, is both beautiful and monstrous. If we were to judge his face as a character apart from the rest of the painting, we might consider him the more attractive boy, with a pretty smile on his angelic face, but in this situation his delight is a smirk of pure cruelty. Behind the smoke-screen of his casual words, Gainsborough has created a work of seriousness, sadness and complexity, for he seems to suggest that, although sheep may safely graze, the idyll of the pastoral is not always to be believed.

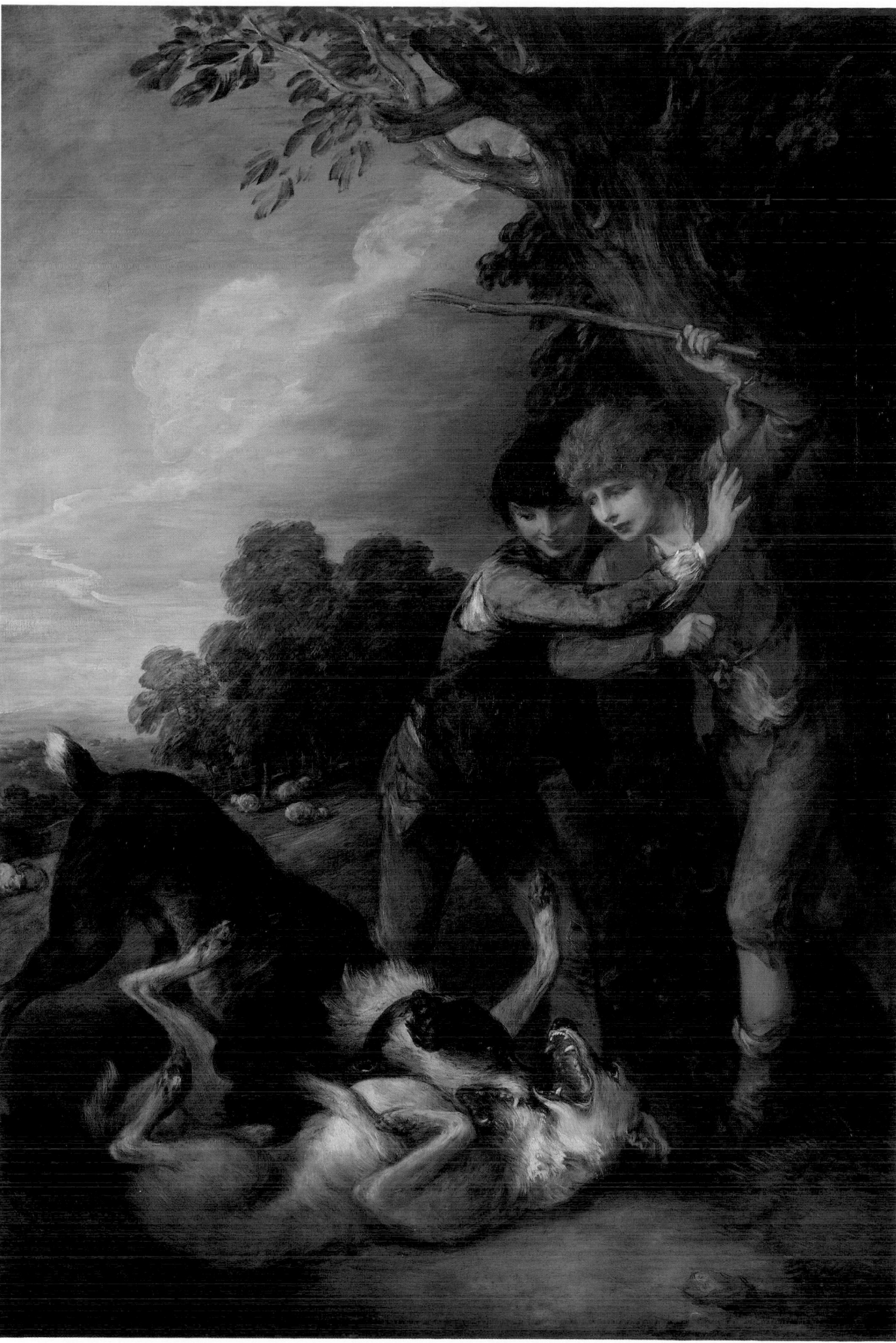

1784. Oil on canvas, 129.5 x 179.8 cm. Royal Collection

This portrait was at the centre of the dispute between Gainsborough and the Royal Academy which resulted in the irrevocable rupture of their relations. Gainsborough had painted the three elder daughters of George III at the request of the Prince of Wales, their brother. The picture was intended for a specific location at Carlton House, London, where it was to be placed at about five and a half feet above the ground. The finished portrait was sent, along with 17 other works, to the Royal Academy exhibition of April 1784. Larger paintings, such as this, were always hung above the level of the doors, a height of about eight to nine feet known as the 'line'. Artists, including Gainsborough, would deliberately heighten their effects by increasing contrasts, brightening colours and emphasizing features, in order that pictures placed high up would still stand out. But, on this occasion, and for this painting, Gainsborough asked the Hanging Committee to make an exception. They refused and he withdrew all his works:

> Mr. Gainsborough's Compls to the Gentlemen of the Committee, and begs pardon for giving them so much trouble; but as he has painted the Picture of the Princesses, in so tender a light, that notwithstanding he approves very much of the established Line for strong Effects, he cannot possibly consent to have it placed higher than five feet & a half, because the likenesses & Work of the Picture will not be seen any higher...he will not trouble the Gentlemen against their Inclination, but will beg the rest of his Pictures back again.

The painting was exhibited at Schomberg House the following July. Gainsborough's description of the portrait as being painted in a 'tender light' well describes its delicacy and his avoidance of harsh contrasts of tone. Princess Charlotte (1766–1828) is flanked by Princess Augusta (1768–1840) to the left, and Princess Elizabeth (1770–1840) seated at the right. The three figures form a harmony of refined colour, from their powdered hair and porcelain complexions to their gowns in subtle fondant shades, softened further by overlaid layers of gauze and lace. Ironically, the painting was cut down from its original full-length size early in Queen Victoria's reign in order that it should fit above a door.

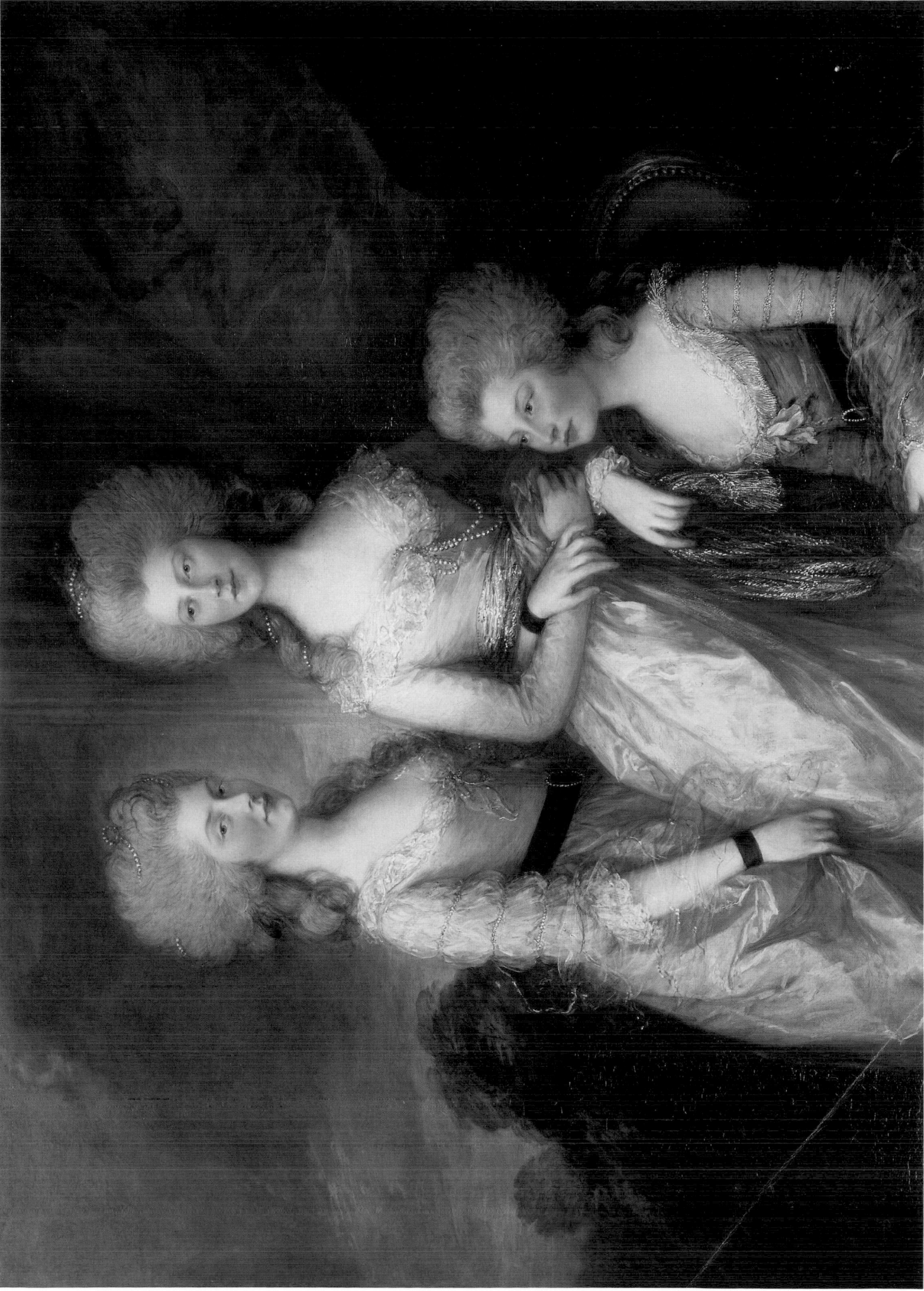

Dogs Chasing a Fox

1784–5. Oil on canvas, 177.8 x 236.2 cm. Iveagh Bequest, Kenwood, London

Here, in an exercise similar to the *Shepherd Boys with Dogs Fighting* (Plate 40), Gainsborough explores and extends the imagery of animal painting, a genre traditionally regarded as limited and low in comparison with the high art of the great Italian masters. Gainsborough bought works by the Flemish painter of hunting scenes, Frans Synders, but in this instance he seems to have been inspired by a specific example that he would have seen at Corsham Court (Fig. 39) when he lived in Bath. But whereas a typical Flemish animal picture remains descriptive and without much empathy, Gainsborough invests his subject with palpable pain and emotion. It is difficult not to identify with the outrun fox, who turns, snarling, to the hounds, larger and quicker than him. The dogs, embodiments of swiftness, have less individual character.

The paint is thinner and less colourful than in *Shepherd Boys with Dogs Fighting* (Plate 40) and the image has a translucency normally associated with watercolour. Gainsborough conveys the speed and agility of the running animals with fluid, visible brushstrokes. The coarse hair of the dogs, flattened by the rush of air, contrasts with the softer fur of the crouching and stilled fox. The shapes of the dogs are described in exaggerated lines and curves, and the way in which the white dog's leg extends beyond the canvas, adds to our sense that this is a sudden eruption of violence and death into an otherwise empty landscape.

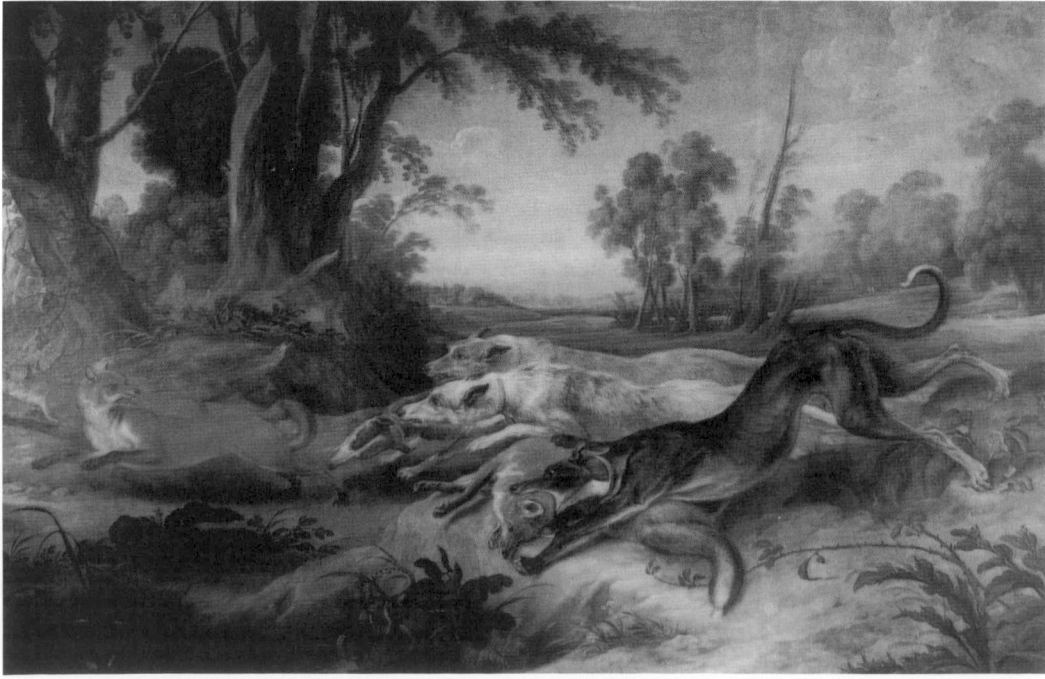

Fig. 39
FRANS SNYDERS
The Fox Hunt
*c*1640. Oil on canvas,
202 x 330 cm. Methuen
Collection, Corsham
Court, Wiltshire

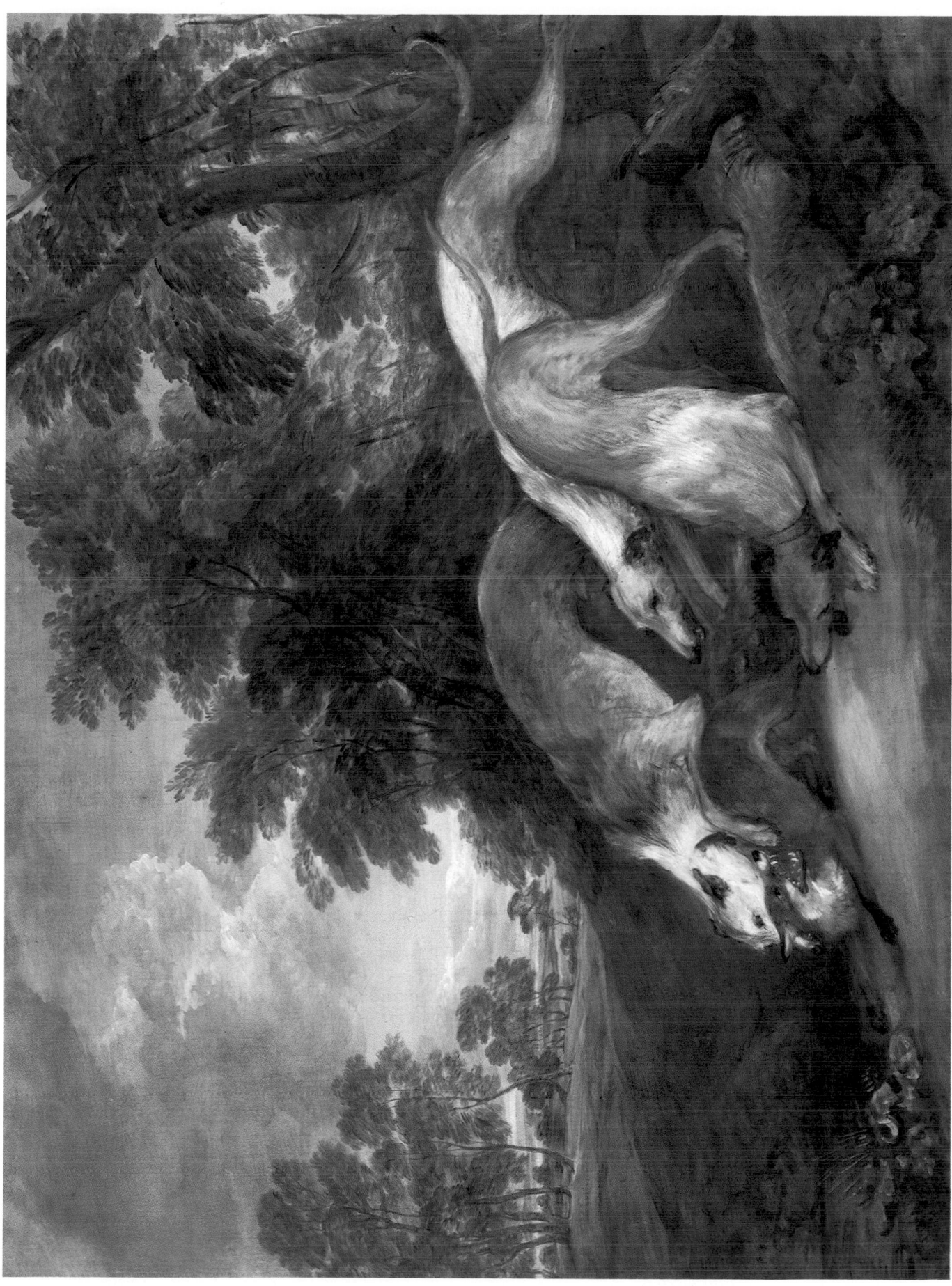

Mrs Siddons

1785. Oil on canvas, 126.4 x 99.7 cm. National Gallery, London

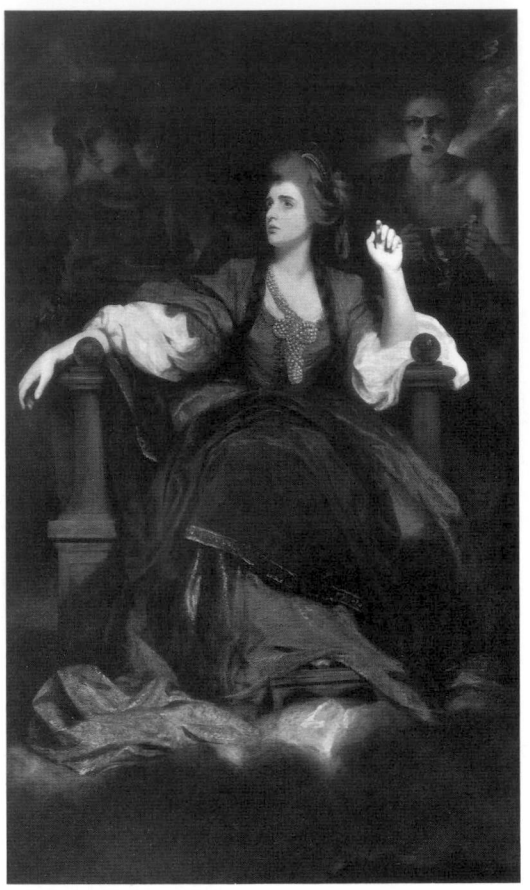

Fig. 40
SIR JOSHUA REYNOLDS
Mrs Siddons as the
Tragic Muse
1784. Oil on canvas,
236.2 x 146 cm.
Henry E Huntington
Library and Art Gallery,
San Marino, CA

A comparison of Reynolds's portrait of Mrs Siddons (Fig. 40), exhibited at the Royal Academy in 1784, with that by Gainsborough, shows the two artists at their most divergent. Reynolds's portrait of the great actress illustrates his belief that a supposedly low genre of art, such as portraiture, could be elevated by the infusion of a higher genre. He does this by borrowing motifs, in this example, from Michelangelo's Sistine Chapel and by using similar colouring and light to Rembrandt. Arguably, the somewhat overblown theatrics of this conceit are appropriate to the professional persona of Sarah Siddons (1755–1831), who was at this time the undisputed queen of tragedy on the London stage, but Gainsborough's portrait is the more revealing. Again he explores a tension between the sitter's face and body to suggest the complexities of character. Mrs Siddons's costume, which was particularly '*novelle*', according to the Press, is almost alive, with scintillating twists and curves of colour and texture – a virtuoso performance in paint. Her face, in contrast, is highly finished and, in expression, utterly composed. Mrs Siddons, the great performer, in contrast to Giovanna Baccelli (Plate 36), makes no attempt whatsoever to engage the spectator but fixes her gaze inscrutably ahead of her.

This portrait seems not to have been a commission. It was seen, unsold, in Gainsborough's studio the following year, which suggests that it may have been painted deliberately to rival Reynolds.

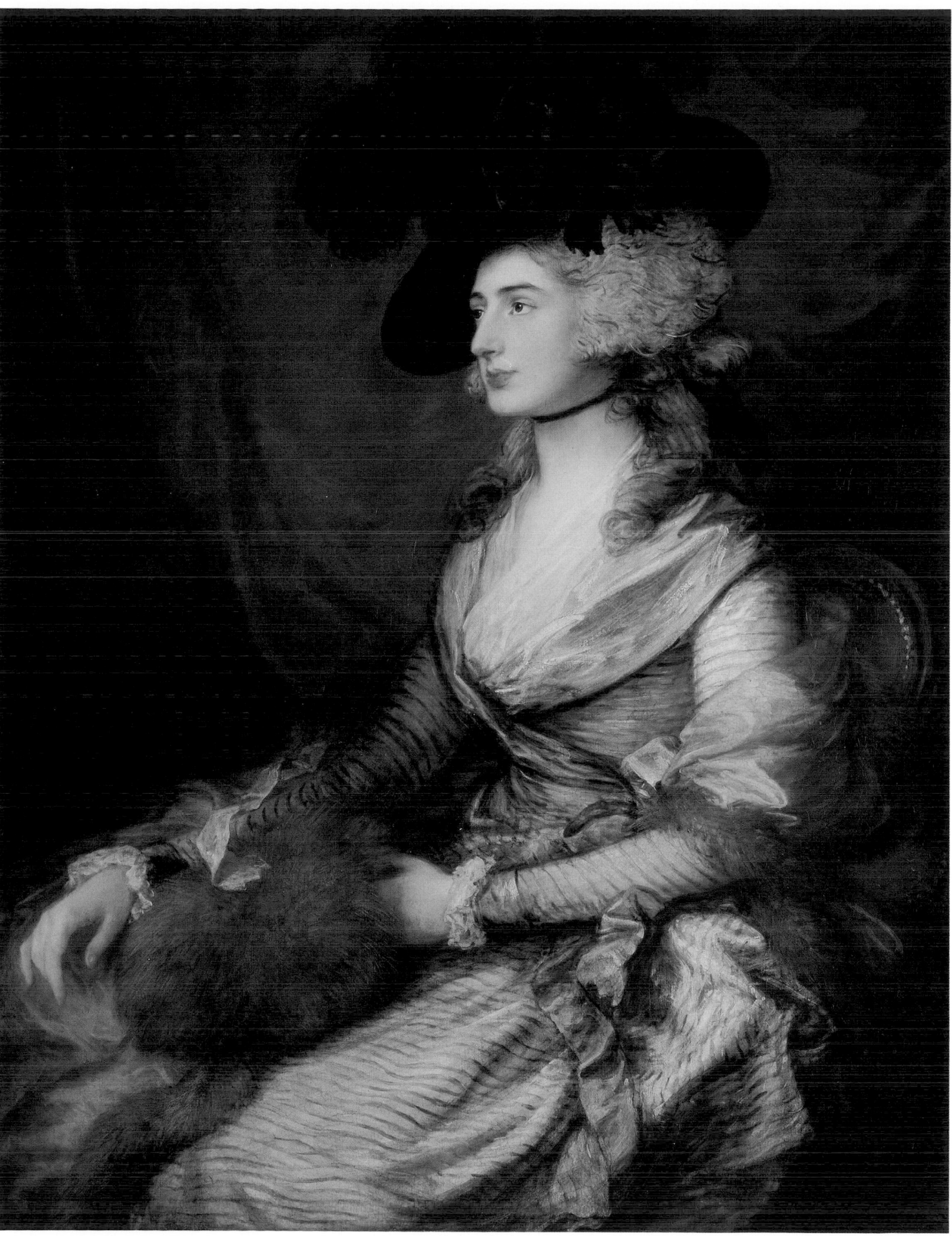

Mrs Sheridan

1785. Oil on canvas, 219.7 x 153.7 cm. National Gallery of Art, Washington DC

Gainsborough had known Mrs Sheridan, née Linley, (see Plate 24) since she was a girl, and he no doubt had some inkling of the tribulations of her married life. Her public singing career had been terminated by her husband and the couple had spent the first years of their marriage working together at the Drury Lane theatre – Elizabeth helped Sheridan considerably with his writing and did the accounts. By the time of this portrait, however, Elizabeth was a political wife (Sheridan had entered parliament in 1780) and her life was a hectic round of social engagements. Sheridan was spectacularly unfaithful to Elizabeth and had numerous and well-known affairs with several society beauties. Elizabeth, ill with tuberculosis, died seven years after this portrait was painted, her longings for 'a little quiet home' never fulfilled.

Given Gainsborough's long-standing admiration and affection for Elizabeth Sheridan, it seems likely any sense of tension in this image between the turbulent movements of the windy landscape and the figure's stillness is quite deliberate. Nature, agitating Elizabeth's hair and gauzy dress, is a metaphor for her own restless but constrained unease. The portrait, unlike the generality of Gainsborough's later depictions of glamorous women in landscape settings, is quite definitely expressive of this specific character, who, with her sad beauty, seems to have been made for this Romantic style.

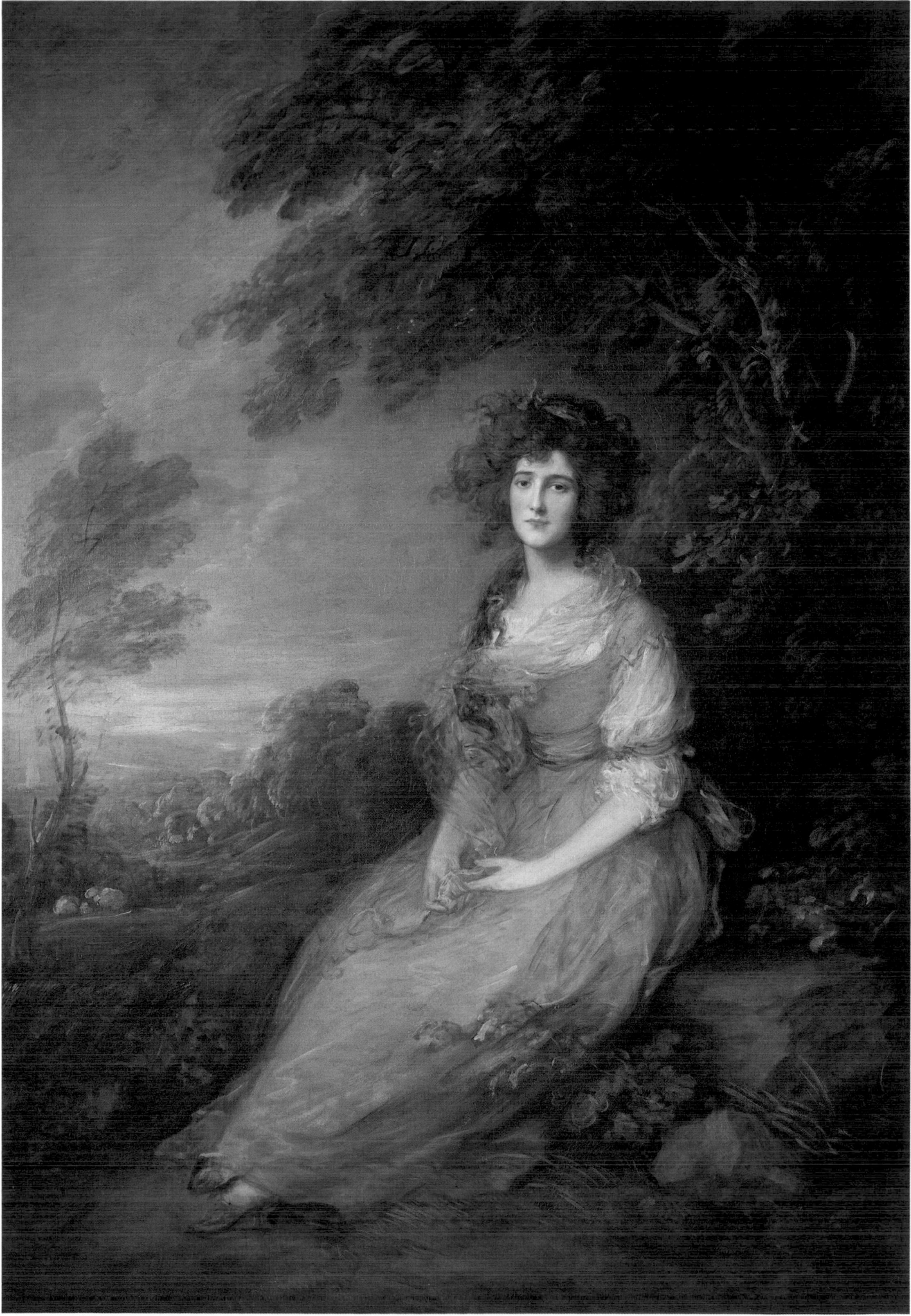

1785. Oil on canvas, 236.2 x 179.1 cm. National Gallery, London

Looking from *Mr and Mrs Andrews* (Plate 5), that other depiction of newlyweds in a landscape, to this portrait of Mr and Mrs Hallet, the distance travelled by Gainsborough over nearly four decades seems immense. Sitters in the conversation pieces of the 1740s and 1750s demonstrated their fashionable informality through their choice of setting. The same basic idea has, in this full-length portrait of William Hallet (1764–1842) and his new wife, Elizabeth (1763/4–1833), become a vehicle expressive of utmost elegance. The rather jolly approachability suggested by the earlier style has been superceded by an aristocratic and inward melancholy.

This couple, with their elongated bodies, are physically fused to the charming parkland through which they stroll by harmonies of colour, characterized by a highly controlled palette dominated by cool greens and pearly greys. The way in which the ground shows through in sketchy areas of both Mrs Hallet and the landscape, creates the impression that the couple are literally emerging from nature. This nature is, of course, no more realistic than Gainsborough's Rococo landscapes of the 1750s.

The Morning Walk (and that this painting is better known by this impersonal title is significant) is a good example of Gainsborough's late portrait style in which, allowing for some exceptions (see Plate 44), it has been convincingly argued that individual character is sacrificed to the overall Romantic mood.

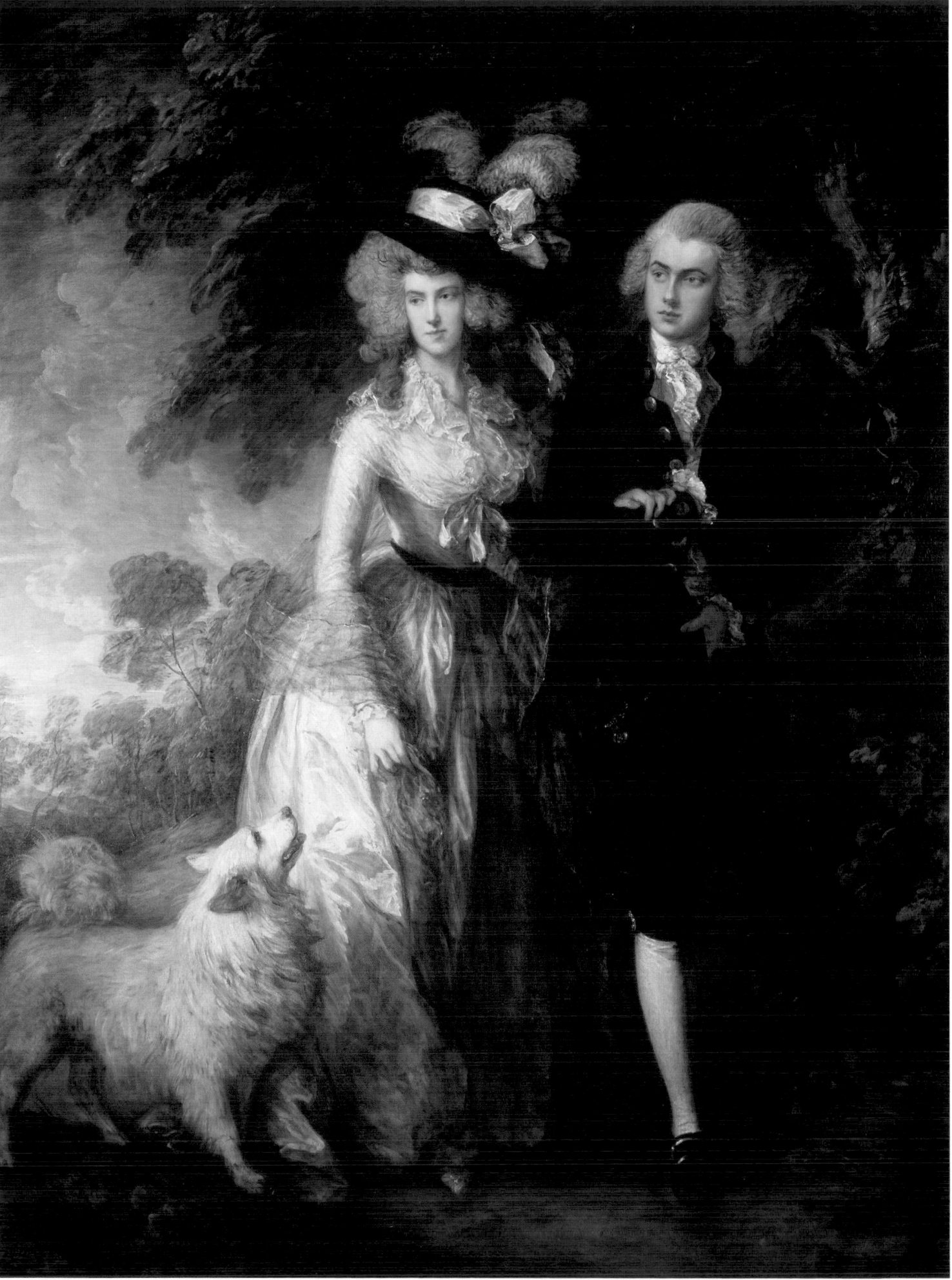

Girl with Dog and Pitcher

1785. Oil on canvas, 174 x 124.5 cm. National Gallery of Ireland, Dublin

In the 1780s, Gainsborough, although not interested in the pompous stories of grand manner painting, responded to the ever-present challenge of traditional high art with his fancy pictures. With this image, Gainsborough creates a significant subject, not from any particular event, but in the sentiment embodied by the girl's faraway expression. Contemporary audiences would have been touched by the contrast between the child's sensitive physiognomy and her ragged clothes, and the fact that any direct appeal issues from the soft brown eyes of the puppy, while the girl looks to the side, unaware of the viewer.

The period as a whole was an age of 'sensibility', and Gainsborough himself, as we have seen, was particularly susceptible to feelings of the heart before scenes of rural innocence and poverty (even when reproduced in his London studio). At a time when sentiment was less fashionable, or perhaps just more commonplace, the nineteenth-century critic William Hazlitt condemned Gainsborough for painting 'an ideal common life' rather than reality, and snidely observed that the dog 'looks as if it had been just washed and combed'. But he misinterpreted Gainsborough's motivation, and forgot that his own idea of a 'simple, unaffected nature' would not have been possible without its sentimental discovery in the 1780s.

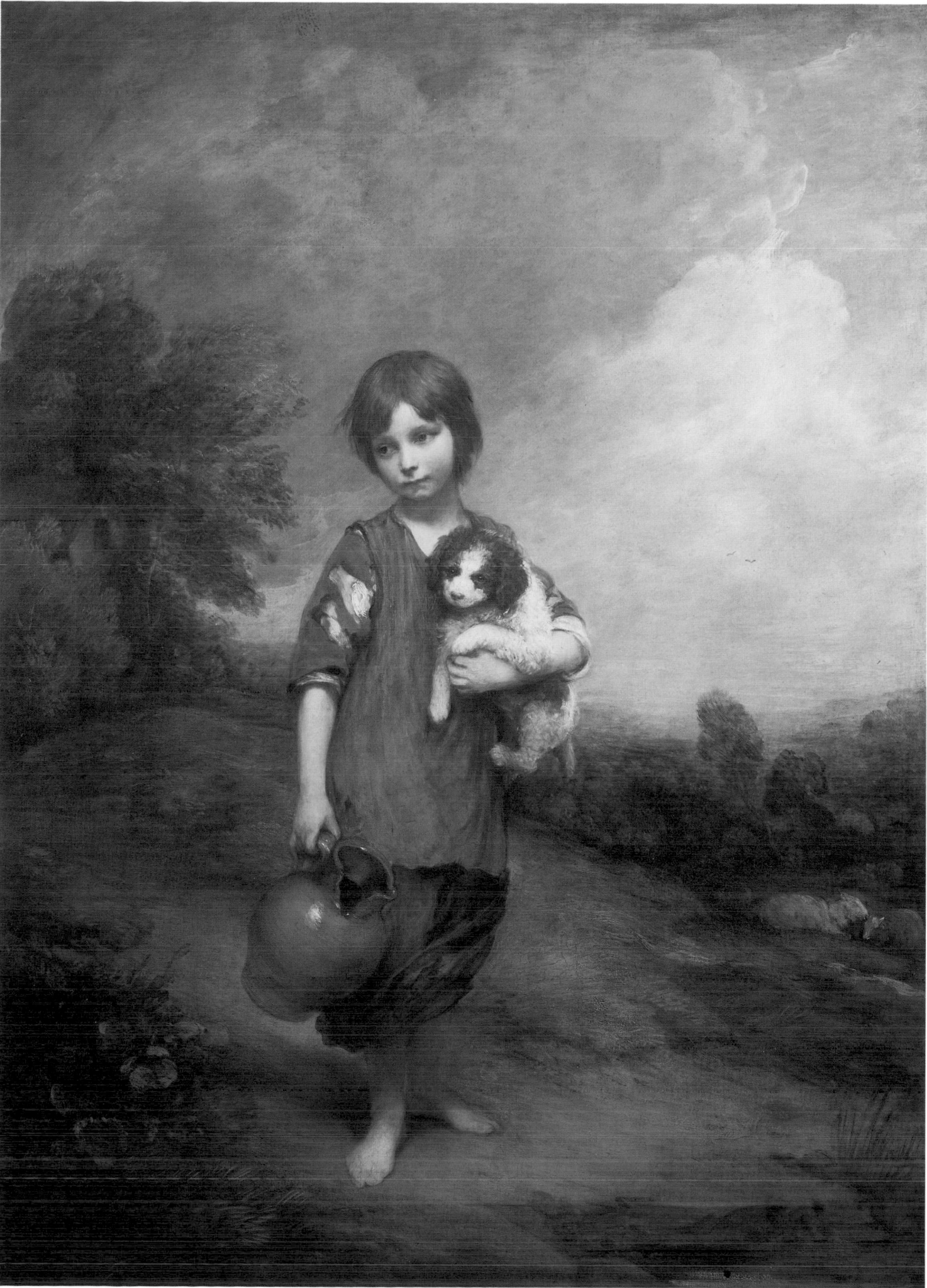

47

Diana and Actaeon

c1785. Oil on canvas, 158.1 x 188 cm. Royal Collection

The legend of Diana and Actaeon was best known from its telling in the *Metamorphoses*, by the Roman poet Ovid, a classic and much translated text. Actaeon, while out hunting, inadvertently glimpsed the Goddess Diana bathing naked with her nymphs. Furious at this intrusion, she splashed Actaeon with water and turned him into a stag. Actaeon was subsequently torn apart by his own dogs. This example of Gainsborough taking a story from the literature of myth, the traditional food of grand manner artists, is unique in his *œuvre*. *Diana and Actaeon* is an example of Gainsborough's experimentation with subject-matter during the 1780s (Fig. 41), but unlike the fancy pictures, the work was not commented on at the time. It was never exhibited and remained in his studio until his death.

For all Gainsborough's protests that he (in implied contrast with Reynolds) 'never could have patience to read Poetical impossibilities', the one time he appears to have done so, he did not, as he feared 'make himself ridiculous by attempting it'. Gainsborough used the story in a manner entirely in keeping with his own lyrical and idyllic vision which was closer to the dreamland of the French Rococo than to the morally serious world of traditional history painting. There is nothing indicative here of impending tragedy, even though Actaeon has already grown horns. The picture, although technically unfinished, is one of the most beautiful Gainsborough ever painted. His use of the ground colour to unify the composition and create a tonal harmony can be seen clearly. Actaeon is indicated by barely a few strokes and washes of colour, and the nymphs seem to have grown up bonelessly and sinuously from the depths of the canvas. The greeny-gold of Diana's hair is repeated in the foliage and in the shadows of the nymphs' bodies. The whole surface is enlivened and bound together by the rhythm of Gainsborough's brushstrokes.

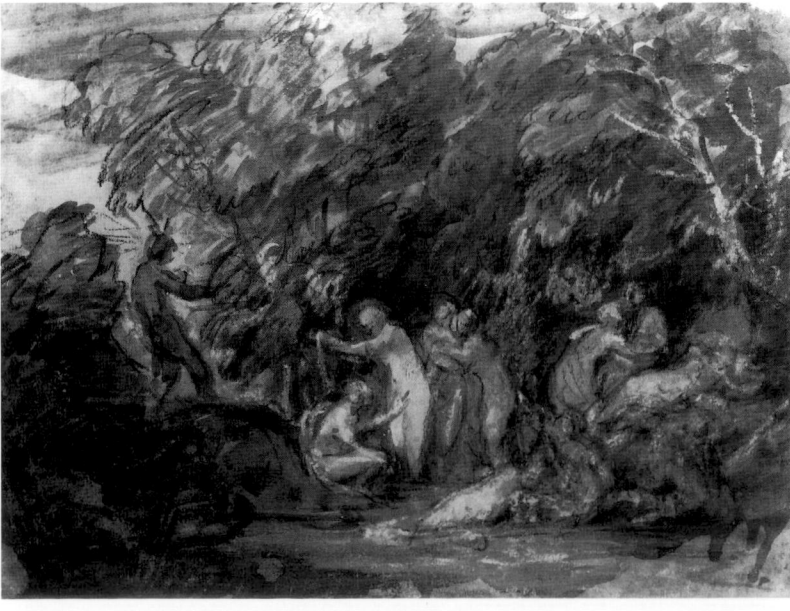

Fig. 41
Study for Diana and
Actaeon
1784–5. Black chalk,
grey and brown wash
and gouache on paper,
27.5 x 35.6 cm. Cecil
Higgins Art Gallery,
Bedford

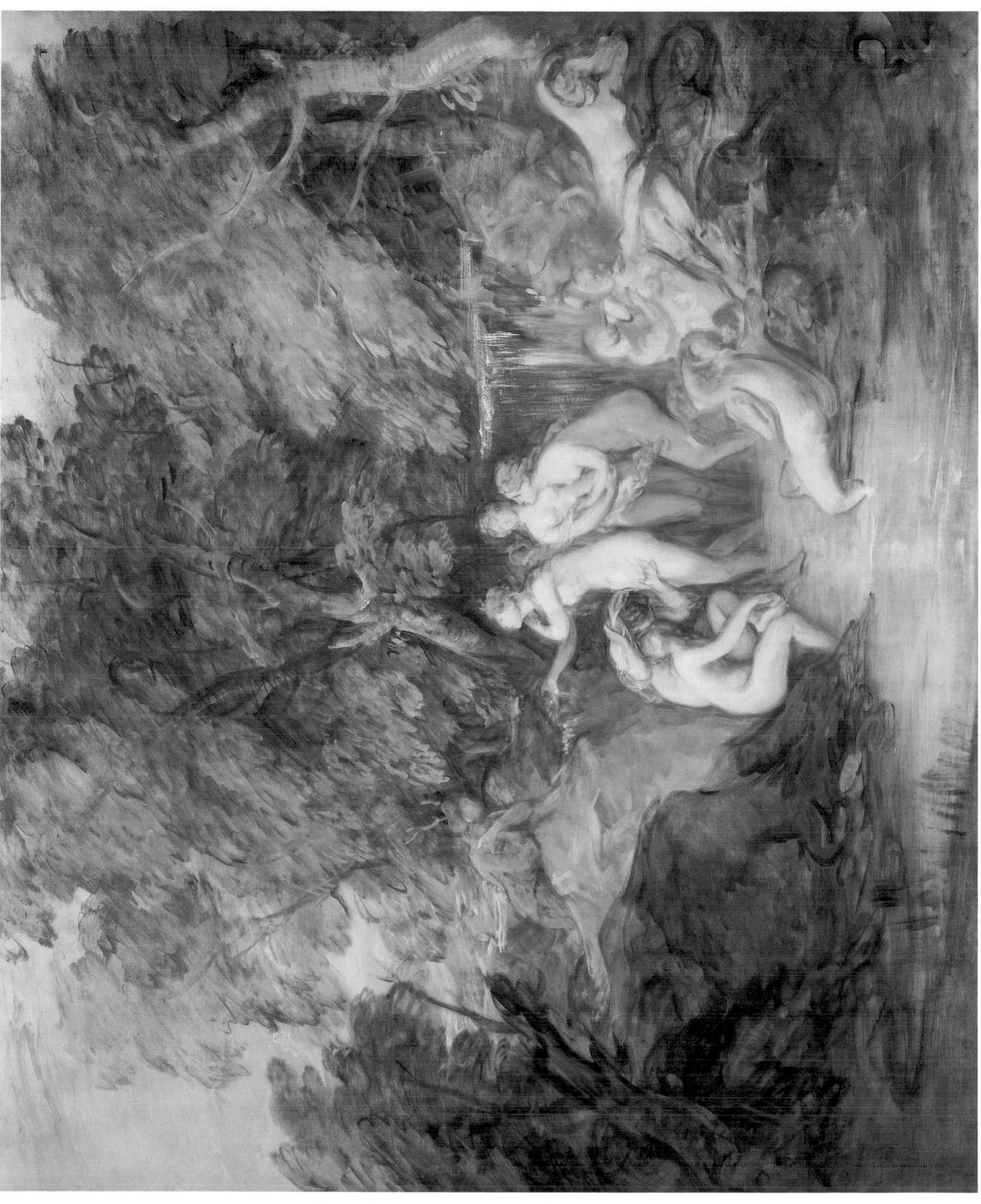

The Market Cart

1786. Oil on canvas, 184.2 x 153 cm. National Gallery, London

In his last landscapes, Gainsborough reworked the now familiar themes of market carts and cottages, but with an ever greater sense of emotion and grandeur. Some of the motifs in this painting appear in Gainsborough's first landscapes, for example, the woodgatherer on the bank to the right is a direct descendant of the little figure in the foreground of *Gainsborough's Forest (Cornard Wood)* (Plate 2). Even the basic composition can be read as a distant development of the early screens of massive and characterful trees enclosing human activity. However, rather than creating a barrier parallel to the picture plane, the trees now seem to curve inwards, enveloping the cart in dense and warm foliage. Another crucial difference to the landscapes of the 1740s, is that Gainsborough is now a very long way from any direct observation. Although Henry Bate felt that this picture was 'expressive of autumn', this is in an emotional rather than a strictly botanical sense. Out of deceptively simple ingredients, and as a result of a lifetime's relationship with nature, Gainsborough has created an almost palpable emotion of landscape. It was this that Constable reacted to when, on several occasions, he found that he was unable to look at Gainsborough's paintings without finding tears in his eyes. He said of his fellow East Anglian 'With particulars he had nothing to do, his object was to deliver a fine sentiment – & he has fully accomplished it.' Although Constable's approach to nature was fundamentally different to Gainsborough's, relying as it did precisely on 'particulars', his object was the same (see Fig. 42).

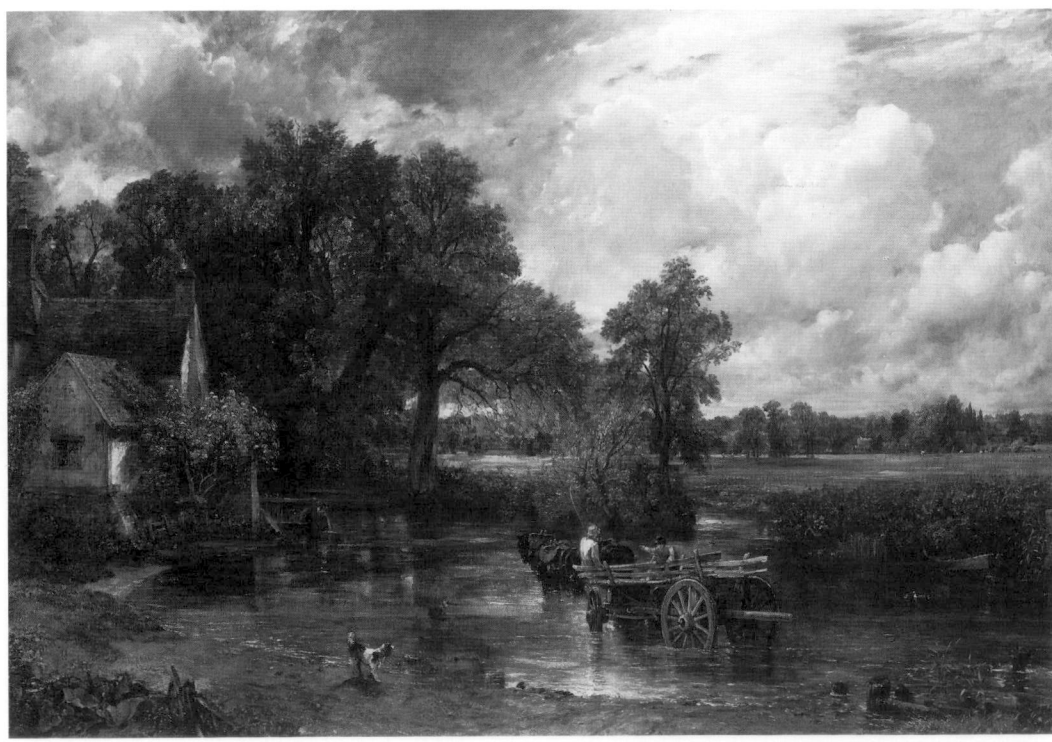

Fig. 42
JOHN CONSTABLE
The Haywain
1821. Oil on canvas,
130 x 185 cm. National
Gallery, London

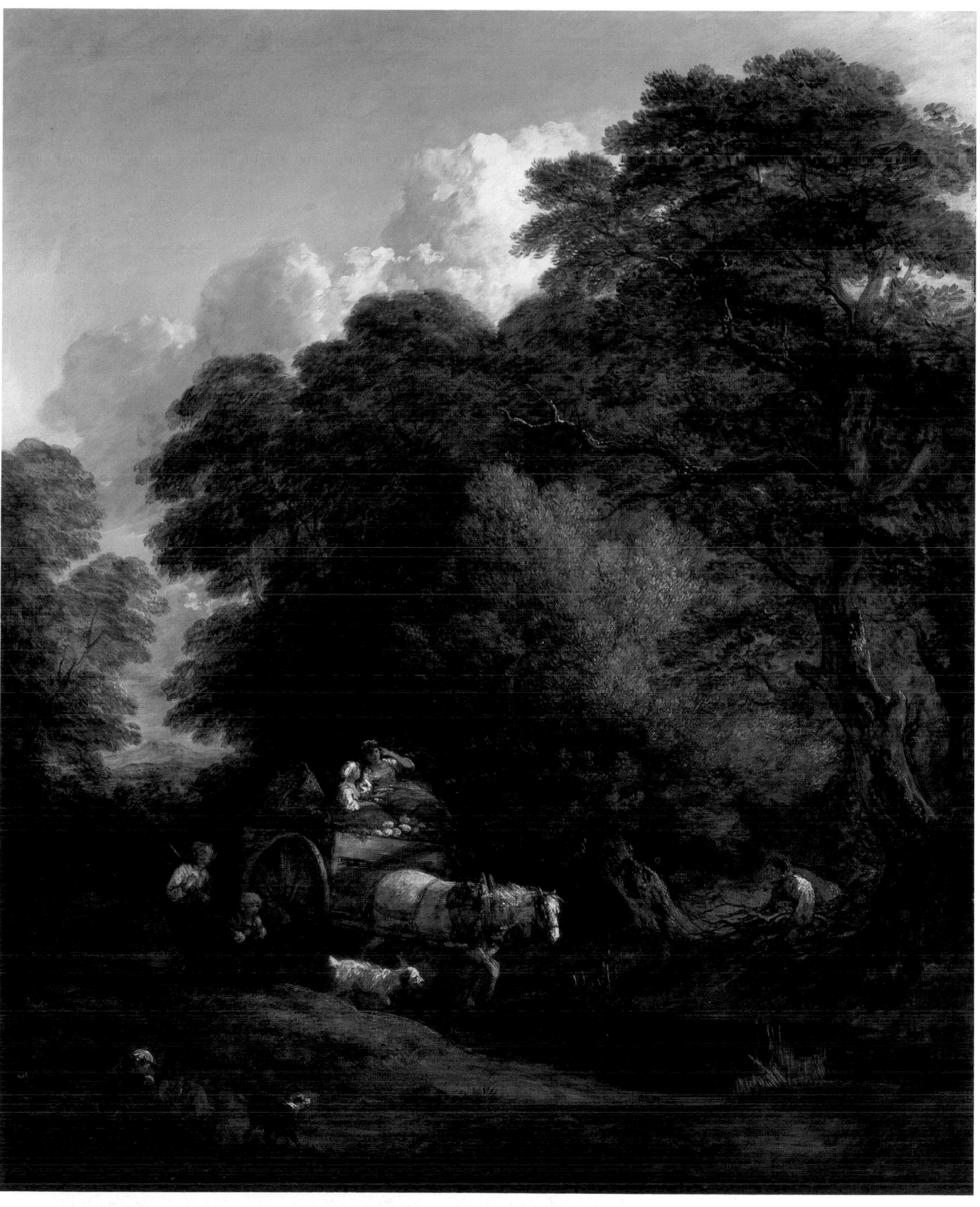

PHAIDON COLOUR LIBRARY
Titles in the series

FRA ANGELICO
Christopher Lloyd

BONNARD
Julian Bell

BRUEGEL
Keith Roberts

CANALETTO
Christopher Baker

CARAVAGGIO
Timothy
Wilson-Smith

CEZANNE
Catherine Dean

CHAGALL
Gill Polonsky

CHARDIN
Gabriel Naughton

CONSTABLE
John Sunderland

CUBISM
Philip Cooper

DALÍ
Christopher Masters

DEGAS
Keith Roberts

DÜRER
Martin Bailey

DUTCH PAINTING
Christopher Brown

ERNST
Ian Turpin

GAINSBOROUGH
Nicola Kalinsky

GAUGUIN
Alan Bowness

GOYA
Enriqueta Harris

HOLBEIN
Helen Langdon

IMPRESSIONISM
Mark Powell-Jones

**ITALIAN
RENAISSANCE
PAINTING**
Sara Elliott

**JAPANESE
COLOUR PRINTS**
J. Hillier

KLEE
Douglas Hall

KLIMT
Catherine Dean

MAGRITTE
Richard Calvocoressi

MANET
John Richardson

MATISSE
Nicholas Watkins

MODIGLIANI
Douglas Hall

MONET
John House

MUNCH
John Boulton Smith

PICASSO
Roland Penrose

PISSARRO
Christopher Lloyd

POP ART
Jamie James

**THE PRE-
RAPHAELITES**
Andrea Rose

REMBRANDT
Michael Kitson

RENOIR
William Gaunt

ROSSETTI
David Rodgers

SCHIELE
Christopher Short

SISLEY
Richard Shone

**SURREALIST
PAINTING**
Simon Wilson

**TOULOUSE-
LÀUTREC**
Edward Lucie-Smith

TURNER
William Gaunt

VAN GOGH
Wilhelm Uhde

VERMEER
Martin Bailey

WHISTLER
Frances Spalding